Beatrice,

 Don't forget all you know
just because you get older—
 love,

 Dave,

 2016

G
R
O
W
I
N
G

U
P

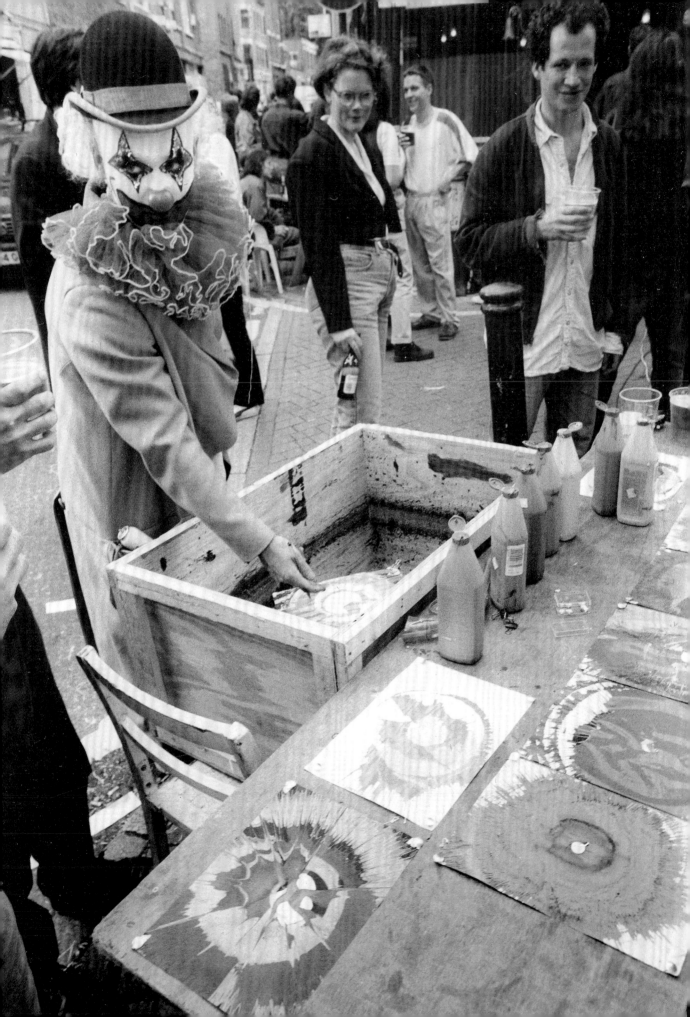

Jeremy Cooper

GROWING UP

The Young British Artists at 50

PRESTEL

Munich • London • New York

CONTENTS

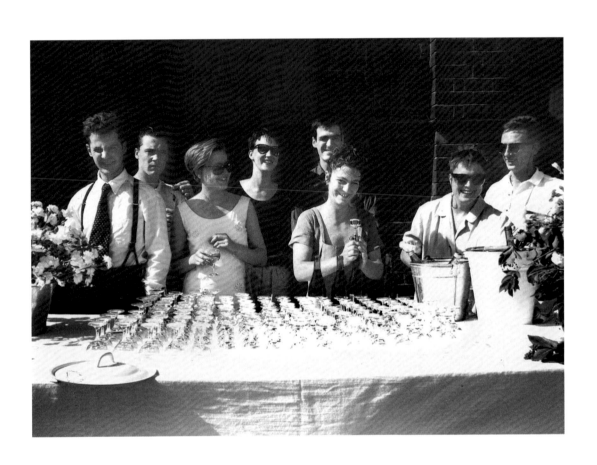

INTRODUCTION /
THE DESIRE TO BE AN ARTIST

There are no rules about being an artist, and no reliable guide as to how to become one. It is difficult enough to define what art itself is.

What does seem possible is to describe, in retrospect, the way in which a particular group of art-makers became who they are – in the case of this selected five, relatively well known. And, with care, also to suggest how they may or may not be equipped to approach the older years ahead.

Anya Gallaccio, Damien Hirst, Gary Hume, Michael Landy and Sarah Lucas studied at Goldsmiths College of Art in the late 1980s, exhibited together in the student-run exhibition *Freeze* in 1988, made their meteoric rise to public attention in the 1990s, established international careers in the 2000s and face in the 2010s, as they enter their 50s, the possibility of a dramatic diminution in critical interest in their work. Some of the Goldsmiths group have tended to court celebrity, which has obscured a realistic understanding of what being a 'young British artist' meant, how it felt, what the personal characteristics and public circumstances were that enabled them to function. Hume maintains that it is only by making the stuff that you find out if you are any good at it, and you only can be any good if you keep on making it, whatever happens!

In the case of these particular yBas, lasting friendship has played a significant role in enabling them to sustain the will-power to do little else than make art for over 20 years. No two of these five artists live together, and all have committed partnerships with others, with whom they have made homes in disparate parts of the world: Gallaccio currently in San Diego, Hirst in north Devon, Hume in up-state New York, Landy in east London and Lucas in Suffolk. Hume and Gallaccio are the only ones who have made marital commitments, Gallaccio to another woman. Of the five, only Hirst and Hume have children. Their young lives of wild companionship are long gone, the obligations of family and work leading to frequent periods of not meeting up, with the result that, though mutually loyal and loving in intent, in practice they seldom find themselves together. They have become independent-minded, solitary creators, as most artists are. In the early days, though, the Goldsmiths group were exceptionally involved in each others' lives, in work and play, to such a degree that their friendship remains an influential factor in how they see themselves today. In actual practice, the day-to-day structures of their companionable lives intimately affected their artistic trajectories.

Whilst art students often form alliances, which on occasion develop in professional life into a recognisable 'school', few have been as

dedicated in their togetherness as the Goldsmiths group, despite sharing little common stylistic ground in their work. The artist Peter Blake has commented on the loyalty amongst this group, 30 years his juniors. 'I think what's so interesting with this generation of artists is that they are all so supportive,' Blake told *The Guardian* in March 1996. 'They all look after each other. You didn't have that with my generation. I've never seen anything like it before.' Norman Rosenthal, then Exhibitions Secretary of the Royal Academy of Arts, wrote in the catalogue to *Sensation*, the exhibition which he commissioned in 1997 of recent British works from the collection of Charles Saatchi, that at the time of their student exhibition *Freeze* in 1988, 'There was … and there happily continues to be, a great generosity of spirit among these artists, who not only show together but help each other in a thousand other ways too.'

The artists are not unaware of the importance of these bonds of friendship to their creative energy and stability. Sarah Lucas is quoted in the catalogue to her major show in 1996 at Portikus in Frankfurt, founded by the inspirational curator Kasper König: 'Lots of my friends I have known for ten years now. We have grown up in the art world together. That's a big help. It's fantastic.' At the wake held at Tate Britain on 25 July 2008 to mark the death of their Goldsmiths colleague Angus Fairhurst, Anya Gallaccio made a moving speech, in which she quoted a favourite phrase of Fairhurst's: 'You'll never make it alone.'

On an emotional level, encouragement by like-minded fellow travellers is a boon for any kind of maker, where self-belief is for everyone at times fragile and the determination to persevere in chosen forms of expression is enhanced by the approval of one's peers. In the early days, when sales were minimal and spare money non-existent, they were also a practical help to each other, co-operating in the mounting of shows, sharing studios and equipment, undertaking projects together and generally lending a hand wherever possible. At the *Freeze* show in 1988, when Gallaccio burnt her foot in the initial session of work on her molten lead piece *Waterloo* and was unable to walk, her colleagues rallied round and executed it for her, while she sat at the side giving instructions. 'We were all Anya's slaves, making her piece,' Hume recalls, 'while she hung around on crutches drinking a glass of wine!' By the early 1990s, after Landy and Hume had been the first to exhibit in a commercial gallery, the art world began to take notice of all five, and step by step they helped each other to climb, at exceptional speed, the art-market ladder. Rivalry of some kind is inevitable amongst artists, but the Goldsmiths group managed to limit competition between themselves to benign proportions, sustained – as is equally true for the rest of us – by the dependability and familiarity which build between people who have known each other for many years, sharing good and bad experiences. They know the ridiculous behaviour each is capable of, how offensive they can be when drunk, how fragile and defensive they are in periods of stress. They know and, by and large, forgive.

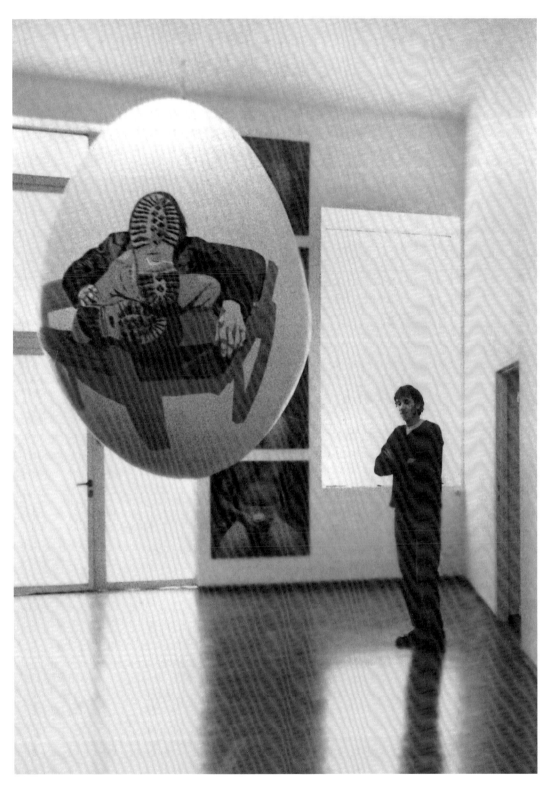

Image from the back of the catalogue to Sarah Lucas's exhibition at Portikus, Frankfurt, in 1996. The artist Angus Fairhurst, her partner at the time, is standing in front of Lucas's photographs from 1992 of Gary Hume, her previous boyfriend. The oval mobile in the centre of the gallery is a self-portrait by Lucas.

For six months in 1993 Sarah Lucas and Tracey Emin kept a shop together on the Bethnal Green Road, where they sold objects that they made themselves, including the Lucas mobile hanging from the ceiling on the left.

In an interview with the art critic Richard Cork in 2000, Damien Hirst said: 'I think it would be a shame if the group broke up now, if it was all just individuals. I feel attached to the people in my year at Goldsmiths.' Hirst is gregarious and enjoys company, as he stated in a published conversation in 2006 with the novelist Gordon Burn: 'I like working with people. They have a big influence on what happens.' The essence of this way of being was captured by another member of the group, Gary Hume, in a public discussion in 2008 at Modern Art Oxford, when he was asked if he thought about the future buyers of works as he made them: 'No, not at all. When you take a risk the only audience you think of are other artists. Because they're familiar with the feeling. Only your artist friends can understand.'

The practical motivation for setting out on a lifetime of making things is not easy to pinpoint. For some, the making of art is experienced as a personal necessity. Lindsay Seers, who completed her MA at Goldsmiths in 2001 and now lectures at the college, wrote in the remarkable paperback text produced by Matt's Gallery in east London in 2010 to accompany her exhibition *It Has To Be This Way*:

We both believed in creative practice as the only thing that made sense. We were both tormented by our own demons that could either be unleashed or held at bay by creativity. I needed art as a structure in which I could embody my thought, a link between mind and body; it was a necessity for me. I was driven to make a space where I could practise as an artist.

Michael Landy says much the same thing, in different words: 'No choice ... That's it, simple, there's no choice. From quite early on, already at secondary school ... I mean, and then, after art school, you just drive forward, whatever the setbacks.'

Drive is an essential. Many people express the wish to write a book or paint a picture but never find the time to do so. Wishing to make art is different from the insatiable desire to become an artist – a 'necessity', in Seers's view. Perhaps it is this sense of necessity which helps equip some-one with the tenacity required to sustain, for years and years, the un-quantifiable activity of making art, in which the emotional motivations and experiences of individual artists are no less important than intellec-tual argument and natural talent. To sculpt full human beings from the crude pedestals on which the heads of Hirst and his companions have been placed by journalists requires an understanding of their personal narratives. Gratuitous sensationalism has characterised the approach to recent British art by a number of observers, and by some of the artists themselves. Instead, the aim here is to describe the day-by-day tensions of making art, and to observe how these resolute makers of things are motivated by many of the same fears and foibles as the rest of us. What-ever the public preenings, privately, in the company of their children, families and friends, the artists themselves acknowledge their fallibility.

It is, for example, instructive to discover that Gillian Wearing (born in Birmingham in 1963), Keith Tyson (born in Cumbria in 1969) and Gary Hume (born in Kent in 1962) all left school in their mid-teens with minimal qualifications and went straight into ordinary work to earn a living. Several years later they took themselves off to art school, all three of them in the end being short-listed for the Turner Prize and two of them – Wearing and Tyson – winning it. Neighbourhood scepticism about the path of art turned, in these cases, to praise at success. Experience of peer disapproval of teenage interest in the arts crosses generations: Richard Hamilton, who was born in 1922 in Marylebone, London, and died in October 2011, left school with no formal qualifications and went to work as the office boy in a local electrical engineering firm. In *The Observer* in 2010 Hamilton described his boyhood love of drawing as making him a 'misfit'. Forty years later Wearing went through the same process, think-ing of herself as 'weird at school'. Often against the incomprehension of family and the ridicule of society, these young men and women found and sustained a desire to make things.

RIGHT
Gary Hume (on the right) sitting on a garden bench beside Jeremy Cooper, photographed in 2004 at Cooper's home in west Somerset.

BELOW
Gavin Turk and two of his children on the early morning of 9 August 1997, on the corner of Rivington Street and Charlotte Road in Shoreditch, with the popular pub the Bricklayer's Arms to the left. The photograph was taken on the day of *Live Stock Market*, the art street event organised by Turk and attended by thousands.

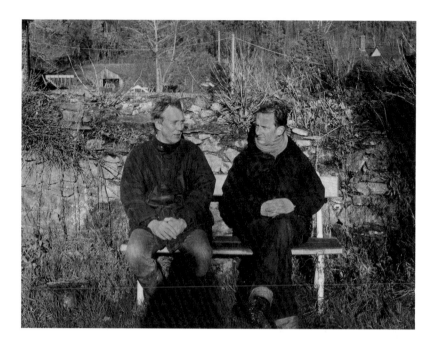

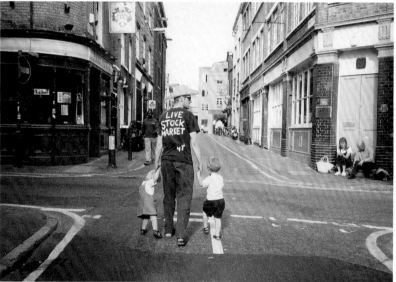

Why? How?

Gavin Turk, who studied for his BA at Chelsea College of Art and Design and his MA at the Royal College of Art, was one of the five artists, including Hirst, represented by Jay Jopling at the opening in 1993 of White Cube, soon established as the leading London dealers in this field. Turk is convinced that there is nothing else he could conceivably have done but make things. At school in pony-club Surrey, Turk was struck dumb in his mid-teens in bewilderment at it all and dropped from the top to the bottom of the class, inflicting puzzled alarm on his parents. When he eventually arrived at Chelsea, his spirits revived, and he remains, to this day, one of the most outgoing artists of his generation. Typical of

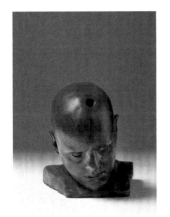
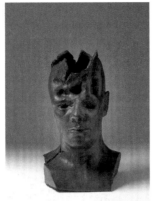
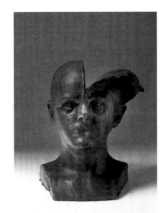

Gavin Turk in his studio in Bow Road early in 2010. Beside him on the table are three of the unfired terracotta casts of the self-portrait busts which he invited artist friends radically to alter before firing of the individual pieces. The final work, called *En Face*, comprised 72 differently manipulated busts, titled in anagrams of the artist's name. The three shown here are *Garvin Kut, Grin Vatuk* and *Ring Vat Uk*.

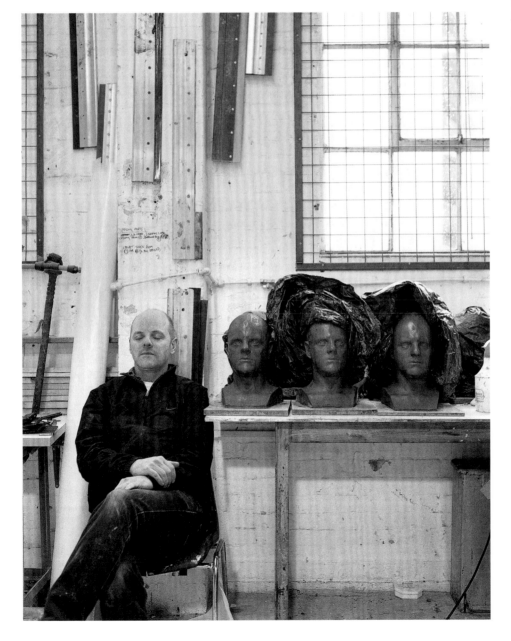

the participatory element of Turk's work is the series *En Face* (2010), in which he made other people responsible for the final form of his sculpture, inviting a large group of artist friends to a black-tie 'Bust Party' in his studio in Bow, in the old East End of London, where he exhibited on plinths 72 identical unfired terracotta casts of his self-portrait, supplied an assortment of sculptor's tools and general implements, and asked the party-goers to work at will on his busts.

Excess is seen as characteristic of the Goldsmiths group. In 2008 Landy set himself the extreme task of executing 70 portrait drawings in a continuous batch, beginning in late April and finishing in September, treating it as a job of work, arriving at his studio every weekday morning at nine o'clock and seldom packing in before seven in the evening. Subjects were required to pose for two full days, in minimum half-day sessions (see p. 110). With appointments strung out across the summer, he shifted in disciplined concentration between the half-dozen or more drawings on the go at any one time – 'I feel like a hairdresser. Taking appointments!' Landy commented. 'Sorry, can't cut your hair next week, love, I'm fully booked. What about the Tuesday after?' Along with family, and his friends from Goldsmiths, the remainder of the subjects were dealers, collectors, curators and other art market contacts, together with his first ever self-portrait. Landy is a Royal Academician these days, as is Gillian Wearing, his long-term partner.

Many of the Goldsmiths group happen to have made money with their art, some of them a lot of money. This is the first generation of British artists to have done so with such wide-ranging conviction and at such an early date in their careers. All the same, money-making has seldom been the primary motive – other, more intimate factors were at work, dependent on their individual personalities and on the nature of the society into which they were born. And, crucially, the choice of becoming a professional artist has been affected by things which individually occurred in their young lives: the absence of a father, the advent of parenthood, illnesses, love affairs, travel ... and the machinations of the art market, with its critical and financial failures and successes. In retrospect, these artists have been credited with leading a revolution, as described by Virginia Button and Charles Esche, curators in 2000 of the Tate show *New British Art*: 'The so-called "yBa" generation, by creating, almost from nothing, a mass audience for contemporary art, have allowed artists of all generations and locations to feel confident in their social role and courageous enough to try to speak to as broad an audience as possible.' Although this does seem to have happened, it was not the specific intention of these young people when they set out.

The first line of A. L. Kennedy's novel *Paradise*, published in 2004, reads: 'How it happens is a long story, always.' To reach some understanding of how these young students managed to make themselves into committed artists requires literary depth. Real discursive detail is

Eyes, in Michael Landy's view, are the vital feature in portrait drawing, as illustrated in his *Self-Portrait* of 2008, where the tension of his gaze into his own eyes in the mirror is expressively transcribed.

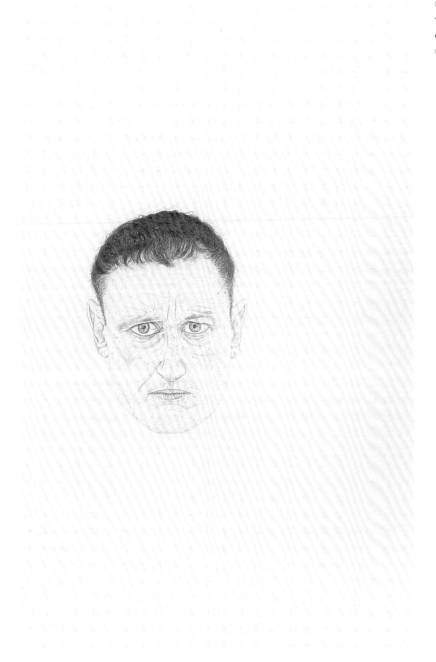

a necessity – and also a pleasure, in describing the personal experiences that made them who they are. In the words of Sarah Lucas: 'The circumstances of your life have a direct bearing on the art you do. Exactly how ... well, we don't really know.' Many of the happenings here related concern the making of things; others explore the events which surround time in the studio and the intimate effect of ordinary life on what is done there.

1 / ART SCHOOL AND 'FREEZE'

Like several of his contemporaries, Gary Hume felt alienated at school, out of place. He left at 16, with only three 'O' Levels. Looking back at boyhood, he identifies a narrative of rebellion:

> When it came to exam time, it was made clear to me that without these qualifications my life wouldn't be worth living, because this was my passport to the future. So I said, in effect, that the country you're offering me citizenship of I've no interest in. I want to be a citizen of a different country. I don't want your passport. Or I may end up living in your fucking country, and you lot all run it and you're driving me mad.

Anya Gallaccio, though reasonably well qualified from her good London comprehensive school, felt equally out of place and did various things before reluctantly accepting advice to attend art college. She chose Goldsmiths as the only place at the time where she would not be forced to specialise. 'I really struggled whilst I was there. I felt I was being self-indulgent and it was too abstract just making stuff ... I was always fighting with myself ... The artist Richard Wentworth, who was my tutor, persuaded me to stay,' Gallaccio recalled in an interview with Rebecca Fortnum for *Contemporary British Women Artists in Their Own Words* (2007). Looking back in the autumn of 2011, Gallaccio remembers:

> I had this terrible session when Wentworth told me to throw all my work out of the window! Later I understood that he didn't think I was a terrible artist! That he meant something different altogether! ... I only had a difficult time at Goldsmiths because I'm a difficult person. Pragmatic and also wildly romantic. I'm totally contradictory and drive myself nuts!

For none of these five Goldsmiths artists has the trajectory been straightforward. Michael Landy, the son of an Irish tunnel builder badly injured in an accident underground in the 1970s and unable ever to work again, was uncertain how best to approach things after school and enrolled at Loughborough College to study textile patterning, also taking courses in embroidery and drawing. He later applied to Goldsmiths, where he gained a place at his second attempt. Sarah Lucas's father was a milkman in Holloway, a working-class area of inner north London, and

OPPOSITE
The Three Strange Partners, one of the collages made by Damien Hirst at home in Leeds between 1983 and 1985, constructed from the mountain of materials he found in the house abandoned by his near neighbour Mr Barnes (see Chapter 5).

after an unhappy period at the London College of Printing she went to art school in part as an attempt to overcome personal loss. In Leeds as a boy Damien Hirst grew up without his father, and his stepfather got the push when he was ten; and though he made interesting Schwitters-influenced artwork while on the Foundation Course at the local art school, he afterwards worked on a building site for a couple of years before beginning his BA at Goldsmiths College in south London.

They were not the only art students with unconventional histories. Another Goldsmiths graduate of the 1980s, Mark Wallinger, winner of the Turner Prize in 2007, is from a family of fishmongers in Chigwell, Essex, a background which he is pleased still to feel close to, even though the progress from there to art renown puzzles him. Speaking to *The Guardian* in February 2009 about his performance piece *Sleeper* (2004) in Berlin, Wallinger acknowledged that at times when wandering around the Neue Nationalgalerie in solitude on ten consecutive nights, dressed – by artistic choice – in a realistic brown bear suit, he did say to himself: 'Mark, how did you get from Chigwell to here?'

The quality and direction of teaching tend to be more important to artists than to writers: though secondary to his individual drive and talent, Goldsmiths will have influenced the pattern of Wallinger's progress, despite his subsequent hostility to the place. Gallaccio, Hirst, Hume, Landy and Lucas have all individually acknowledged the benefit to them of their time at the college.

The man who guided this fertile period at Goldsmiths was its Dean of Fine Art, Jon Thompson. Having practised throughout the 1960s as an abstract painter, with solo exhibitions in London and New York, Thompson devoted the central part of his life to teaching, after taking up his post at the art school in 1971. His earliest noteworthy intervention in the established practice was to remove the obligation on students to name a specific discipline in which to specialise, leaving them free to roam from department to department, combining – say – the techniques of etching with bronze-casting, or alternatively, as in Hume's case, knuckling down solely to painting. There was no preferred path. Not even becoming an artist was obligatory, and several students of this Goldsmiths generation felt free later to set up specialist businesses in related fields and to cease directly practising the so-called 'fine arts'. Mark Darbyshire, for example, is now one of the leading London frame-makers, with a substantial workshop in Gloucestershire, whilst Gavin Brown travelled in the opposite direction and has become a powerful contemporary art dealer based in New York. Richard Wentworth, who taught at Goldsmiths from 1971 to 1987, spoke about Thompson in a published Tate interview: 'Jon Thompson organised Goldsmiths in an open, porous way ... Students were invited to swim in waters that were so full of possibilities and contradictions ... All working side by side, exposed to each other, expected to be answerable for their actions.'

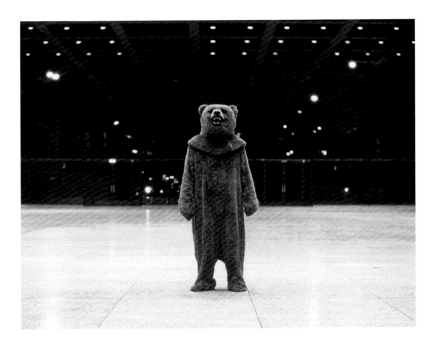

At the Neue Nationalgalerie in Berlin in 2004, Mark Wallinger created his piece *Sleeper*, for which he spent ten nights alone in the gallery, wearing a brown bear suit. Crowds came to witness his presence through the glass walls of the ground floor; one night someone arrived dressed in another bear costume and wandered up and down outside.

The other major figure for students at Goldsmiths in the mid-1980s was the painter Michael Craig-Martin, described by Hume as 'encouraging, empowering ... with Michael it was always about how to do the next thing, how to carry on'. A Canadian, Craig-Martin had taken his degree at Yale University, where, as he told the London art critic Louisa Buck:

> I learned that art could be talked about in straightforward terms;
> that it needed to be rooted in the very experience of ordinary life
> I had thought it sought to escape, that contemporary art existed
> in a context as complex as that of any earlier historical period;
> that, for an artist, art needed to be approached as work.

Craig-Martin appreciated the raw energy of this particular group of students' engagement with art, as Landy remembers: 'Michael said he'd been waiting for years for people like us to come along. A bunch that fed off each other and built up a competitiveness amongst themselves.'

The direct influence of Craig-Martin's own paintings was marginal at the time, partly because the fashion then amongst his students was still for his earlier conceptual work, such as *An Oak Tree*, a piece composed of a clear glass of water placed on a high-ish plate-glass shelf. His paintings, which had yet to settle on the high-octane colour palette of today, were less well known by Craig-Martin's pupils. 'MCM', as his students referred to him, taught the degree course at Goldsmiths from 1974 to 1988, and returned in 1993 as Millard Professor of Fine Art, afterwards remaining available to these particular graduates for advice and support, and still to be seen 20 years later at their private views. Although his art-world connections were undoubtedly helpful, it was the tutor's personal

The subject of smoking was explored by several of the yBas in the 1990s. In addition to Sarah Lucas there was Damien Hirst, with his gargantuan ashtrays, and Sarah Staton, with the painted paper-pulp cigarette packets that she made for her SupaStore, first seen at 148 Charing Cross Road in 1993 and which toured Britain and America over subsequent years.

Prizes made by Tracey Emin for her stall Rat Roulette at the *Fête Worse Than Death* in Hoxton Square in 1994.

conduct which particularly impressed: his faith in creative difference, his treatment of painting as work, the complete seriousness of his personal dedication to art and the fact of having, in 1988, a major exhibition in a fine public space, the Whitechapel Gallery – an example that Hume was to duplicate with his own solo show there in 1999 (see p. 98).

The impact on Lucas of her time at Goldsmiths was considerable, moving her on from the formalist sculpture in an academic mode that she began by making. Her crushed aluminium piece *Untitled*, illustrated in the *Freeze* catalogue, heralded a breakaway to forms of expression of which she felt personal ownership, using subjects familiar to her from her home in Holloway. Lucas has continued to make art out of the artefacts of her everyday life – tabloid newspapers, cigarettes, crashed cars, underwear – and remains close to her roots in voice, dress and attitude. In her Museum Boijmans van Beuningen catalogue of 1996 Lucas said: 'Art has to be something that is totally mine, it can't be taken away from me by lack of money or materials. It is important to me that you can make art out of anything at all.' Typical of her approach, Lucas joined Tracey Emin in 1993 to co-make art objects for sale in their shop near the traditional street market in Brick Lane. Carl Freedman said at the time: 'I think *The Shop* is probably one of the best works of art I have ever seen, or probably better to say experienced ... I had lost interest in art since [curating the] Building One [exhibitions in 1990] and Tracey and Sarah brought me back to life.' The two young women had only met the year before, when Emin turned up at the opening night of Lucas's solo exhibition at City Racing, but both believed in collaboration and they sat down together to make things, selling in *The Shop* self-made mobiles and badges and clothes, such as T-shirts emblazoned 'GOD IS DAD' and 'NIETZSCHE IS DEAD' and 'HAVE YOU WANKED OVER ME YET'.

Like Lucas, Gallaccio also gained from Goldsmiths. She had elected not to continue in education after leaving school at 18 and instead 'drew a lot and travelled for a bit', ending up with a job in the wardrobe department of the Royal Court Theatre. She then became interested in contemporary dance and discovered 'working practices where there seemed to be no hierarchy between performer, director and designer – a true collaboration that I found both exciting and inspiring'. The invitation from Hirst to join the *Freeze* exhibition proved a turning point in Gallaccio's life as an artist, enabling her to place herself and her work in a viable context. As she has put it:

> The more restrictions Damien imposed, the clearer my choices became ... Pouring the lead and working directly in the space opened up a whole new set of possibilities for me and then I was invited to do another show. Something clicked into place in my brain and I'd found a way I could allow myself to make things.

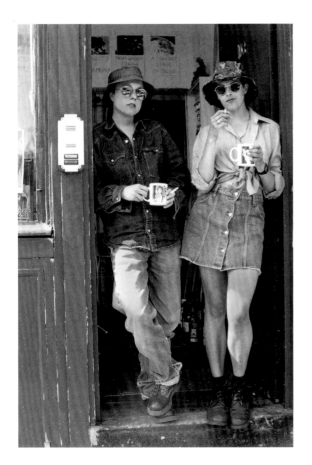

Sarah Lucas and Tracey Emin (on the right) standing outside the door of *The Shop* in 1993, which they ran together for several months as an art event, located close to the Brick Lane street market. The photograph was taken by Carl Freedman, now a contemporary art dealer but who at the time was Emin's boyfriend. In 1995 Freedman took another now classic Emin shot, which she made into her photographic piece *Monument Valley*.

Lucas and Emin liked to make cardboard lapel badges for sale in *The Shop*, with safety pins secured to the back by sticking plaster. Together they made a series on the subject of David Hockney, including *Hockney on a Rothko Comfort Blanket*. It was never made clear who did what at *The Shop*, although the phrase 'Clarity = Harmony', as used in the badge she titled *A Constant State of Order*, was certainly Emin's. The green curtain of badges belonged to Joshua Compston, a good friend of Emin's, and was presented to the Tate in his memory when he died in 1996, at the age of 25.

Patient and determined, Landy applied two years running for the course at Goldsmiths. Craig-Martin, who was on the admissions panel both years, recommended the second time that Landy be accepted, because he made better sense in the interview, the tutor explained, and because the portfolio was more impressive – he discovered years later from Landy that his portfolio submission was in fact completely unchanged! Landy spent much of his second year stacking sheets of toilet paper, which were always falling over: his obsessiveness earned him the nickname Stacks. Karsten Schubert, who had moved from assisting at the Lisson Gallery to set up in April 1987 his own commercial gallery in Bloomsbury, was invited by Craig-Martin to call at Goldsmiths in the summer of 1988 for a preview of the graduation work and snapped up Ian Davenport, Michael Landy and Gary Hume for an exhibition later that year. Landy remembers the arrival of Schubert's offer on the day before the opening of their degree show as a defining moment in his trajectory as an artist, temporarily separating the three of them from the rest.

Rock and pop music occupied a central place in the lives of many of the Goldsmiths group. Fairhurst (lead singer and guitarist), Collishaw (bass guitar), Hume (rhythm guitar) and Hirst (drums) formed a band at Goldsmiths to make their own brand of music – albeit music with a difference, for they did not play but mimed to complex tracks put together by Fairhurst, the most serious musician of the four. The air-band performed under various names – Bandabandoned, Abandobandon and Lexopwectations – before settling on Low Expectations. They initially played in esoteric art venues and then, as the band's members became better known as artists, moved on to main music spots, before audiences of thousands. At the Brixton Academy in December 1995 they strutted their conceptual stuff as support band to Pulp; Low Expectations was

admired by Pulp's Jarvis Cocker and his ex-art-school musicians, who enjoyed the coded gestures of these artists of their same generation and appreciated the dialogue between pop culture and art. The band featured regular dance performances beside them on stage by the ex-Slade student Pauline Daley, who is now a director of Sadie Coles HQ, Fairhurst's and Lucas's dealer. Hume was an energetic mime guitarist – so much so that he damaged his hand one night, drawing blood. And then, to his distress, Fairhurst arranged a tour to Helsinki from which Hume was excluded; another White Cube artist, Cerith Wyn Evans, took his place. 'You're too enthusiastic,' Fairhurst complained. 'Cerith is ... more restrained. Cooler.' Reflecting in 2007 on the experience, still touched by disappointment, Hume said: 'I mean, how unmusical can you be? I wasn't even allowed to play silently!' He refused to give up, bought himself a piano and took lessons!

There is a long pedigree for active art-student involvement in music, with its consequent creation of a lifetime's connection through memory of the shared public vulnerability of performance. Bryan Ferry, Andy Mackay and Brian Eno of the band Roxy Music were all art students before becoming full-time musicians. Ferry had been taught at art school in Newcastle in the late 1960s by Richard Hamilton. Low Expectations, however, reversed this trend and, for the first time in England since the birth of rock, fine artists themselves were to become as publicly celebrated as pop singers. Not everybody was pleased, and there is weight behind Mark Wallinger's remark, as guest co-editor of Peer's *Art for All?* (2000): 'Curators pick and choose from a smorgasbord of narcotic sensation, a baseless language of outrage. Art is the new rock-n-roll.' The Canadian artist Rodney Graham sees the connection in a more positive light. Speaking to the magazine *Modern Painters* in 2007, he acknowledged the part played by music in his iconoclastically creative life: 'It was rock that got me into painting. Being a painter is an extension of the performance idea that started with my interventions into serious music.' Gavin Turk is one of several London artists of the period who make use of pop music in their work, in his case regularly giving art performances as a DJ. Rachel Whiteread experienced things differently and after being short-listed for the Turner Prize in 1991 began to feel alienated by the hype and photo shoots and general razzmatazz: 'There's an important difference between being a pop star and being an artist,' she told Richard Cork in 1999. 'The possibility of becoming a superstar certainly existed for members of our generation. Damien has it both ways. But for some it's been a massive drawback, sucking them into the publicity machine. I have a complex relationship with the media.'

The fundamental difference between this group of five artists and other Goldsmiths undergraduates was *Freeze*, mounted in three separate parts in the summer of 1988 in the Port of London Authority's disused gymnasium down on Surrey Docks while they were still students.

The artist-run exhibition *Freeze* took place in three parts through the summer of 1988. The location was this disused gymnasium in the Surrey Docks, belonging to the Port of London Authority, down in the abandoned riverside acres south of the Thames, a decade before the fashionable 'docklands' boom.

Although Mat Collishaw provided the title for the exhibition, derived from his light-box image *Bullet Hole* (1988), said to depict the moment of impact of a bullet in the top of the skull, captured in a 'freeze-frame', it was unequivocally Hirst's show. He selected all the participants and personally invited them one by one; he negotiated the venue, established the principles and advised his colleagues on what work to show; and he was the one who secured sponsorship from the London Docklands Development Corporation. They all shared the labour of getting the PLA gym ready for the exhibition, spending several weeks repairing the building and then, once *Freeze* began, dividing out gallery attendance between them. The full alphabetical list of exhibitors at *Freeze* was: Steven Adamson, Angela Bulloch, Mat Collishaw, Ian Davenport, Angus Fairhurst, Anya Gallaccio, Damien Hirst, Gary Hume, Michael Landy, Abigail Lane, Sarah Lucas, Lala Meredith-Vula, Stephen Park, Richard Patterson, Simon Patterson and Fiona Rae. Dominic Denis's work appeared in the illustrated catalogue but was excluded from the show, as Hirst felt he had neglected to take the project seriously enough and sacked him, too late to amend the catalogue. Landy is missing from the best-known photograph of some of the group, shown standing beside the drinks table immediately prior to the opening of the show – as the only one with a car, he was off fetching the ice!

Freeze was not, in fact, the first exhibition of its kind, for earlier in the year Fairhurst had organised a student show at the Bloomsbury Galleries in the University of London's London Institute of Education on Bedford Way, where he showed work by himself, Collishaw, Lane and Hirst. Its public impact was minimal, despite the thoughtfulness of Fairhurst's views on art. 'I didn't curate it, I just let everyone put one piece in,' he told Marcello Spinelli in 1995. 'For me, the idea was to start a

dialogue with the outside world, rather than just being in the cocoon of the college. That was my reason for doing it. It wasn't an enterprise thing.'

Because of the subsequent achievement of financial power in the contemporary art market by Hirst and his gang, the *Freeze* exhibition has assumed mythic status. An article in *The Observer* in June 2008 made the bizarre assertion that it was one of the most significant exhibitions of the entire 20th century: '*Freeze* has entered modern art history as a cataclysmic happening on a par with the Cabaret Voltaire and the *Salon des Refusés*.'

At the time, although the show felt personally important to the artists, it did not register as historically significant. This was no ordered assault on the system, no targeted revolution. Despite subsequent claims, not many people actually made the trek to south-east London to see the show, and nobody could have predicted the changes that followed. Gallaccio commented in 1996 to Patricia Bickers, the editor of *Art Monthly*:

Damien Hirst's *Boxes* (1988), as illustrated in the *Freeze* catalogue, shown in the first of the three-part show he organised while a student at Goldsmiths College of Art.

It is amazing how *Freeze* has been cemented into art history. Hardly anyone saw it, and most people don't even know what it is they are acknowledging ... The original energy of *Freeze* was not cynical. It was genuine enthusiasm to make work and get seen. I don't think anybody at the time realised how much was at stake.

Hirst agrees. In January 1992 at the Institute of Contemporary Art he made the comment: '*Freeze* is the kind of exhibition that everyone said they saw and hardly anybody did.'

Sitting in his office at home in Devon in September 1999, Hirst spoke to Gordon Burn about the difficult task of carrying his strong, Leeds-nurtured Schwitters influence into a fully contemporary form of expression: 'I believed in what I was doing when I was doing the collages. But it was very difficult to keep that belief and bring it forward ... And I'm surrounded by Gary Hume and all these people making these brilliant, really up-to-date, perfect things!' Friends recall Hirst's impatience during the pre-*Freeze* period, frustrated at his inability to find the right kind of work to do, as demonstrated in his derivative wall-piece of coloured blocks of cardboard in the first part of *Freeze*: Michael Landy remembers that bits of it were always falling off the wall, and the first task when they

One of the earliest of Damien Hirst's spot paintings, a double image painted directly on the wall, titled *John, John* (1988). Later he began giving these paintings names taken from a pharmaceutical catalogue.

opened each morning was to stick the night's casualties back up with double-sided tape! Then, coming across by chance an image of Gerhard Richter's *1024 Colours* (1973), a geometric colour chart of straight-from-the-tin commercial gloss, Hirst conceived a way forward. The picture he had seen was in a book that had recently arrived at the Anthony d'Offay Gallery, where he worked as a picture-mover to earn the money to pay his way through art college. Graham Gussin, a Chelsea art student who also worked part-time at the Dering Street dealers, remembers Hirst staring and staring at the picture in the book, before saying of Richter: 'What a free man!' Shortly afterwards, he executed the first of his own type of colour charts, a spot painting directly onto the wall in the third part of *Freeze*, after which he calmed down, able to say to himself 'OK, well, it can be done.'

Hume describes his friend's spot paintings as 'the perfect expression of what Damien is on about ... Faultless!' Hume believes them to be a brilliant invention for the age in which we live, a form of art that is repeatable and at the same time – because of the infinite possibilities of variation on the grid – endlessly unique; something which can be marketed as a brand, which a studio assistant can execute and whose price wealthy buyers wish to see go up and up. Hume's own work at the time also explored a single theme, executed in a largely mute-toned selection

of commercial gloss paint on ply panels in the precise pattern of a pair of swing doors in St Bartholomew's Hospital in Smithfield. 'It wasn't about illness, it was about a democratic use of the symbol of the door,' Hume is quoted as saying, in the catalogue for the show *'BRILLIANT!' New Art from London* at the Walker Art Center in Minneapolis in 1995.

> I had to use a totally democratic door. That's a hospital door ... The institution of the hospital won't care whether I'm Gary Hume the artist or Gary Hume the dustman. At the moment of crisis I will be passing through those doors, so I wanted to make them democratic. I'm not naming the political, but the man.

Hume had sold his set of three doors at *Freeze* before – for once – Charles Saatchi was able to acquire them. So he painted three more for the collector, on commission! By 1991 Hume had expanded the colour range of his doors and altered some of the patterns, to impressive effect.

Hirst was exuberant: 'All of us lot, we caned the art world. Absolutely totally phenomenal. We caned the art world as *kids*,' he said. His energetic response at the time was to set about locating a similar type of exhibition space for further ventures, working with Carl Freedman, a friend from Leeds who abandoned his anthropology degree at University

Gary Hume's door paintings took on an increasing variety of colours, whilst retaining elements of the original 1988 doors, based on those seen at St Bartholomew's Hospital, where he was taken after a bad motor scooter accident. The black and gold doors *Present from an Octogenarian* were painted in New York in 1991-2.

27

College London to curate the shows, and Billee Sellman, a friend of Freedman's from college. In 1990 they mounted three exhibitions at Building One, a disused biscuit factory in Bermondsey, starting with *Modern Medicine* and moving on to *Gambler*. These were more professional operations than *Freeze*, but nonetheless self-generated and independent. Hirst invited older artists to join in, one of whom was Tim Head, who showed his painting *Perfect World* (1990), from a series of works abstracted from found shapes in machine-made sources, such as the pattern inside airmail envelopes. Without having previously met him, Hirst had simply turned up one day at Head's studio, then in Mornington Crescent, and had spoken with a speed and energy that Head still remembers as being almost combustible. It was fun, Head found, being involved with the younger generation, especially as *Gambler* included Hirst's first monumental piece in a glass and steel cage, *A Thousand Years*, with a white box of hatching maggots in one side and severed cow's head and fly incinerator in the other, a work that Head admires.

The third and last of the Building One shows, *Market*, in September and October 1990, was a vast installation by Landy alone, praised at the time even by a severe critic of the yBas, Julian Stallabrass, for its 'specific and clear-cut stand on social issues; its irony is directed entirely against a situation the artist objects to, rather than spinning in the air or rebounding on the work'. Stallabrass described Building One as

> a poignant place for display ... [in which] some of the fittings were still intact – there were regulations to workers pasted on the walls – and the building's massive rooms had their own life as the light changed ... The art was, in a sense, an excuse for being there.

In a Tate booklet, John Slyce also praised Landy: 'The scale of Landy's achievement derives from work that is public in practice and spirit and, at its best, reveals the art process as a social practice grounded in an art world that is never a world apart.' Wallinger, a consistent critic of his Goldsmiths contemporaries, saw things differently: 'The most bogus claims were that of accessibility to a new audience. These were the most elitist of shows – a direct appeal to money, ladies who lunch, collectors and big shots who were air-lifted into east London (*ich bin ein Londoner*).'

The pace at which things developed for these artists after *Freeze* was unprecedented. Whilst *Freeze* had been an esoteric affair, less than two years later at Building One there was undoubtedly a sense of 'happening', of being in the presence of a group of young people destined to make waves in the art world. Had it not been for the quality of the three exhibitions, this promise of impact would quickly have evaporated. It didn't. Against Cassandra-like warnings of meaningless excess, the Goldsmiths group went on to dominate British art for the next 20 years.

The clean industrial lines of Building One in Bermondsey, recently vacated by the biscuit manufacturers Peake Frean, were adopted by Carl Freedman in 1990 for the show *Gambler*, which he co-curated with Billee Sellman and Damien Hirst. *A Thousand Years* (1990), Hirst's first glass and steel cage piece, is near the back wall, with a set of three paintings by Dominic Denis to its left and a Hirst medicine cabinet on the near left.

Michael Landy's *Market* was the last of three exhibitions mounted in 1990 in Building One. Some elements of the large installation were sold separately, and Hume still has a stack of Landy's red bread-baskets standing in the hall of his studio.

2 / ART MARKET START

Art-market habits cleave to the conventional, based on dozens of decades of control by the rich and powerful. Until relatively recently, little was known about how the contemporary art market worked, about who sold what to whom and for how much. There were established ways of doing things that it was difficult to challenge: graduates from art school were expected to find part-time employment and produce years of work without a solo exhibition, with the aim first of inclusion in mixed shows, and then, after a minimum of ten years, secure a small solo show at a minor gallery, after 20 years gain representation by a major gallery and after 30 years begin to place work in public collections. The art world exuded exclusivity, felt patronising and hypocritical. In Britain it was the art graduates of the 1980s who began to change all this. The artist Ross Sinclair, who was part of a group of independently minded students at Glasgow School of Art in the late 1980s, expressed the attitude of this whole generation in an essay for the arts journal *Windfall* in 1991: 'Why wait for your work to be approved/validated/confirmed by some ex-public schoolboy in a sharp suit/jeans'n sneakers? You get out there, do some fucking hot shows and invite them over on your own terms.'

It was exhilarating to witness how these young artists refused to be bound by convention and took things into their own hands. The artist-run exhibitions put on by Hirst, Lucas and their friends, because they occurred in London, have received the greater attention, but equally adventurous actions were taken by their contemporaries in Glasgow: Douglas Gordon, Jonathan Monk, Christine Borland, David Shrigley and Ross Sinclair, amongst others.

The establishment of a viable platform for artistic display outside the normal market habits does not happen easily. Indeed it does not 'happen' at all, but is created, by the artists themselves. The freedom to feel part of things rather than feel excluded is a radical turnaround for younger artists. Through the international publicity given to Hirst and his companions, it is now almost as if it is the artist, rather than the power-broking nexus of dealer, collector and museum director, that is in control. Young artists these days frequently find their work being exhibited and bought early in their careers, and the most accomplished of them are fought over by art dealers already at graduate shows. In the aftermath of *Freeze*, one of the student exhibitors, Richard Patterson, harboured disappointment at the immaturity of much of the work that followed, and was disillusioned about the art market and its blind scramble to sign

OPPOSITE

To the exhibition *Louder than Words* at the Cornerhouse in Manchester in 1991, Damien Hirst contributed *Aesthetics (and the way they affect the mind and the body)* (1991). He later supplied a Polaroid image of this for the postcard catalogue of Douglas Gordon's solo exhibition at the Deutsche Guggenheim in 2005.

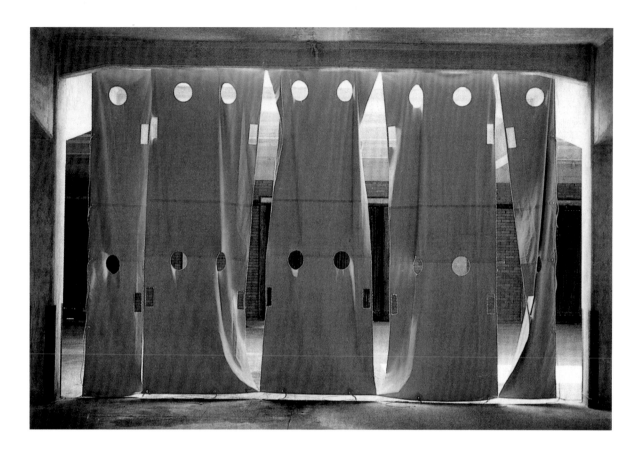

Each artist in the *East Country Yard Show* in Rotherhithe, curated by Sarah Lucas and Henry Bond in the early summer of 1990, was allotted 20,000 square feet to play with. For his piece, titled *Bay A, Bay B, Bay C, Bay D, Bay E, Bay F, Bay G, Bay H, Bay I, Bay J, Bay K* (1990), Gary Hume made a corridor of green flag-doors.

up his Goldsmiths group. 'So I stopped making art completely for four years,' he has said. 'I didn't have a studio and I didn't want to claim to be an artist without doing work. So I told people that I'd given up.' Both Richard and his brother Simon Patterson have been solidly back at work for a number of years now, staying as far away from the British media limelight as they can manage.

To begin with, in London as in Glasgow, instead of waiting to be asked, the young artists mounted shows of their own. In the same year as the three Hirst-involved exhibitions at Building One, the artists Henry Bond and Sarah Lucas put on *East Country Yard Show* in a cavernous storage warehouse at South Dock, Plough Way, Rotherhithe, which ran from 13 May to 22 June 1990. Within thick, uncoloured card covers the catalogue simply gave the titles, dates and dimensions of the work below the artists' names: Henry Bond, Anya Gallaccio, Gary Hume, Michael Landy/ Peter Richardson, Sarah Lucas, Virginia Nimarkoh and Thomas Trevor. There were colour details and black-and-white installation photographs of each of the 20,000 square foot spaces occupied by the seven artists.

Affected by his intimacy at the time with Lucas, Hume deserted his gloss enamel for green cut canvas, in a door-like composition of two long corridors of material hung between the concrete columns. The Lucas touch ignited the whole show, for which Gallaccio devised one of the earliest of her perishable installations, *Tense* (1990), where the central premise concerned watching, and indeed smelling, the descent into putrefaction of natural material over the course of the exhibition. A ton of oranges were strewn around her allotted space – the fruit lost its sheen

and colour, began to shrivel and eventually to rot, whilst around the walls Gallaccio had mounted a floor-to-ceiling grid of lithographed images of oranges, for ever perfect in their lush regimentation. The main piece in Lucas's own exhibit comprised 55 pairs of soccer balls 'corralled' within low white painted post-and-rails. There were also three 4-foot cubes mounted with squared images, including one with the Hume photograph of Lucas eating a banana, and seven small wall-mounted photographic cubes, all with 'throbbing' in the title: *Throbbing Seven Valley Reds* (1990), *Throbbing Stocks* (1990), *Throbbing Sand Faced Flettons* (1990) and others.

At another of Lucas's self-run shows, this time alone, *The Whole Joke* at the Alternative Art Gallery in Kingly Street, west Soho, in 1992, she presented the piece *Fried Eggs and a Kebab* (cockney slang for female body parts), for which she spent days standing in the window frying eggs for the suggestive sculpture. 'I like the handmade aspect of my work,' she said in an interview with the audio cassette magazine *Audio Arts*. 'I'm not keen to refine it: I enjoy the crappy bits round the back. When it's good enough it's perfect.' Various other artist friends put on their own shows, with many of the same people in them, such as *Lucky Kunst*, presented by Sam Taylor-Wood and the art writer Gregor Muir in a defunct flower shop in Silver Place, Soho, in 1993.

Hirst co-curated, with Tamara Chodzko and the then private dealer Thomas Dane, his early solo show *In and Out of Love* (1991) in a vacant building in Woodstock Street in the West End, where Malaysian butterflies – alive and dead – were the main element of the work. Hirst explained to the animal rights protesters in the street outside: 'No questions

and no answers, just instability. I'm perfectly happy with contradictions. I try to say something and deny it at the same time.' All eight of the pictures downstairs at Woodstock Street, with exotic butterflies placed in the thick bright single-colour gloss of the paintings, were bought by Karsten Schubert's ex-partner Richard Salmon, for £1,000 each. As an indication of the fame that was destined to be Hirst's: in May 2007 *Beauty Is in the Eye of the Beholder*, a circular yellow butterfly picture from this 1991 show, sold at auction in New York for $1,160,000.

When the artist-run space City Racing, in Lambeth, closed in 1998 after ten influential years, two of its five founders, Paul Noble and Keith Coventry, joined established contemporary dealers and became internationally collected. City Racing's ground-breaking shows in their appropriated premises included Lucas's solo exhibition *Penis Nailed to the Board* in 1992, and a Gillian Wearing show in 1993 that included *Take Your Top Off* (1993), as well as the first appearance of her *Signs that say what you want them to say and not signs that say what someone else wants you to say* (1993).

Whilst Hume, Landy and Davenport were the first amongst the *Freeze* artists to exhibit in a commercial gallery, it was Fiona Rae who won the race to establish representation by a West End dealer. Rae, a painter of colour-rich, non-linear abstract canvases, had a solo show at the Third Eye Centre in Glasgow in May 1990, curated by Andrew Nairne and accompanied by a booklet illustrating more than 50 of the artist's drawings, and the following year an established dealer in Cork Street, Waddington's, gave her a one-person exhibition titled *Playing for Time*. The respected contemporary art critic Stuart Morgan, commissioned by the dealer to write the catalogue, likened the facility of Rae's painting to a juggler introducing pretend mistakes in his routine and skilfully overcoming threatened disaster: 'Don't forget that the elaborately witty play on problems of intention and accident, the doleful suggestion of letting things go to rack and ruin before trying to pull them into some shape, the perpetual straw-clutching, are all part of the act.'

Meanwhile, over the half-dozen years following Hume's first mixed show at Karsten Schubert in the winter of 1988, the dealer presented two individual exhibitions of the artist's work, in July 1989 and July 1991 (see p. 88), and included pieces by him in six group exhibitions: in February 1990, February 1991, March 1992, August 1992, May 1994 and April 1995. Interviewed by Suzanne Cotter in 2008, Schubert said of Hume's paintings: 'People were with them from the word go. There was no hesitation. Hume was right up there.' Landy was more problematic, tending to create shows that were difficult to sell, such as his third and final solo exhibition with Schubert in 1993, under the title *Warning Signs*. Schubert had been generous to Landy in the early stages, letting him use the gallery's basement as a studio, and the two have stayed in contact ever since. Gallaccio also had her first commercial exhibition with Schubert, placing in

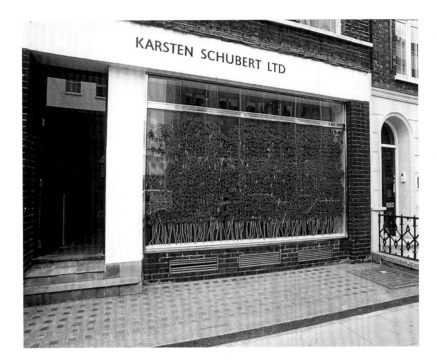

Photographed from the street, the window of Karsten Schubert in Charlotte Street, Fitzrovia, in 1991, exhibiting *preserve 'beauty'* by Anya Gallaccio.

his window in Charlotte Street in 1991 her *preserve 'beauty'*, comprising 800 red gerbera flowers on long stalks, pressed between two sheets of clear glass, where they slowly wilted and turned brown. The gerbera is a greenhouse hybrid produced exclusively for internal display, a fact which, as the years pass and environmental issues grow in relevance, assists this work to gain in power, through Gallaccio's regular revivals in different forms. At a Tate showing in 2010 of *preserve 'beauty'* Gallaccio said: 'The sense of longing and loss was always in my work ... that idea of an object that you can't possess and something that's quite intangible.'

Although Rachel Whiteread has kept herself distinct from the Goldsmiths group, her public achievements have been instrumental in the rise of this generation to market power. Whiteread had her first solo show in 1988 at the Carlyle Gallery in Islington, a critical success that produced no sales. In preparing for the exhibition of *Ghost* at the Chisenhale Gallery in 1990, she made frames, taught and did all kinds of extra things to pay her way. Widely praised, the work was bought by Saatchi, and Whiteread was almost instantly sought after by other collectors, in part owing to Hirst's generous enthusiasm in bringing people round to her studio. Whiteread was pleased to feel less isolated, content to be associated in the public's mind with this group. She did become, for a period, one of Schubert's artists, and her West End defection to Anthony d'Offay was a serious blow. Furious at the loss of his top-earning artist, yet powerless to stop her going, Schubert vented his anger one night by urinating through his rival's letter box! Schubert had also done his best to secure Hirst for the gallery, but the artist was already developing different long-term plans.

Rachel Whiteread has been, since childhood, a collector of postcards. These she uses in preparation of sculptural projects and also works on as objects in themselves, the small images retaining many of the same qualities as her major pieces – as in this National Trust postcard of 1985 of Hardwick Hall (an Elizabethan house in Derbyshire), hole-punched by Whiteread in 2009.

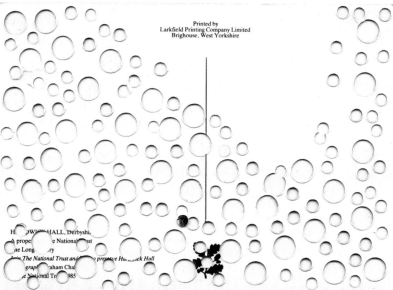

In the summer of 1991 Prue O'Day, an early fan of the yBas, mounted at her gallery at 255 Portobello Road the exhibition *Show Hide Show*. Work by Abigail Lane, Jake Chapman, Alex Hartley and Sam Taylor-Wood was curated by Andrew Renton, who now directs the Cranford Collection of contemporary art and, until recently, taught at Goldsmiths. Jake Chapman had just completed his sculpture studies at the Royal College, where he was in the year above Gavin Turk, and had yet to form a working partnership with his elder brother Dinos. In *Show Hide Show* Chapman exhibited a series of geometric drawings in ink titled *Studies for Ronan Point* and one of a series of slatted radiator-like wooden sculptures, mounted on the wall. Taylor-Wood, Chapman's girlfriend at the time, also showed sculpture: a metal and rope barrier system around a plywood platform. Both of them were still finding their way towards what became their characteristic forms of expression. When Taylor-Wood turned to photography, she initially used her artist friends as models, placing

Abigail Lane at the centre of her own Shoreditch loft in *Five Revolutionary Seconds V* (1996). Back in the summer of 1991, Gerald Deslandes curated the show *Louder than Words* at Cornerhouse in Manchester, with the sculptural theme focused on 'nine artists who arrange found materials into a scene or narrative space', including work by Damien Hirst, already designated in the catalogue as 'courtesy of Jay Jopling Fine Art'. At the time Jopling was going out with the Californian jeweller Maia Norman (see p. 72), who soon became Hirst's partner, whilst Jopling married Taylor-Wood.

Right from the start, the dealer Maureen Paley was a committed supporter of the yBas, presenting at her gallery Interim Art in 1992 the exhibition *On*, of work by Henry Bond, Angela Bulloch, Liam Gillick, Graham Gussin and Markus Hansen. The catalogue, designed by Tom Shaw with a bright lemon-yellow cover, gave no indication of the work to be seen, reproducing instead 25 black-and-white snaps of the artists and their friends (see fig. p. 72). Paley, originally a practising artist, moved from New York to London in 1977 to study for an MA in photography at the Royal College of Art. By 1979 she was living in Beck Road in Hackney, where she rented a small terraced house from the artist-run ACME Housing Association, joining Genesis P-Orridge of COUM Transmissions, the radical Helen Chadwick, the painter Alison Turnbull and other artist tenants in the street. Abandoning her career as a photographer, Paley set out in 1984 to deal in contemporary art from home. Sunday visits to Paley in Beck Road, near the Columbia Road Flower Market, became standard practice for these young London artists, attending such events in 1988 as the occasion when Bill Furlong and Michael Archer of *Audio Arts* stretched piano wires across a room, the hall and outside beneath the railway arch, both to record and to project the sounds created by merging electronic manipulations with noises naturally present in the house and the road.

In 1992 came the yBas' first substantial group show in a commercial gallery in New York, with the influential Barbara Gladstone and her English co-curator Clarissa Dalrymple in Greene Street. From the exhibition check-list of Lea Andrews, Keith Coventry, Anya Gallaccio, Damien Hirst, Gary Hume, Abigail Lane, Sarah Lucas, Steven

Maureen Paley's small terraced house in Beck Road, Hackney, where in 1984 she founded Interim Art. The image was taken by Edward Woodman, the finest art photographer of the period, during the Artangel Roadshow of June 1985. On this occasion Paley was showing work by Hannah Collins, David Mach and Julia Wood.

Liam Gillick designed and wrote the catalogue for the first commercial show of the yBas in New York, at the Barbara Gladstone Gallery in 1992. There was no information in the catalogue about the art or the artists, who included Whiteread, Lucas, Lane, Hume, Hirst and Gallaccio; the whole-page black-and-white plates were taken from a preparatory storyboard of images. At the top of this image is an *Estate* piece by Keith Coventry, not in the show, above the photo of a Damien Hirst fish tank sculpture and the ink pad impression of Abigail Lane's buttocks.

Pippin, Marc Quinn, Marcus Taylor and Rachel Whiteread, five of the artists had exhibited at *Freeze*. Of the 11 only one, Andrews, has since slipped out of art-world sight, as she moved on to form the band Spy 51 and currently lives in north London, where she composes music and writes her entertaining 'Great Lesbian Invasion' column for *The Guardian*. The Gladstone catalogue was compiled by Liam Gillick in an unconventional form, the front cover retelling a found narrative and the internal text providing information about a number of German research institutions and discographies of the bands Joy Division and AC/DC, with no information directly about the artists. The 40 pages of part-repeating illustrations were taken from a pin-board of material put together in research for the show, including work by Angus Fairhurst, despite his absence from the final selection.

Gladstone was already a supporter of Hume's, having provided him with a studio in Rome for several months during 1990, on the walls of which he worked directly with local pigments to 'fresco' several pairs of single-colour doors. In a paint-your-own-Hume gesture, viewers could purchase wall measurements, pigment formula and painting instructions for the pieces! This was part of a Gladstone/Westreich project in which a succession of international artists were invited to stay for three months,

free, in their studio in a mews in the Trastevere district of Rome, permitted to do whatever they wished in the large working space, with an internal staircase leading to the apartment above. The 12 artists selected were those who, in Gladstone's view, would make the best creative use of this opportunity. The project began in 1989 with the American photographer Cindy Sherman and her husband, the French-born video artist Michel Auder, and ended in the autumn of 1991 with the German polymath Reinhard Mucha, including on the way the respected figure of On Kawara as well as young Gary Hume, the only Englishman. Encouragement of this kind is of inestimable value.

Full credibility in the market place is dependent on exhibition at major institutions and, ultimately, on acquisition by public collections. Soon after the outset of their careers, the Goldsmiths group was exceptionally fortunate in both these respects.

Already in 1990 Davenport and Hume were selected for *The British Art Show* at the Hayward Gallery on the South Bank – along with Andrews, Julian Opie, Rae, Whiteread and others. One of the curators, Caroline Collier, wrote in the catalogue: 'Art is part of a complicated web of experience and isn't a hermetic activity, separate from the variegated happenings, trivial and profound, that make up the texture of our lives.' The following year, at the Serpentine Gallery in Kensington Gardens, the yBas were awarded a major institutional show to themselves, *Broken English*, curated by Andrew Graham-Dixon, known at the time for his television programmes on contemporary art. His selection included the ex-*Freeze*-ites Bulloch, Davenport, Gallaccio, Hirst, Hume and Landy, who were joined by Sarah Staton, a graduate of St Martin's School of Art, and Rachel Whiteread, who had studied at Brighton Polytechnic and then the Slade School of Art in London. Graham-Dixon felt that the work he chose demonstrated a generational desire to break free from

After being included in a small show in New York in 1989 at the Lorence-Monk Gallery, the following year Gary Hume was offered the use of Barbara Gladstone's studio in Rome, where he 'frescoed' these doors directly onto the wall. In 1991, when Matthew Marks founded his gallery, work by Hume was included in the opening show. Marks has represented Hume in the USA ever since.

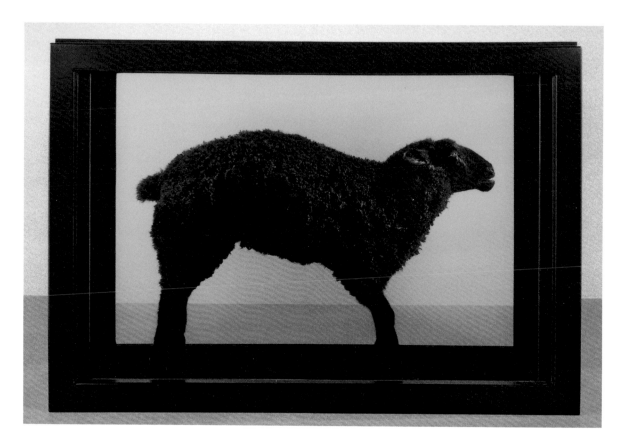

Damien Hirst has regularly reused ideas in a variety of related forms. His headline-catching *Away from the Flock* at the Serpentine in 1994 became in 2007 *Black Sheep*, of similar dimensions and pose.

the parochial concerns of earlier modern British painters, architects and composers, most of whom were over-influenced by classical images of the Arcadian landscape. 'These artists have found, in the wreckage of the modern art tradition, not a dispiriting ruin, but a source of stimulation,' Graham-Dixon wrote. 'They have not been discouraged, but provoked, by the multitude of languages available to them. They recognize the fragmented nature of their inheritance and find an alibi in it for their own freedoms.' He was aware, however, that although they spent social time together as well as helping out in each others' studios, these were highly individualistic producers of artwork, united in friendship rather than aesthetics. Lucas captures the reality of these heady times in describing relationships themselves as a form of artistic collaboration, and also in finding important the plain companionship of having a partner on the soul-destroying social rounds of the London art market.

In *Broken English* Hirst exhibited *Isolated Elements Swimming in the Same Direction for the Purpose of Understanding*, comprising 37 different species of fish bought one morning from Billingsgate Market, suspended in individual tanks of formaldehyde and ranked nose to tail on shelves behind sliding glass doors. The artist again signalled his delight in confusion and controversy: 'I really like these long, clumsy titles which try to explain something but end up making things worse, leaving huge holes for interpretation.'

With enviable self-confidence, Hirst, not yet 30 years old, approached the Serpentine with his ideas for curating another show, which he called *Some Went Mad, Some Ran Away* ..., adapting the title of Fairhurst's solo show of 1991 at Karsten Schubert's, based on his essay of 1989, 'Some Went Mad, Some Ran Away, the Great Majority Remained Faithful unto Physical Death'. The exhibition opened in London in the summer of 1994 and moved later in the year to Helsinki and then to Hanover, before ending up in Chicago from January to March 1995. Invited by Hirst to join his Goldsmiths friends and contacts were the American Kiki Smith, the German Johannes Albers and the Frenchwoman Sophie Calle, together with English artists such as Jane Simpson, whose work Hirst continues to admire 20 years later. The 'star' piece of the show was Hirst's own *Away from the Flock* (1994), a black-faced Suffolk lamb embalmed in a glass-and-steel case of formaldehyde, over which an objector managed to throw black ink, resulting in the kind of tabloid attention seldom accorded contemporary art. The American curator and art historian Richard Shone wrote an introductory essay to the catalogue, in which he described Hirst as being 'in an enviable position, riding freely through the grasslands of art, finding nutrition in the company of his kind ... He shows us the melancholy results of prescience, the decay that follows birth, violence after order.'

Unexpectedly, in the South Bank touring show *Wall to Wall* of 1994, curated by Maureen Paley, of the 19 artists exhibited, only two – Bulloch and Patterson – were from the Goldsmiths group; the ubiquitous Gillick, however, again wrote the catalogue.

By 1995 the yBas were being shown regularly abroad. In March 1995 the Kunstforeningen in Copenhagen presented *Corpus Delicti*, the ten young British artists selected including Collishaw, Fairhurst, Lane and Lucas. In October the circus moved to Minneapolis with *'BRILLIANT!' New Art from London* at the Walker Art Center, which transferred to Houston in the spring of 1996. With Gillian Wearing, Steven Pippin, Chris Ofili, Georgina Starr and Glenn Brown joining the established crew of artists, Neville Wakefield wrote in the newspaper-style catalogue: 'Cultural pessimism has been transformed into conceptual energy, boredom into the impetus for action and provocation.' Separately interviewed for the catalogue, the 22 individual exhibitors revealed healthily divergent points of view. Hirst spoke about his spot paintings:

In the mid-1990s Angus Fairhurst shared a studio in Clerkenwell with Sarah Lucas. They were both amongst the ten artists selected to exhibit in *Corpus Delicti* in Copenhagen in March 1995. The catalogue to the show illustrates a little-known version of a series of Fairhurst photographs – in this case a form of self-portrait, with dyed blond hair.

> I come from Leeds, where people have the idea that you paint how you feel. If you're depressed, you do a big brown and purple painting. If you're happy, you do a red and orange and pink painting. If you're blue, you do a blue painting. So I just created a structure that doesn't allow that to work. No matter what you do, if you're working within the structure – which is quite scientific, a grid with evenly spaced dots – you always get a happy-looking result. It was the idea of art without the *angst*.

Landy, on the other hand, acknowledged feeling a political and a personal anger: 'People don't seem to have ideas and there's no real ideology any more. There's just a middle ground where everyone seems to be huddling.' 'Often I think of my work in terms of breathing,' Adam Chodzko said. 'What happens in the gap between the inhalation and the exhalation? Life or death. And I think the art object happens in that gap. It's a very weird void.' Fairhurst expanded on his approach to making art:

> You can't always explain everything. That's not even what people want. You have to keep trying to make things and show their edges. The edge becomes the important part, the part that allows people in ... making art in the twentieth century has been about showing the edge, about removing artifice, removing illusion. It's the end of dissimulation, if you like.

In London the major public show of 1995 for the yBas was *Minky Manky*, at the South London Gallery, curated by Carl Freedman, which showed work by Collishaw, Gilbert & George, Lucas, Pippin, Hume, Emin, Hirst and Critical Decor. A major exhibit was Emin's *Everyone I Have Ever Slept With 1963–1995*, a blue, bell-shaped tent embroidered internally with the names of all the people with whom the artist had shared a bed, beginning with her twin brother, Paul, and ending with Freedman, her partner at the time. The piece was destroyed in the warehouse fire in 2004 at Momart, where the Saatchi collection was stored. For the catalogue Freedman first transcribed interviews with each of the artists and then asked himself questions. Despite being at the centre of yBa life in the early 1990s, socially and artistically, Freedman described himself as 'quite bored' with the public attention. He saw 'the new generation thing as more or less a *fait accompli*', with yBa 'exhibitions happening all over the world'. For him it was the art, not 'the hoo-hah', about which he was passionate: 'It's that passion which was an important part of curating *Minky Manky*.'

For many others, involvement with contemporary art is more a matter of finance and fashion than of passion. This is seldom true of the artists themselves, even for those who make a great deal of money. In a recorded conversation at the ICA in January 1992 with his novelist friend

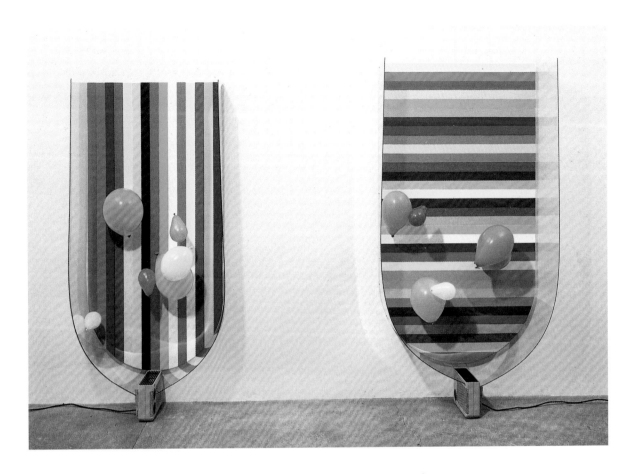

Gordon Burn, Hirst said: 'I find the money aspect of the work part of its life. If the art's about life, which it inevitably is, and then people buy it and pay money for it and it becomes a commodity and manages still to stay art, I find that really exciting.' Others dislike art-market commercialism and, if fortunate enough to be represented by a good dealer, leave it to her/him to handle all of this. Most artists produce objects that they need to sell and feel they have little choice but to join the market merry-go-round, in some form or another. In the early 1990s the Goldsmiths group were in a position to bypass the established market structure and operate instead through artist-run exhibitions. They chose not to, in part because the most enterprising of them, Damien Hirst, did not wish to give up his own creative ambitions in order to organise the commercial side of things for his friends. By 2000 they were fully absorbed within the system.

There are signs by now, owing to economic decline and to doubts about some of the art itself, that buyers are losing their zest for the contemporary. Indeed, it looks as though market manners may – sadly – turn towards the establishment status quo. All the same, the art market does appear to have made some kind of shift, thanks to the ambition of students in Glasgow and London in the late 1980s and early 1990s. Whilst tradition survives, the possibility of doing things differently exists.

At *Minky Manky*, curated by Carl Freedman at the South London Gallery in the summer of 1995, Damien Hirst exhibited *A Celebration at Least* (1994), a pair of works in which coloured balloons were kept aloft by blown air.

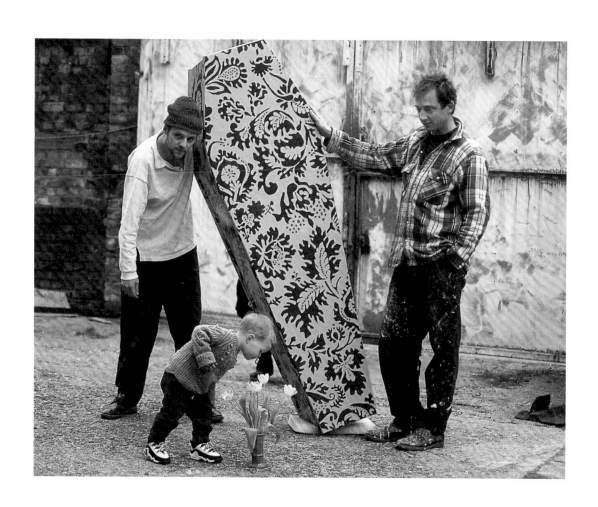

3 / ART LIFE IN SHOREDITCH

One of the myths which has grown up around this Goldsmiths genera-
tion of British artists is that they lived, worked and exhibited together
in east London, which consequently became a hub of creative activity.
This is incorrect on at least two counts: most of the leading artists of the
Goldsmiths group have never been based in the East End; and at notable
periods in the past, other artists had already made studios in semi-indus-
trial buildings in Shoreditch and neighbouring boroughs, participating in
the life of local communities with a curiosity lacking in the invasive art
take-over of the late 1990s.

After the close of *Freeze* in 1988, Hirst, Collishaw, Lucas, Bulloch
and Patterson remained south of the river, using the exhibition building
as their studio for a while. By 1990 Hirst had moved to Jacob Street,
Bermondsey, making his studio in a building he shared – at a pepper-
corn rent – with Gallaccio, Fairhurst and Davenport. In the early 1990s,
after living for a while in Carl Freedman's late Victorian terraced house
on the site of the old gasworks in Greenwich (later bulldozed to build
the Millennium Dome), Hirst set up home in Brixton, close to where
Jay Jopling lived, the Old Etonian who soon became his dealer. In 1991
one, only, of these five Goldsmiths artists – Hume – lived and worked in
Shoreditch, in a 1950s' machine shop at 11 Hoxton Square. Lucas, howev-
er, did share this studio for a time, until she got together with Fairhurst,
who had a studio in Shoreditch in the early 1990s before moving to an-
other in Clerkenwell, both of which Lucas used. Gallaccio and Hirst had
their studios in Bermondsey, Landy's was in Clapham and Bulloch had
meanwhile set up her studio in Bagram Wharf, on the south bank of the
Thames at Rotherhithe.

Other artists were ahead of Hume in their eastward shift, nota-
bly the Beck Road residents Helen Chadwick, Maureen Paley, Genesis
P-Orridge and others. In Hoxton, closer to the City, the canyon of poly-
chrome brick furniture factories in Charlotte Road, with their double
doors opening to hinged platforms and rising up to iron derricks, of-
fered attractive spaces to artists, particularly on the upper floors, where
the sculptor Mick Kerr and a group of artist friends worked from the
mid-1980s under the joint name of Globe. Julian Opie, a Goldsmiths
graduate of 1982, was another early-comer, with a studio a few hun-
dred yards south of Charlotte Road, on the other side of Great Eastern
Street. His tutor, Michael Craig-Martin, also had a studio off Old Street
for a time.

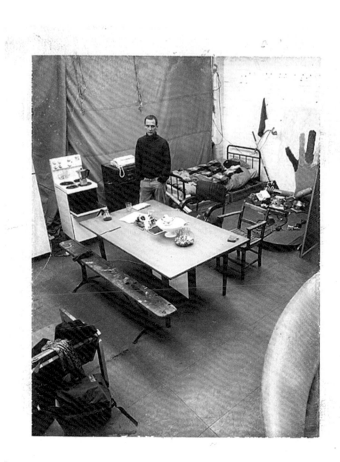

A faded Polaroid from 1991 of Gary Hume in the living section of his studio at 11 Hoxton Square, an unheated 1950s' machine shop which was demolished ten years later. The iron bed, surrounded by children's toys, was Hume's son Joe's on the nights when he came to stay. The working studio was through the far side of the tarpaulin, behind the cooker.

Artists in other fields fuelled the spirit of things. The then struggling fashion designer Alexander McQueen lived and worked in Shoreditch long before he and the district made their names – his suicide in February 2010 was registered by colleagues in the area as a sad artist loss. In sculptural terms, the most significant East End event – at the time and in retrospect – was the creation by Rachel Whiteread of *House* (1993), through the patronage of Artangel, James Lingwood's enlightened foundation specialising in architecture-based projects, with whom Whiteread had been discussing her plan since 1991. Together with sponsorship from Beck's, the German beer company, and valuable supportive work by the dealer Karsten Schubert, the artist obtained on 2 August a temporary lease on 193 Grove Road, Bow, the last house standing in a condemned Victorian terrace. Under the overall supervision of building technicians Atelier One, Whiteread proceeded to construct a concrete cast of the inside of the whole house, room by room, giving shape to the negative space of generations of family life. Already the subject of furious debate amongst the councillors of Tower Hamlets – Councillor Eric Flounders, Chair of the Bow Parks Board said, 'We will be brave enough to ignore the fusillade of froth from the arts lobby and remove the monstrosity as soon as the contract allows' – the sculpture was completed by the end of October, when dismantling of the scaffold and tarpaulins attracted thousands of visitors and hundreds of column inches of press comment. The smooth sides of the piece also drew competing graffiti, with 'WOT FOR' and 'WHY NOT' providing appropriate summaries of the contrary arguments. Whiteread confirmed that *House* was in part a political statement, intended to arouse strong public feeling. Andrew Graham-Dixon understood that with this work 'the artist has asserted her right to construct her own world out of the materials of this one, to make a fantasy real and palpable'. Works of art exist primarily in felt memory, this piece solely so, for it was soon demolished and the site grassed over.

Whiteread has always been a self-contained maker of things, who seldom participated in public performances. She did not, therefore, contribute to the parade of street art events that emerged from the fertile

mind and physical energy of young Joshua Compston, the founder in 1992 of Factual Nonsense at 44 Charlotte Road, in the Shoreditch Triangle. A recent graduate in Art History from the Courtauld, Compston succeeded in garnering the support of dozens of the yBas to lend heads and hands to the various enterprises generated at Factual Nonsense until his death in March 1996. Compston's story admirably illustrates the yBas at creative play, an antidote to the popular image of mindless debauchery. Given the fashionable bloom of Shoreditch today, it is an effort to remember how neglected the area was in the early 1990s. There were no smart bars or ethnic coffee shops in the Triangle, no galleries in Hoxton Square, no loft flats and not a sign of a delicatessen for miles; the Bricklayer's Arms and the Barley Mow were still the traditional East End drinking spots they had been for decades. In retrospect, it can be seen that Factual Nonsense's wild street events were a catalyst for in-crowd attention to the stylish Victorian furniture factories that dominate the Curtain Road district, half empty, unwanted, big, beautiful and cheap. FN led the move, for not until four years after Compston's death did White Cube expensively convert a publisher's warehouse in Hoxton Square into one of London's major modern art galleries, at the same time as droves of internet designers and commercial video makers set up offices near by, and the 'night-time economy' of south Shoreditch exploded.

In these years before pursuit by the press, the yBas were their own audience. Some of the most memorable semi-private activities at this period, in which dozens of young artists were involved at one time or another, were organised by Imprint 93, set up by the artist and curator Matthew Higgs, at the time a kind of punk conceptualist, whose mimeographed announcements were posted out to a list of approximately 200 regular recipients. Some missives were single-sheet statements to accompany an event, others were card invitations and some were longer graphic pamphlets, such as their 43rd project, *Black* (1997), by Chris Ofili, which comprised 12 pages of photocopied newspaper clippings of reports of violence committed in London against black people. Imprint 93 material was always economically printed/Xeroxed, stapled not stitched, and no less effective for this. Fiona Banner's *36 STOPS* (1999) worked especially well: 36 plain black punctuation marks, gigantically enlarged, printed one a page with a list of the 36 types in red on the back. Participation by this generation of artists in inexpensive and yet time-consuming group activities is indicative of their approach to making things, even at a time when already receiving substantial public attention: Ofili won the Turner Prize in 1999, and Banner was short-listed in 2002.

Joshua Compston was temperamentally inclined towards louder statements. A year before the opening of Factual Nonsense in November 1992, he had organised an ambitious exhibition in has final undergraduate year at the Courtauld, including substantial pieces by the *Freeze*-ites Rae, Hirst, Hume and Davenport. When Compston then moved to

Chris Ofili standing in a Charlotte Road doorway holding the painting he made at Mick Kerr's stall Paint a Plank, during Gavin Turk's *Live Stock Market* in 1997. Like the cover of Ofili's *Black*, published the same year by Imprint 93, the lettering is in black on black.

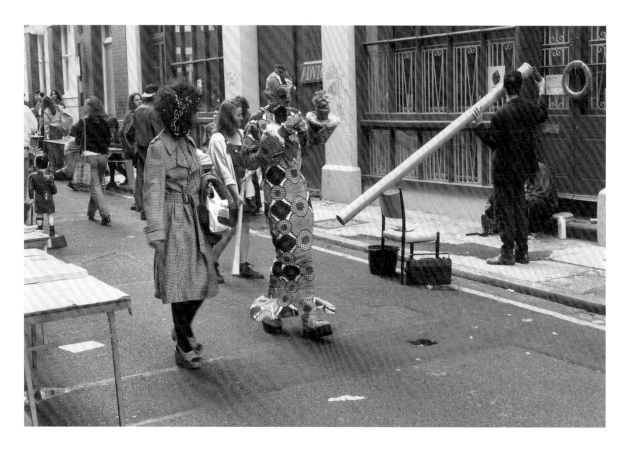

Preparations in Charlotte Road, Shoreditch, for the first *Fête Worse Than Death*, organised by Joshua Compston in the summer of 1993. Walking down the road are Gillian Wearing and her creation for the day, the *Woman with Elongated Arms*, while on the pavement Gavin Turk erects his *Bash a Rat* stand.

Shoreditch, he and Hume became friends. Despite the difference in art-market reputation and age – Hume was eight years Compston's senior – it was often the younger man who made the running, persuading the painter to participate in fantastical projects which tended to make no sense in advance and yet ended up being both fun and inspiring to be involved with.

It was the first *Fête Worse Than Death* in 1993 that secured Compston his place in the affections of this group of artists. His idea was simple: hire 50 trestle tables, place them down either side of the pavement in Charlotte Road, rent out the 'stalls' for a nominal sum to artist friends, persuade others to provide music, food and street entertainment, stoke up studio imaginations during the preceding weeks and on the day itself cheer on competing extravagances of invention – with the extra enticement of traditional fairground booths in the tram shed and all-day opening of the corner pubs. There were wonderful sights. Gillian Wearing arrived dressed in a schoolgirl's uniform, accompanied by the masked and diaper-sheathed *Woman with Elongated Arms*, whose paid-for hugs were recorded by the artist in Polaroid snaps. Emin and Lucas set up a stall for *Essential Readings*, unorthodox tellings of the future from the palms of passing hands. John Bishard and Adam McEwen, immaculately pale, in crew cuts and cream shirts, sold for 20p *Advice About Absolutely Anything*. Despite provocative questioners queuing to break the artists' deadpan

commitment, they never released the chink of a smile – crowds formed to gape and listen, giggling at the humour of the responses. At the next-door pitch Gavin Turk offered fairgoers the opportunity to *Bash a Rat*: down an angled grey plastic drainpipe he slid a notional rat, made of old socks, which they invariably failed to bash with a baseball bat as it came out, their aim skewed by the *Tequila Slammers* supplied at the stall opposite, dispensed by a man wearing a straw sombrero: Hume, impersonating a Mexican bandit.

And throughout the afternoon a loudly costumed pair of white-faced clowns with broad red lips hired out their spin-painting equipment at £1 a go, signing the punters' art with their own names: Angus Fairhurst and Damien Hirst (see frontispiece). On payment of an extra 50p they exposed themselves, revealing striped cocks and spotted balls, colourfully contrived by the jeweller-cum-model-cum-performer Leigh Bowery. 'He did us up right and proper, including our bits. We were nervous about doing the clown thing, and the genitals were a good ice breaker,' Hirst told Bowery's biographer, after the artist's death on the last day of the following year, aged 33. Their spotted balls mimicked Hirst's series of spot paintings.

In appreciation of his day and night out at the *Fête Worse Than Death* on 31 July 1993, Angus Fairhurst sent the organiser, Joshua Compston, a drawing in red biro inscribed at the top 'Josh, Many Thanks, Angus'. Fairhurst and his friend Damien Hirst had hired elaborate clown costumes for the event – with long shoes, red noses, excessive wigs, all the kit – and arranged for their faces to be made up by fellow artist Leigh Bowery, who also painted their 'bits': striped cocks and spotted balls!

Their fairground pitch was called *I Should Coco the Clown*. Delighted with the day and night's fun, three days later the pair dressed up again in the clown costumes and make-up and installed themselves in a Mayfair pub, sitting on stools at the bar telling each other a series of gruesome stories, filmed for a work which they titled *Cannibals Eating a Clown*. At the Fête they had promised a prize dinner for the 'best' spin painting, to be given at Green Street, their favourite West End restaurant at the time, up the road from Jopling's first White Cube. Fairhurst and Hirst awarded the prize to a beautiful young stranger whom they met on the appointed night in their clown costumes. The *Fête Worse Than Death* witnessed the first appearance of Hirst's spin-painting technique, subsequently developed into an enduring emblem of his studio production, housed these days in museums around the world. That the colours of these small experimental paintings were chosen by passing punters is a neat coincidence, the remnants twirled into a Pollock-like maze on the tarmac outside the Bricklayer's Arms (see p. 12), where the artists danced and drank the night away.

Both older and younger artists were invited by Compston to play in the Factual Nonsense world. While still a teenager, Compston had introduced himself to Gilbert & George, simply by knocking on the

Factual Nonsense flyer made by Compston in 1994, using an image of the Gilbert & George picture *Naked Dream* (1991), for which he had posed as the central figure.

Deal with **FN**or be dealt with

door of their house in Spitalfields – after which he became an occasional model for them, featured larger than life, naked, at the centre of *Naked Dream* (1991), one of their multi-panelled photo pieces. The next year, on 15 October 1992, two weeks before the official opening of Factual Nonsense, Compston was the youngest of 30 guests at Gilbert & George's 100th birthday party, given in a private room in a Soho restaurant on the precise day when their joint ages added up to this aesthetic figure – there were nine courses and nine different wines, concluding with a 99-year-old Armagnac.

Compston's adoption at Factual Nonsense of this then little-known group of young artists was not for commercial reasons – every event he put on lost money! – but because he loved their wild engagement with life. In advance of public appreciation, he was also aware of the qualities of their work, as was acknowledged by Emin in a booklet she published in 1996, dedicated 'For Joshua, who always encouraged me to write', a limited edition with the title *Kiss me – Kiss me Cover my Body in Love* crossed out and replaced by *Always Glad to See You*. Compston had been one of the first to publish Emin's writings, printing the whole of her story *Like a fucking dog – when the truth is hard to bear* in his what's-on-for-the-day brochure at *Fête Worse Than Death* in 1994, which concludes:

> **This story is for Margerite Girlinger – the greatest love of my Mum's life –**
> **For 16 years they'd been (as my Mum would say) MORE than just good friends –**
> **Margerite died of cancer last year –**
> **July 24th 1993.**

Collage of material relating to Factual Nonsense's *Fête Worse Than Death* T-shirts, designed by Gavin Turk, whose baby son features on the programme cover, with a helium balloon made by the artist for sale at the event. Compston wrote the 'ND (SFM)' document '(Notorious Dream [Struggle for Modernism])', and the *Fête Worse Than Death* programmes.

In another presumptuous act, Compston was the commissioning curator of Hume's very first print, a medium for which the artist has by now produced over 100 images. *Happy* (1994) was one of 15 text-based images selected by Compston for the limited-edition portfolio *Other Men's Flowers*, published by the Paragon Press. Curating this project brought Compston into professional contact with a host of young artists, his final choice of contributors being, in alphabetical order: Henry Bond, Stuart Brisley, Don Brown, Helen Chadwick, Mat Collishaw, Itai Doron, Tracey Emin, Angus Fairhurst, Liam Gillick, Andrew Herman, Gary Hume, Sarah Staton, Sam Taylor-Wood, Gavin Turk and Max Wigram.

The second *Fête Worse Than Death*, in 1994, expanded massively in scale to take over Hoxton Square, with a substantial printed programme and Turk-designed T-shirts for the stewards. Billed by Compston as a 'Hybrid "Pop Culture" Extravaganza', from three in the afternoon until after midnight 'a rolling magic carpet of music and performance' was presented on the main stage in the Circus Space courtyard, with one-man shows including Cerith Wyn Evans's *People Should Beg God to Stop* and Gavin Turk's *Killers and Cannibals*, in which, wearing lipstick and mirror shades, Turk mimed to David Bowie's song 'Scary Monsters', while excreting artificial sausages from his false bottom, a string of real sausages cling-

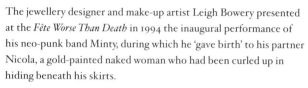

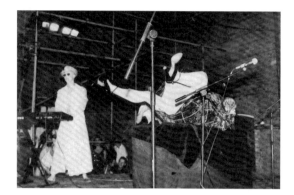

The jewellery designer and make-up artist Leigh Bowery presented at the *Fête Worse Than Death* in 1994 the inaugural performance of his neo-punk band Minty, during which he 'gave birth' to his partner Nicola, a gold-painted naked woman who had been curled up in hiding beneath his skirts.

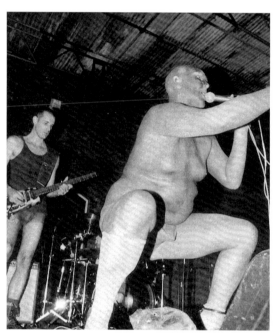

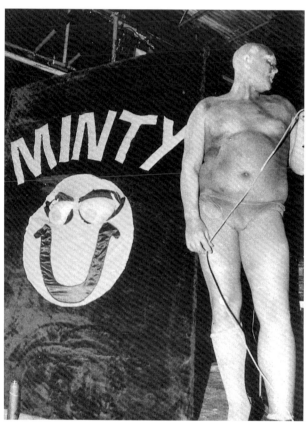

filmed across his stomach. The highlight was the riotous public première of Leigh Bowery's neo-punk band Minty, during which the artist gave birth to a gold-painted naked woman, concealed until the revelatory moment within the belly of his sequinned stage costume. Compston's own favourite art band was the Ken Ardley Playboys, which performed at most Factual Nonsense events, run by the artist Patrick Brill, an MA graduate in 1993 from Goldsmiths, who calls himself Bob and Roberta Smith. By now, Brill's colourful placards with their subversive slogans have found their way into the Tate, Southampton City Museum & Art Gallery, the Michael Goss Foundation and other national collections.

The best-known of a slightly younger generation actively to involve themselves with the Factual Nonsense project were Tim Noble and Sue Webster, who moved from Nottingham to London in 1992 to study for an MA in sculpture at the Royal College. They were assiduous in involving themselves in the art scene, turning up – invited or not – at all the private views, live-working from 1995 in one of a run of small-scale

Tracey Emin's contribution to the *Fête Worse Than Death* in 1994 was a game she invented for Hoxton Square called Rat Roulette, with which she was assisted by the printer Tom Shaw. The victim was seated on a swivel chair at the centre of a segmented circle, a rat mask placed over their head and a bamboo pointer in their hands, and the chair sent spinning. When it came to rest, the player was given a prize according to the segment pointed to. Each one was made by Emin herself, such as a cigarette packet with ears (see p. 20).

workshop buildings in Rivington Street, on the way to Old Street Underground from Charlotte Road. Their first FN appearance was in 1994, at the second *Fête Worse Than Death*, when they exhibited a life-size colour flat of Gilbert & George, into the oval cut-out heads of which punters poked their own faces to be photographed. A printed image, with their own heads, they captioned 'Everything you have ever done since the day you were born was because you wanted something.'

Factual Nonsense's summer event of 1995, *The Hanging Picnic*, held on a beautiful July Saturday in Hoxton Square, was filmed by London Weekend Television. The accompanying leaflet for the event was emblazoned with characteristic Compston phrase-making: 'COME AND WAVE TO YOUR FRIENDS AS THE REAL BECOMES IMAG-INED! COME AND BE ON TV! FN: NO FUN WITHOUT U & FUN CAN SERIOUSLY MAKE YOU FN!' The cover featured Hume's *Jammy Boots*, a colour close-up of his bare feet covered with strawberry jam, and around his ankles slices of white bread secured by masking tape, like puttees. Placed on the concrete in front of his left big toe was a wrapped loaf of Mother's Pride. The photograph was taken by Shoreditch resident Anthony Oliver and choreographed by Compston. In another in-art twist, the notices on the

A postcard by Tim Noble and Sue Webster, of themselves sticking their heads through the cardboard cut-outs of Gilbert & George which they made for Compston's *Fête Worse Than Death* in 1994.

Gary Hume posed in the yard attached to his studio in Hoxton Square, for a shot devised by Compston for the cover of the *Hanging Picnic* brochure, Factual Nonsense's televised event of 1995. Titled *Jammy Boots (Version 1)* (1995), Hume's feet were covered in jam and loaves of bread taped to his ankles, like old-fashioned military puttees.

Portaloos for the picnic were designed by Mat Collishaw. Two local policemen on duty for the day, their presence redundant, entered into the spirit of things by tying striped red-and-white 'No Entry' tape between a lamppost and the railings and labelling their art work *Roped Off Area*.

Webster and Noble acted separately in their contributions to *The Hanging Picnic*. Webster hung on the old black railings a photograph of herself with her head stuck impossibly between the solid iron uprights, printed life-size and placed exactly in the spot where the photograph was taken … magic! Noble's piece involved nailing a white-painted bird's nesting-box high on the trunk of one of the plane trees, with hidden wiring to enable it to play a constant barrage of crow-like squawks. At least that's how it at first appeared – as *The Daily Telegraph* art critic Richard Dorment explained in his column: 'Only gradually do we realise that the irritating noise is actually a stream of recorded obscenities manipulated in such a way that every once in a while a single swear word can be heard clearly.'

During the second half of the 1990s the Shoreditch scene gained recognition within wider art circles. But although art critics had started to review Factual Nonsense events, the principal beneficiaries of Comp-

ston's convictions were the artists themselves. They performed for each other, together made their own fun, as yet oblivious to public reaction. And other artists joined in. The painter Lucian Freud, for example, turned up at the Barley Mow in Rivington Street to watch a provocative performance by his friend and model Leigh Bowery for *Factual Nonsense's First 'Party' Conference*, billed to run from 18 to 22 October 1993; on Bowery's night at the pub he served 'crushed, cloned and extruded cocktails', an indispensable ingredient of which was his own urine. The 'demure evening's drinking with Sarah and Tracey' passed without indictable incident, with special guests Albert Irvin, an older abstract painter and Royal Academician, Stuart Morgan, the critic, and Max Wigram, now a Bond Street dealer. On another evening the artist Stuart Brisley, from an earlier generation of British radicals, and Helen Chadwick, the inventive artist, were billed to join the dealer Maureen Paley for a 'splendid Quiz Night'.

The Factual Nonsense years were a time of pre-fame freedom, when Turk, Hume, Emin, Hirst and the rest were offered by Compston elusive ideas to play with in public. As Emin wrote in an obituary of Compston in *The Big Issue*: 'He went to extremes, of generosity, of

A queue of artists formed outside Christ Church, Spitalfields, to pay their last respects to Joshua Compston before his memorial service. Albert Irvin holds the strap of his haversack, with Gilbert & George a few steps behind in their double-breasted overcoats and, near the back, the draughtsman Adam Dant and the printmaker Allen Jones.

bringing people together, and within the vision of art. That's why he was loved so much.' By the time of his death by his own hand in March 1996 Compston's artist friends had already started to build a public reputation – for wild behaviour as well as for provocative art. Hume points out that they were invited out to fashionable dinner parties with the implicit expectation that they would behave outrageously. 'So you behave badly because it's expected of you. And the next day they can all enjoy their "grown-up" gossip and giggle. While we forget about it and get on with our work.' A record of these party nights was published by Johnnie Shand Kydd in *Spit Fire*, black-and-white snapshots of the years 1996 and 1997, in the earliest of which, at Fairhurst and Lucas's shared studio in Clerkenwell Road on 5 March 1996, Compston appears. This was the night before he died. He was not found for three days, stretched out on the plank bed above his picture store in Charlotte Road, killed in his sleep by inhaling fumes from a spilt bottle of liquid ether which he had salvaged a year earlier when he broke in to the derelict German hospital in Hackney.

These young British artists knew how to make memorable a public occasion. Compston's coffin was painted by Turk and Hume, adapting a William Morris wallpaper design to which Fiona Rae, Georgie Hopton and Deborah Curtis had also contributed their ideas. Accompanied by a jazz band, the funeral cortège passed on foot through the Shoreditch streets, the coffin carried by an alternating troop of male artist friends, concluding with a memorial service at Nicholas Hawksmoor's magnificent Christ Church, Spitalfields. Gilbert & George, who have lived 100 yards around the corner from the church since 1969, were amongst the hundreds who paid their sorrowful respects at the coffin outside the church.

Months before his death, Compston had been described as a meteor, moving very fast and burning very bright, but in danger of extinction. Too much drink and drugs threatened the careers of several of the yBas, and yet they have mostly survived, holding to a central concentration on the work that they wanted to make. The fact that they have been able to sustain, for over 20 years, the desire and the ability to make things is one definition of being an artist. The lasting connections are obliquely illustrated by the fact that Compston's premises in Charlotte Road are now the Carl Freedman Gallery, from part of which Freedman's Counter Editions operates, publishing and selling original editions of work by, amongst others, Emin, Landy, Wearing, Lucas, Hume, Collishaw, Taylor-Wood, Whiteread, Ofili and Turk.

In memory of Factual Nonsense, Gavin Turk laid out artists' stalls and pitches along Charlotte Road and Rivington Street in organising in August 1997 a day-and-night street event which he called the *Live Stock Market* – the livestock being the people, the live stock their art of performance, and the market a free street party. Scores of artists gathered to reinvent the exponential fun of an FN day. Turk designed and printed his own Bull notes, which punters exchanged for pounds between the bars

of Factual Nonsense's old window. The artists' stalls were especially inventive: the sculptor Cedric Christie, who lived in Charlotte Road at the time, as did Turk, borrowed a cow and its calf from the East End community farm, marked out a pen in numbered squares and invited passersby to guess on which number it would next shit; Sean Dower wandered about in a chef's hat and butcher's apron, carrying a tray from which he sold 'Senseless Subliminals'; and Webster and Noble did roaring business in painted tattoos. Wearing and Landy worked all day making composite Polaroid portraits of people, Wearing taking the photos and Landy putting them together according to the punter's choice. The price rose from the initial £5 to £8, ending up at £15 – as Wearing said, tired but satisfied: 'We've really started to get somewhere with these!' As a mark of the popularity of the yBas by the later 1990s, nearly 10,000 people are estimated to have attended this street event, all of them obliged to pay in Bulls, the only currency accepted not only by the stallholders but also by the Bricklayer's Arms, Barley Mow and the Cantaloupe bar, all of whom did more business than they had ever done before in a single day.

In his singular language the young Joshua Compston had captured in his press release for the *Fête Worse Than Death* in 1994 something of the essence of this way of being an artist: 'An exciting and tumultuous one day event to be held in the open air composed of the multifarious talents and glamorous possibilities created by combining a selection of Britain's hottest visual arts practitioners.'

Gavin Turk's *Betrayal of the Image*, made in September 1996, on a fortnight's fellowship to the art institute at Schloss Morsbroich, in Leverkusen, his first work after the death of Joshua Compston. The title is René Magritte's actual name for the work now universally known by its inscription, 'Ceci n'est pas une pipe'.

4 / ANYA GALLACCIO

Anya Gallaccio was one of the few members of this Goldsmiths group not to take an active part in Factual Nonsense's street events. Nor was she in the shows *Gambler* or *Modern Medicine*, put on by Carl Freedman and Damien Hirst in 1990 in Building One, Bermondsey. She remains, however, close to the centre of their circle, and spoke movingly on behalf of Angus Fairhurst's artist friends at the Tate's wake in 2008, and – for instance – attended, along with Tracey Emin and others, Freedman's 40th birthday celebrations in Marrakech in 2005.

In order psychologically to survive the precariousness of creativity, some element of control is required in the making of art works, at the very least in the development of individual methods of execution – even the adoption of a wilfully naïve technique demands, if the work is to resonate significantly, concentration and care. And, over time, all worthwhile work undergoes change, develops its own particular course of expressive growth, however slow and slim and slippery this might happen to be. Or wild and violent. The trajectory is unknowable in advance, sometimes taking the artists themselves by surprise, reassuring them that there is always more to achieve. An impressively articulate artist, Gallaccio expressed her feelings about making things in a tape-recording made by Bill Furlong for *Audio Arts* in 2005:

> Artists are supposed to be good at what they do and supposed to impose their will over their paint or their stones. I see it much more as a fluid thing, a relationship with the material in the way that you have a relationship with a person, and you might be able to anticipate the way they are going to respond to the situation but hopefully they will surprise you – or they should do in a good relationship ... I am just starting something off and seeing if it does something and of course sometimes you are disappointed and sometimes you are not.

Gallaccio has made very little art that can be owned and bought. Much of her work has been constructed, after extensive research, for installation at specific sites, where with the passage of time the sculptural creation disintegrates back into the natural environment. This is deliberate, an approach adopted in her earliest work after leaving art school, and followed ever since.

OPPOSITE
Anya Gallaccio outside her studio in Jacob Street, Bermondsey, in 1990–91, photographed by fellow artist Henry Bond.

Decay is an essential element in much of Anya Gallaccio's early work, memorably in her show of red gerbera flowers, *preserve 'beauty'* (1991), in the window of Karsten Schubert's gallery in Fitzrovia (see p. 35). Gallaccio has regularly made smaller versions of this piece, one of the earliest being *single red door, with key* (1994), the title of which refers to the colour of the flowers rather than the salvaged door.

She knows the reason for this decision: 'My work is very much tied to me and I've always had a terror of being possessed,' Gallaccio says, invoking what sounds like a personal, overtly sexual truth. The same danger persuades her not to produce editioned photographs or models of her large-scale work and to avoid, as far as it is possible to do so, the commodification of art. 'I just want acknowledgement now, I'm not interested in making some huge monument to myself to prove that I was on this planet,' she said already in 1996 to Patricia Bickers, the editor of *Art Monthly*. In this conversation Gallaccio also noted the risks she takes: 'I'm treading a fine line between what is acceptable and what is not acceptable. For a woman to work with flowers, for instance, is a really crazy thing, at least if you want to be taken seriously.' The major early work the artist here refers to, *preserve 'beauty'*, was made of red gerbera flowers and unveiled in the window at Karsten Schubert in 1991 (see p. 35). Although perishable, it has nevertheless been made available for sale in a number

of different forms: in 1994 she adapted a green-painted, salvaged door to frame stacked vertical rows of gerbera in *single red door, with key*; her work *can love remember the question and the answer* (2003), a pair of tall mahogany doors with small glass panels of gerbera, was bought by the Arts Council in 2005; and *Preserve Beauty (New York)* of 2003 was acquired by a collector the following year from her American dealers, Lehmann Maupin, for $22,500. In all three, the flowers are replaced for each new exhibition, the process of decomposition every time different.

The editions which Gallaccio does occasionally make are original to their specific purpose, not replicas of her installations. In 1992, exploring in divergent ways the theme of a work exhibited in Wapping, she made *Prestige #2* for G-W Press, founded and run by the London-based American collector and publisher Jack Wendler, working with the Goldsmiths graduate Liam Gillick. Gallaccio made an inked and printed text on graph paper, published in an edition of 21, and reading: '21 different drawings each presenting 0.2 seconds of time from a DAT recording of 21 whistling kettles, processed through a computer programme at Imperial College London and charted on graph paper. June 1992. This drawing represents 0.2 seconds 249.6 seconds from the beginning of the tape.' The year before, Gary Hume had made a small edition for G-W Press, of similar shape to a take-away pizza box, printed with the front pages of four European newspapers. Another early Gallaccio multiple, *Couverture*, a labelled aluminium can of chocolate and coconut butter, was published in 1994 by Filiale of Basel in an edition of 20. An example is owned by the Arts Council, one of whose curators, Andrew Patrizio, saw the genesis of this Gallaccio piece stretching back to Marcel Duchamp's painting of a chocolate grinder, more recently to Joseph Beuys's first multiple, *Two Maids with Shining Bread* (1966), which was made out of chocolate, and immediately to Helen Chadwick's *Cacao*, a vat of boiling chocolate, seen for the first time at the Institute of Contemporary Arts in 1994, two years before the artist's death at the age of only 43. Gallaccio's *Couverture* is directly connected to her installation *store*, of the same year, at Karsten Schubert's, in which the gallery walls were lined to head height in card and then smeared with Cadbury's Bournville chocolate. The smell that suffused the gallery was sickeningly sweet.

In order to finance their Gallaccio exhibition *red on green* in the Nash Room in July 1992, the ICA sold multiples in advance, to be made from the remnants of the show after it closed. Gallaccio presented a carpet of 10,000 English hybrid tea roses, the stalks separated from the heads, and for the multiples the artist decided to circumvent the tempting prettiness of the decaying roses and instead to pulverise their remains. The dust was combined with linseed oil, beeswax and Damar varnish to make green and red crayons of different sizes, slotted side by side in a black box. Gallaccio made three different versions: *two dozen roses* (1992) in an edition of ten, most of which were given to the donors

In her first version of *blessed* in Amden, Switzerland, in 1999, Anya Gallaccio draped an apple tree in the fields with 200 kilos of fruit, in homage to Otto Meyer-Amden's leadership of a small artistic community there in the mountains between 1901 and 1912.

to the show; *six dozen roses* (1993), also in an edition of ten; and *one dozen roses* (1994), in an edition of 20.

In 2003 Gallaccio produced *While reaching for Alma Ata*, adding to a series of works she has made over the years around apples and apple trees. One of these was *blessed* (1999), executed in a pasture in Switzerland, whilst in *because nothing has changed* (2000), reinterpreted as *because I could not stop* for her Turner Prize display in 2003, the life-size bronze cast of a lopped tree was festooned with bunches of real red apples, which decayed over the period of the exhibition. *While reaching for Alma Ata*, produced in an edition of six, consisted of five slip-cast porcelain apples, each uniquely hand-painted by the artist to appear to be decaying, set in a bed of curled apple-tree planings. Produced by the publishers Ridinghouse, which is owned jointly by Gallaccio's former and present dealers, Karsten Schubert and Thomas Dane, *While reaching for Alma Ata* followed a year after Gallaccio's major installation in the Duveen Galleries at Tate Britain, and coincided with her short-listing for the Turner Prize – in the pamphlet for which, one of the Tate curators, Rachel Trant, described her as a 'virtuoso of the extreme gesture'. During the same year Gallaccio made, in a longer edition, *Cast*, a handful of real English acorns and one unique cast-bronze acorn in a special box, produced by the Multiple Store in a numbered edition of 35. Gallaccio invited the buyer either to plant the acorns for the future or keep them to dry out and die or throw them away, leaving only the bronze cast.

In 2008, on exhibiting a vast reassembled horse chestnut tree at the Camden Arts Centre (see p. 154), Gallaccio was also commissioned for one of their limited editions, *Only Love Can Break Your Heart*, bronze casts of six different conkers, sold individually and as a set.

An element of Gallaccio's fear of possession is resolved through these publications of original editions, which mean that the work is never owned by a single person. The personal is, in her case, certainly politi-

In 2003 Ridinghouse produced a limited edition of six of Anya Gallaccio's *While reaching for Alma Ata*, each with five differently hand-painted slip-cast porcelain apples.

cal, but it is also in part private. Contrary to popular perception, many yBas are content to send their work out into the world to speak on their behalf, guarding their privacy at home in the studio. Whiteread has become the maestro of this method, Hirst the undisputed king of its opposite. The women in this group have tended to be more political than the men – as defined by Whiteread in conversation with Andrea Rose, who commissioned her for the British Pavilion at the 1997 Venice Biennale:

> **Everything is political in some way ... But when people ask me if I see myself as a female artist, or whether my work is in part feminist history, I don't think I'm political in that sense. I see myself as a sculptor and as an artist and I think that my mother, her mother and their grandmothers worked incredibly hard for my generation to be able to do what we do.**

Gallaccio was 16 when Margaret Thatcher first became Prime Minister, and her artwork reacted against what the Conservative Party came to stand for. And yet, in a sense, the independent stance of this group was implicated in the late 1980s' ethos of individualism – as Gallaccio acknowledged to Patricia Bickers in their conversation in April 1996: 'We weren't polite graduates who were content to wait around to be discovered. We took control of the situation. We did not wait to be invited in. I guess you could say that that is a Thatcherite idea.' Teaching art now herself in San Diego since 2007, Gallaccio is astonished by the passivity of students, slumped in flaccid expectation of being fed the answers. Recently she has noted:

There's that weird paradox. Because of the success of my particular generation, 'the Damien thing', people now go to art school thinking it is a vocational degree. Whereas when I was at art school my tutors never saw it as a job, a career. It was simply being an artist! ... I didn't get it to begin with ... Eventually I decided to accept the enjoyment of this period of mucking around, playing, whatever I was doing. Later I could worry about getting a job, earning a living!

In proof of her sense of enterprise, Gallaccio is unafraid of scale or of tackling conventional settings, working in this case at Houghton Hall, Norfolk. She made *Sybil* (2007) from copper beech hedging, by now growing to its full stature.

In the clothbound catalogue for Gallaccio's solo show *Chasing Rainbows* at Tramway in Glasgow in 1999, the curator Ralph Rugoff wrote, with acuity:

Gallaccio's entire practice involves a shift away from the creator's traditionally egocentric involvement with his chosen medium ... While she works with everyday materials, she tends to do so in absurd and fantastical quantities, littering an exhibition space with 50,000 5-Rappen coins; laying down a bed of 10,000 roses; pouring 11,000 pounds of salt under a barbed-wire instillation; spreading ten tons of stones across a pair of galleries. They are the kind of unimaginable numbers associated with fables and folk tales, and they call attention to a fairy tale-like thread that weaves a wayward path through the body of her work.

Anya Gallaccio installed giant tree trunks and a whole root ball in the Duveen Gallery at Tate Britain in 2002, in a piece she called *beat*. The water basin in the root ball was constructed by Mike Smith, with whom Gallaccio had shared a studio in the early 1990s, before he set up his art-engineering business.

In the typically contradictory way of much contemporary artistic practice, Gallaccio, in her liberated imaginings, is at the same time strictly practical and professional in her approach to each project. To help with installation at the Tate in 2002 of the root ball of a giant oak, she turned to Mike Smith, a student at Camberwell School of Art in the late 1980s with whom she had shared a studio building in Bermondsey in the early 1990s, before he turned full-time to business. In these early days, like many other artists, Smith had to subsidise his ambition to make paintings by taking part-time jobs, such as making the reinforced glass and steel tank for Hirst's basking shark in 1991 and panel-making for Hume, all of which soon took over from his own painting. In the book about his company, *Making Art Work*, which Smith commissioned in 2003, Gallaccio says: 'We all realised quite quickly that he had a big tool box and a practical mind and we always pestered him, borrowing

Several artists in this group work in open, naturally light spaces, including Rachel Whiteread, Gary Hume, Michael Landy, Sarah Lucas and, in this photograph from 2003, Anya Gallaccio, in her Delfina studio in Bermondsey Street.

tools and asking for his advice or help. I don't know, I might be wrong, but I think his business grew out of an accident really.'

Other major art operations undertaken by the Mike Smith Studio have included: building Landy's 12-foot-high shredder for *Scrapheap Services*, first exhibited in 1995; crafting the wood and glass case for Turk's life-size wax model of himself in a bath, titled *Death of Marat* (1998); and the making and installation of a clear resin cast of the vacant plinth in Trafalgar Square for Whiteread's *Monument* (2001; see p. 141). The trust which builds up through personal contact with printers, designers, framers and photographers, as well as with technicians like Mike Smith, matters greatly to the artists. 'That's how the world operates,' Landy says. 'You use someone you know. Go on doing so for as long as you can.' Dependence on services from ex-student colleagues is a practical aspect of art-world friendship for the yBas.

Still today Gallaccio appreciates the value of being able to depend on artist friends from the past, a small group of whom are always available to her if the need arises: 'Even from America I know that if something bad happened there are people, like Gary [Hume], Michael [Landy], Gillian [Wearing], Rachel [Whiteread], Sarah [Staton], whom I could simply call. And they'd be there for me. People I first met in 1985!'

Gallaccio met Sarah Staton through her brother Chris, a colleague at St Martins, and she first worked with Staton in 1993, making things for her SupaStore – the many contributors included Adam Chodzko, Tracey Emin, Georgie Hopton, Rachel Howard and Jane Simpson. This sense, which they all have, of a select, long-lasting artistic community provides a priceless context to their yBa success.

Gallaccio has always been uneasy about class definitions in society, and her distrust of the British obsession with social placings has become greater now that she lives in California. Her uncertainty reflects the conflicts within her family background. She was born in Scotland, and her father's side of the family were working-class Italian immigrants while her mother's side were Polish Jews from the old cotton industry in Manchester. She was five when her parents moved south to live in Twickenham, in south-west London, leaving behind the tightly knit family community in Glasgow. And although she was brought up in a council flat and went to a comprehensive school, her parents had met at drama school and imbued her and her younger brother with left-wing optimism about life's possibilities; both children eventually went to art school. As in the families of Hume and Hirst, there are complexities, including parental secrecy, which make the reliable loyalty of artist friends especially significant. 'I think of myself as a European mutt,' Gallaccio says – adding, with a characteristic broad smile: 'I don't know who I am!' Short-listed for the Turner Prize in 2003, Gallaccio was photographed in her Delfina studio by Justin Westover, looking securely herself.

The environmental concerns in Gallaccio's work fulfil one of the conditions desired of contemporary art: that, whether we like it or not, our attention is drawn to unacknowledged truths. In the Minerva Basin at Hull in 1998, in a work called *Two sisters*, Gallaccio built in the sea a monolith out of local quarried chalk and plaster, to be destroyed gradually by movements of the tide, her major point being to illustrate the precariousness of the city's relationship with water. She had no idea that this fact was to be unveiled so graphically in the floods that invaded the city in 2007. In an interview in 2002 for her Duveen Gallery exhibition at Tate Britain, *beat*, the artist said of this earlier piece:

> **Much of the land around Hull has been reclaimed from the water ... This marshy land was drained and stabilised by Dutch engineers during the reign of Charles I ... Now they are building sea walls to protect the city from the advancing tide, and on it goes. The mutability of Hull and the Humber estuary fascinated me. It seemed to be an embodiment of my approach towards materials and my reluctance to fix or make permanent an object to a place.**

Through various forms of lateral thinking and expression, artists expand the realms of real possibility, enabling them at times to anticipate

Anya Gallaccio built her chalk pillar, titled *Two sisters*, in the Minerva Basin in Hull in 1998. It followed up on the block of salt bricks that she placed on the beach at Bournemouth, *into the blue* (1993), as part of the Bournemouth Festival.

events and on occasion to provoke them. This Gallaccio project was co-ordinated through Locus + in Newcastle, co-founded and directed by Jon Bewley, who declared at a conference at the University of Newcastle in March 2001 his 'belief in the value of artists working in the real world, working with real people in real systems, and taking certain things into the world that we think are of value and important to the way people live'.

In the eyes of many locals, though, Gallaccio's Hull project was a failure: whilst fabricated locally, as she insisted, it collapsed soon after being put up. *Two sisters* had been publicly funded at a much higher level than Gallaccio had ever before experienced: 'more than £60,000, a HUGE amount of money to me at the time'. Even before falling down, it was criticised in the south Yorkshire press for looking like a toilet roll and being a waste of council income, with the result that the artist was placed on the national blacklist as being irresponsible with public money!

Few other artists of Gallaccio's generation display quite the aversion she does to the saleable art object. Most of those who do are women, notably the Irish-born painter Margaret Barron, who now lives in Glasgow and was selected to exhibit at the 2003 Tate Triennial of Contemporary British Art. For Barron makes works that can never be bought or sold, never be owned by a collector or museum. She has developed a way of working in oil on small strips of adhesive vinyl tape, which are then placed close to the sites naturalistically depicted in the pictures: mounted on the passageways of galleries, or, more often than not, outside, on lampposts and gates. In the streets, Barron's work is left to disintegrate beneath grime and weather, whilst inside, at the end of the exhibition period, it is peeled off the wall and destroyed. The fact that the tiny oil paintings display considerable traditional skill makes Barron's refusal to enter the dealer system fundamentally undermining.

Feminist issues are of concern to Gallaccio, expressed in such works as *forest floor* (1995), for which she laid out a large rectangle of machine-made domestic carpet in the forest beside the Chiltern Sculpture Trail in Oxfordshire, neatly cut to surround the trees. These public statements about the role of women echo concerns expressed in her private life, most importantly the decision to mark her marriage to her long-term American partner Kerry Eglinton by organising a party for her artist friends at Mount Stuart, a house on the isle of Bute, off the west coast of Scotland. This happened soon after her art residency on the island in 2005, which had resulted in her silvering a giant pine in the grounds of the house and, unusually for her, exhibiting in the gallery a series of silver gelatin prints of microscopic images of conifer seed. As with most serious artists, life and work are indivisible for Gallaccio.

The move to America in 2007 marked a major shift in Gallaccio's way of life. Being unable to afford two homes, she has sold her flat and studio in London and is committed now to the hamlet south of San Diego where she and Eglinton live, 15 minutes from the Mexican border.

The placing of a machine-made carpet between trees on the Chiltern Sculpture Trail in the piece *forest floor* (1995) resonates Anya Gallaccio's lateral thinking. The next year, at the Wapping Pumping Station, Gallaccio explored another idea, by combining 32 tons of ice and a half-ton boulder of rock salt in *intensities and surfaces* (1996).

This fundamental change would have been unachievable were it not for the domestic know-how of Eglinton and the vital fact that Gallaccio had arranged work for herself as a professor in San Diego – although she had never taught in this way before and struggles with the central commitment to an institution, which is contrary to her instinctual leanings. The proximity of Mexico helps cushion the frustration of dealing with the unfamiliar logistics of American life, and Gallaccio and Eglinton regularly drive across the border for supper of good food, in an almost European atmosphere. All the same, the reason for moving was a desire to set herself down in a new landscape, physically and intellectually, and challenge the comfort of habitual patterns of working. Gallaccio has not been disappointed. After travel through the inexhaustible size of the US desert states, gathering actual materials and atmospheric impressions, her first

solo exhibition back in London, *Where is Where it's at*, in the Thomas Dane Gallery in 2011, appears to herald a distinctly new body of work (see p. 155). Gallaccio herself avoids any such prognosis:

> I really enjoyed doing the new show. I've no idea, though, whether it's a change or not ... What I do think is that it's healthy for me to try to stop worrying what people think about me. To have a bit more confidence ... I never have any sort of a plan ... I'm just enjoying the sense of space in the south-west of the States. I feel as though I've fallen off the edge of the world.

Her increasing physical familiarity with the landscape makes it easier, Gallaccio finds, to appreciate the work of older American artists, such as John Baldessari, who comes from San Diego. Living within the light, underneath the high skies, makes it possible to understand their work. 'About Donald Judd you think: how can a box be sublime? And you go to Marfa and a box is sublime!' Seeing Judd's work in the light in his simple buildings at Marfa, Texas, confirmed the idea she has always held: that the physicality of an object matters above all else, and that it is necessary to experience its actual presence. At the same time Gallaccio maintains her strong European links, regularly exhibiting with the Annet Gelink Gallery in Amsterdam; she first showed there in 2000, with *falling from grace*, which was then shown later that year in the Projektraum at the Kunsthalle in Bern.

An encouraging, and endearing, facet of Anya Gallaccio is her mature acceptance of the plain human fact of contradiction. During conversation in the café at Tate Britain in September 2011, she said:

> I came to art by accident. Because I think of an artist as a 'look at me' person, and I'm not. And yet, of course making things is a conscious demand on people's attention ... I mean, we're all special in our ways, and I felt embarrassed at having to stand on a table and say my specialness is more important than your specialness. And so I have a real push-pull about this. Then my initial thought about being an artist was that it wasn't me that was important but the work, the object. Which I still know is true. And yet the reality of the art world is that you have to have a personal presence, and talk about your work, explain it, defend it ... It's very confusing ... I'm still very confused!

5 / DAMIEN HIRST

Despite building for himself a life of fierce independence as an artist, arranging sales of his own work, producing and marketing his own multiples, Damien Hirst is careful to maintain links with the Goldsmiths group. In a 'conceptual conversation' with the French artist Sophie Calle for the catalogue of his first solo museum show in 1991, Hirst said: 'Life's infinitely more exciting than art. I like other people.'

In the early days Hirst expressed these loyalties by involvement with artist-run shows and by participating in joint yBa exhibitions in museums and galleries, even by curating group shows of his friends' work whilst declining to include his own things in the selection. Later, after establishing his financial security, Hirst could afford to express his admiration of their work directly, by purchasing it for his ever-expanding Murderme collection, due to be displayed to the public in Toddington Manor, the 300-room Gothic Revival mansion in the Cotswolds that he purchased for the purpose. In the sample from the collection selected for the exhibition *In the darkest hours there may be light* at the Serpentine Gallery in Kensington Gardens in 2006, the original *Freeze*-ites were represented by Angela Bulloch, Angus Fairhurst and Sarah Lucas, with others from their London coterie including Don Brown, Tracey Emin, Marcus Harvey and Gavin Turk. Hirst owns a number of major works by Lucas, including *Perceval* (2006), a life-size painted concrete shire horse pulling a bronze cart loaded with giant marrows, and *No Limits!* (1999), of a jacked-up BMW saloon car with its doors removed and the driver's seat fitted with a fibreglass mechanical wanking arm. 'It's just because I love her work ... I just think she's a great artist,' Hirst said in an interview with Hans Ulrich Obrist for the Serpentine catalogue.

Occasionally Hirst writes in the catalogues of exhibitions by artist friends. In a single-page essay titled 'High Art (Sculptures Go on the Floor, Paintings Go on the Walls)', for Daniel Chadwick's catalogue at Lefevre in Bruton Street in 1999, Hirst could have been speaking for himself in describing Chadwick as 'a father and an artist, a lover and a fighter, a loser and a winner and a talented shit (someone who cares about brightening up the place when every other miserable git is complaining about everything) ... We have to keep moving to stay alive.' For the book *Skullduggery: Steven Gregory*, published by the Cass Sculpture Foundation in 2005, Hirst wrote a brief introduction and conducted an extensive interview with Gregory, during which he commented on one of the artist's sculptures: 'The function is unclear and it just raises more

OPPOSITE
Damien Hirst and his partner Maia Norman, the mother of their three sons, from the 1992 catalogue *On*, an exhibition curated by Maureen Paley.

Gary Hume painted the single door
In a Home (Once) in 2005 and, at
the request of Damien Hirst for his
Murderme Collection, extended
this to a set of seven, re-titling the
composite piece *In a Home (Sevenfold)*.

A number of works by Sarah Lucas
are part of the collection, including
the large painted concrete and bronze
piece *Perceval* (2006), photographed
at Hirst's home near Combe Martin,
in north Devon.

questions than it answers. Which all my favourite art does.' Gregory was
brought up in South Africa, and went to St Martin's in London on and off
throughout the 1970s, perpetually leaving and then coming back, taking
ten years to complete his BA. Hirst has a large piece by the artist in his
garden at Combe Martin in north Devon. Another artist to whose work
he has remained attached, after exhibiting together at the Serpentine
in *Some Went Mad, Some Ran Away* ... in 1994, is Jane Simpson, several of
whose refrigerated pieces are in the collection. Smaller cast editions of
new work by Simpson, as well as her 'boxed' pieces, are regularly sold at
Hirst's retail outfit Other Criteria.

Established in 2005, Other Criteria has grown into a major out-
let for the publication and sale of Hirst's and his friends' work. With a
permanent staff now of ten, a shop next door to Sotheby's in New Bond

Street, another near the Wallace Collection in Marylebone and a third in Madison Avenue, New York, they produce a constant run of new work by Hirst himself, ranging from various of his T-shirts from £46 each, through spin-painting-printed steel hubcaps at £935 each, to a group of single butterfly paintings launched in 2011 at £39,000 each. As well as publishing a large number of books by Hirst, Other Criteria commissions monographs on his old Goldsmiths friends. They have several works on *Freeze* exhibitors currently in print, including: *Gary Hume: A Cat on a Lap*, illustrating over 200 of Hume's gloss paintings; a book on Collishaw, sold in a designer slipcase; and Lucas's *The Mug*, a complex publication co-written with Olivier Garbay, described by Other Criteria as 'cataloguing their thoughts and ideas, mixing free-form Anglo-Gallic poetry with various artistic experiments, dabbling in dirt, dominoes, and drinking'. Other Criteria is run by Hugh Allan, the husband of Rachel Howard, a painter whose initial contact with Hirst was employment as one of his spot painters, before she established herself as an artist in her own right. Two of her books have been published by Other Criteria, as have two by Itai Doron, who was one of the five artists, along with Hirst, on the White Cube list when the gallery opened in 1993. His long-term loyalties are clear.

Hirst's work and his career have generated a certain amount of antagonism, in part because of the overt commercialism of his approach. Some of the disapproval is a form of jealousy at the amount of money he has made; other criticism springs from an inherent objection to 'unique' works being produced by a team of assistants in a long series, each with minor variations, a form that pleases the fashionably wealthy, happy to recognise equally expensive matching work on the walls of other electronically protected super-homes. And there are people who object to the cavalier way Hirst opens and closes restaurants, selling the entire fit-out of the Pharmacy bar and restaurant in Notting Hill at auction at Sotheby's in 2004. The decorative idea for the restaurant was based on his exhibition *Pharmacy* in New York in 1992 at the Cohen Gallery, which itself was derived from his medicine cabinet pieces of the late 1980s. Commentators perhaps forget the risks Hirst is prepared to take in seeking to fulfil his wishes, often undertaking projects more likely to lose money than make it. His Notting Hill restaurant, for instance, which was not a financial success and closed within five years of its launch, was set up to satisfy Hirst's love of food and drink – he has since made himself into an audaciously good cook. On another occasion, when Hirst set out to buy back, for millions of pounds, most

The first examples of *Pretty Taxing*, a series of windscreen discs to hold car licences, were produced in limited editions of 500 for the *Art Car Boot Sale* of 2007. Those remaining after the event are now marketed by Damien Hirst's Other Criteria, the designers, including Gary Hume, Sarah Lucas, Abigail Lane, Mat Collishaw, Gavin Turk and – as illustrated here – Don Brown (of his wife Yoko's tummy button) and Georgie Hopton (of her own bottom).

One of a group of different colour-ground, single butterfly pictures, *Love is a Stranger* (2004), first marketed by Damien Hirst's company Other Criteria in 2011 at £39,000 each.

of the work sold over the years through his dealer Jay Jopling of White Cube to Charles Saatchi, bankruptcy for the artist loomed in the gloating eyes of critics. The same thing happened when, in September 2008, Hirst and his team made over 200 new works to be consigned direct to Sotheby's for a single-artist auction, presented on the cusp of the international monetary crisis. Again, he was doomed, they said. Instead, the sale triumphed, earning a total of £111 million pounds for the then only 43-year-old artist. Hirst, however, has not always been best served on such issues by the comments of his supporters. Mariella Frostrup wrote in the Sotheby's *Pharmacy* catalogue: 'I don't remember the opening party in 1998 and neither did the four people I attended it with when I asked them for their reminiscences. I think that's a good sign.' Professor Isabelle Graw, author of *High Price: Art between the Market and Celebrity Culture* (2009), saw the 2008 auction as 'evidence of [Hirst's] serene market realism ... If his works are going to end up in an auction house anyway, it seems only logical to produce them directly for the secondary market and to cut out the primary market.'

The mistake is to assume that, because Hirst is now rich and famous, this must originally have been his goal, and thereby to equate contemporary art-making with business. The market side of things, it is implied, is all that matters, both to art-makers and to art buyers. This

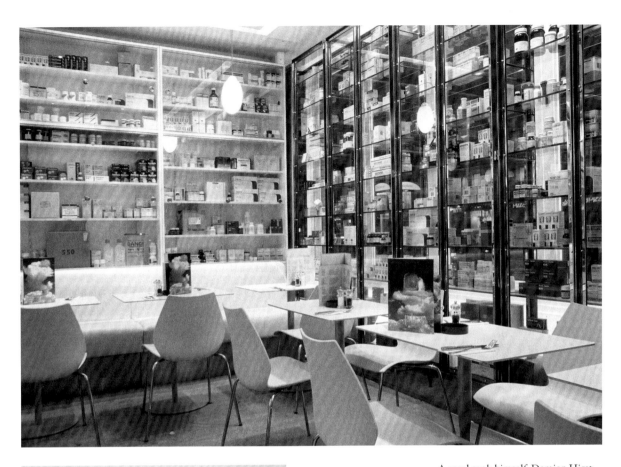

A good cook himself, Damien Hirst opened his Pharmacy restaurant in Notting Hill in 1998. After the restaurant closed five years later, the entire interior and all the fitments were sold at auction, at Sotheby's in 2004.

For his degree show in 1988 Damien Hirst set out to make a series of medicine cabinets. *Pretty Vacant* (1989) is an early example.

is incorrect. No working-class teenager from Leeds went to art school in the 1980s in order to make money. Hirst was motivated by different dreams and ideas. And nothing, anyway, is as clear-cut as is implied by Graw. In the catalogue of his solo show at the ICA in December 1991, Hirst wrote: 'In a conversation with my grandmother I once said "I still feel as confused as when I was seven" and she said "So do I!"' The cover of a guide to this exhibition presented a photograph of the long-haired Hirst's naked upper torso, his mouth moulded into a wide-open 'O'. Inside is an essay by Adrian Searle, the influential artist-turned-critic. The ICA also produced a Hirst edition, *Historical Relationships* (1991), consisting of a card tube with printed label, a ping-pong ball, a glass tumbler and instruction leaflet, a more conceptual piece than some of his later multiples. Hirst is a serious artist, and his work has from the start been attended to by established figures in the arts.

The artist himself does not deny that he likes the limelight, that he enjoys the power of money. Inevitably, there are times when hoped-for success proves illusory – as in Hirst's disastrous return to personal oil painting, with his Bacon-inspired exhibition at the Wallace Collection in 2009 or, another misguided act of hubris, his direction in 1996 of his only film to date, *Hanging Around*. Invariably, though, Hirst has approached his major projects with the desire to make something of lasting worth, regardless of profit. What he has also been tempted gratuitously to do is make headlines, as demonstrated in promotion of his diamond-studded skull. It may, in retrospect, be judged that Hirst's full artistic potential was side-tracked by his being such an exuberant public performer. In her essay 'Mind the Gap: The Concept of Critical Distance in Relation to Contemporary Art in Britain', for a conference at the University of Central England in Birmingham in 1998, Patricia Bickers wrote:

> Damien Hirst has come to be perceived as being somehow above criticism. This may be partly because of his impermeable cheeky chappie persona, and partly because in his recent work he has so completely embraced the language of advertising that there appears to be little room for art critical discourse. Perhaps the explanation is simply that the art world is temporarily star-struck.

The character of the work naturally reflects the kind of person making it – the actual person, as seen privately, away from journalistic performance. Although he was brought up in Leeds by his mother, Hirst was born in Bristol. 'Don't remember anything about Bristol,' he said to Simon Wilson of the Tate, when short-listed for the 1992 Turner Prize, which he went on to win in 1995. 'Dad got chucked out at an early stage ... that kind of thing.' This refusal of maudlin introspection was and is typical. In day-to-day contact through the early 1990s, personal qualities emerged in Hirst's way-of-being that intimately affected the kind of work

he ended up making. He is a sociable enthusiast, with an infectious abil-
ity to share ideas and the drive to lead them to effective fruition. He has
a squat, physical solidity that gives him the stamina to press hard ahead,
for long hours. Hirst is mentally and bodily resilient, endowed with what
seems to be an unquenchable self-confidence. Anya Gallaccio says: 'With
certain people, when they walk in, the room kind of lights up, whether it
be an acrid yellow or shiny bright, like with Damien.' People like working
for him, as he is fun, loyal, generous and individually committed – in early
August 2011, Hirst's summer party for his staff from Other Criteria and
the large studios in south London and Stroud was at Toddington, with a
funfair and gourmet barbecue cooked by Giorgio Locatelli.

Michael Landy, a co-*Freeze*-ite confirms Hirst's generosity towards
his artist friends, suggesting that his self-confidence came from a rock-
solid conviction that he had something to offer, unobtainable anywhere
else. This gives him the strength to treat institutional curators and rich
collectors and influential dealers as his equals. 'He was never reverential
to people, he knew what value he had, from the start,' Landy recalls. 'And
he did it from so many positions, coach, and cheerleader, and fundrais-
er, and dealmaker, as well as artist. With humour ... He was fun to have
around. For them and us.'

Hirst had always been intrigued by the world of pop music and
embraced the opportunity to design a video for the group Blur. He
even performed with Blur's Alex James and the comedian Keith Allen
in a band called Fat Les – they created the unofficial theme tune for the
1998 World Cup, the song 'Vindaloo', which rose to number two in the
pop charts. It was at this time that Hirst began to form his close friend-
ship with the front man of The Clash, the self-christened Joe Strummer.
The two of them first met at the Glastonbury festival in 1995 and briefly
played together in Fat Les. A couple of years later Strummer went to
live in west Somerset, in the Quantock Hills, close enough to the Hirst
household in north Devon for the two families often to meet for extend-
ed Sunday lunches at Podshavers, a secluded farm restaurant near Strum-
mer's place. Hirst's mother, Mary Brennan, who by then had her own
house on the farm at Combe Martin, frequently came too, attentive to
her three grandsons. Another Quantocks local, the oboist/saxophonist
Andy Mackay from Roxy Music, was also a regular at Podshavers.

As often happens with the Goldsmiths group, others also made
use of the same isolated country restaurant. In early November 2001,
Carl Freedman, Gary Hume and Georgie Hopton appeared in the af-
ternoon of a concert at Podshavers of classical English song and built
a big bonfire in the yard before a great storm broke, flooding the lanes
and extinguishing the electricity. The concert took place magically by
candlelight. In January 2001 Freedman had given his birthday dinner at
Podshavers, attended by several art partners, including Michael Landy
and Gillian Wearing, Paul Noble and Georgina Starr, Don Brown and

Damien Hirst's mother, Mary Brennan, with his London dealer Jay Jopling at the artist's first major solo exhibition at Gagosian's in New York in 1996. Others in the photo include Sam Taylor-Wood (behind left), Rachel Howard (right) and Cerith Wyn Evans (in the background). In the spring 2012 issue of *TATE ETC.*, Hirst wrote that he gave the title *For the Love of God* (2007) to his diamond skull in response to his mother's regular comment on his wild ideas ('For the love of God, what are you going to do next?').

David Shrigley, a contemporary of Damien Hirst's, draws extensively and produced with the Polite publishing company *25 Postcards for Writing On*, including the image *Brilliant* (2007), a sideways comment on Hirst's *A Thousand Years* (see p. 29).

Yoko Yamado, and Gary Hume and Georgie Hopton. There was good food and drink. No speeches. During the dancing that followed, Yamado and Hume exchanged clothes piece by piece, until she was wearing over-sized jeans and sweater and he a tight skirt and lace-trimmed blouse.

The most accurate published portrait of Hirst appears in *On the Way to Work*, a book of conversations with his close friend the novelist Gordon Burn, which took place in various locations between January 1992 and April 2000 and was issued by Faber in 2001, in a volume expressively designed by Jason Beard at the Barnbrook studio. Hirst made many revealing comments. In the Introduction he described the struggle to articulate his genuine thoughts and feelings: 'Once you get attention – once you get famous – people don't want dialogue. People don't want to ... know what your work's about. They want to climb on board, get on board and have a piece of it. They don't really want to know what you're actually driving at.' On reading transcripts of the early interviews, Hirst was moved by the reminder of his own enthusiasm and naïvety. In 1992 he had said to Burn: 'With all good art I want to feel something about my existence or something ... I want to feel something. I just want to *feel*.' And, on another topic: 'Obviously it's appealing. To be a ... star. If you say it isn't, you're lying.'

An early purchase from Damien Hirst by the British Council: *I'll Love You Forever* (1994), which has since been shown in numerous exhibitions around the world.

In April 1996, when the two men met in the Hero of Switzerland public house, around the corner from Hirst's studio in Minet Road, Brixton, some of the same issues emerged. 'There's one thing I want more than anything else, and I don't think I'll be able to get it, which is just to live in the present. *Live*,' he emphasised. 'I don't need as much money as I can make in art. It's not about that. It's just about living.' He added: 'You've got to admit you're a boring cunt at some point. D'you know what I mean? You're supposed to be a radical, top-notch, I'm-going-to-change-the-world fucking artist. And you're just a lad from Leeds with childish ambitions.' The last of these published meetings with Burn took place in April 2000 on the island of Lundy, accessed by boat from the north Devon port of Ilfracombe, where Hirst owned a restaurant: 'I don't think you can relax as an artist. Ever. There's no easy lives. You're going for it. It's constant. Twenty-four hours a day.'

Hirst was courted at an early stage by the curators of leading public collections. He was selected by the British Council for his first solo show abroad in 1992, at the Istanbul Biennale, and by 1994 the Council had already purchased two substantial Hirst pieces: one of the spot paintings, and *I'll Love You Forever*, a padlocked blue steel-mesh cage full of medical waste containers. The dealer Anthony d'Offay, who included a Hirst Room in his substantial contemporary art donation to the nation in 2009, had chosen a Hirst work for his mixed show in Dering Street in 1992, *Strange Developments: Ten British and American Artists*. In 1994 Hirst

was already being encouraged by the Demarco Gallery in Edinburgh to dare to displease, in his set for *An Installation for Agongo*, with music by Daniel Moynihan, lit dramatically to reveal in the semi-darkness rats scampering around a cage of pharmaceutical boxes. Andrea Rose, head of the British Council collection, wrote in the Foreword to the 1997 catalogue *Dimensions Variable: New Works for the British Council*: 'What was previously thought of as an undercurrent of energy, optimism and adventure has suddenly emerged as the predominant temper of our times.' From a measured and informed observer, this is praise indeed for Hirst, the leading energiser of the Goldsmiths group. The key public figure in the arts at this time, Nicholas Serota, also recognised Hirst's qualities. Serota was appointed Director of the Museum of Modern Art, Oxford, in 1973 at the age of 27, before moving on to run the Whitechapel Gallery from 1976 to 1988, and then, in the *Freeze* year of 1988, taking over as Director of the Tate Gallery. In this post Serota became the principal force behind the creation of Tate Modern, which opened in 2000 in the converted Bankside Power Station.

Amidst the fuss and clatter of publicity, Serota has managed to remain clear-sighted, soft-spoken and safe. His sober manner and suited formality have drawn accusations of intellectual arrogance from sections of the press, who chose to see Serota's upbringing in Hampstead, with his mother a Labour Minister of Health in the Wilson government and subsequently a life peer and a governor at the BBC, as evidential proof of in-crowd manipulation. In fact, Serota revealed from the start a non-establishment interest in contemporary culture, and has been particularly sensitive to the feelings of young British artists, the openings of whose exhibitions anywhere in the United Kingdom, and in much of Europe, he frequently manages to attend in person when other bigwigs duck out. He wishes to make sure that the individual artist feels supported and valued by him. The effort is appreciated. Tracey Emin remembers with pride how, in her pre-famous days, Serota turned up at an obscure private view, without pomp or pretence; and an older artist, the sculptor Richard Deacon, agreed to take on the out-of-character establishment role of Tate Trustee solely out of admiration for Serota.

Serota is less exaggerated in his judgements on contemporary art than many commentators tend to be. In an interview on 20 November 2000 with the critic and writer Richard Cork, Serota refused to glamorise Tate Modern's early successes:

> **A huge amount remains to be done here. People may be attracted by the spectacle of new buildings, they may enjoy the social experience of visiting a museum, taking in the view, an espresso or glass of wine, purchasing a book or artist-designed T-shirt. But I have no delusions. Many are delighted to praise the museum, but remain deeply suspicious of the contents.**

In his Richard Dimbleby Lecture, also in 2000, Serota asked: 'What lies at the root of the fear that we are being deceived or tricked? Is this art which can have meaning for many or is it simply for the few, those critics, curators and collectors who form an inner circle?' His answer argued that, as with old art, modern work repays close examination and familiarity. Acknowledgement then followed, though, that different criteria are at play in judging the old and the new. As an example, Serota cited Hirst's *Mother and Child Divided*, the piece in which a cow and calf were split down the middle and mounted in formaldehyde in separate glazed cases: 'For me the undoubted shock, even disgust, provoked by the work is part of the appeal. Art should be transgressive. Life is not all sweet.' Serota admitted to often feeling bewildered by his first sight of new work in an artist's studio, but explained that 'over a period of time I have come to realise that it is precisely when I am most challenged in my own reactions that the deepest insights emerge. Frequently, the greatest rewards come from the most unyielding.' Hirst himself said, on interviewing his sculptor friend Steven Gregory in 2004: 'It's usually the things you don't like where you turn around and you end up loving them if you're not careful.' The best art, Serota believes, induces 'an exploration of self and of the world of feeling and intuition'.

In practice, Hirst has had a spiky relationship with the establishment, refusing invitations to become a Royal Academician and declining to join Prime Ministerial boards or to accept public honours of any sort. For many years he also appeared relatively antagonistic to the country's large art institutions: his joint exhibition with Lucas and Fairhurst in 2004 was the first significant appearance of work sanctioned by him at Tate Britain. This changed in the spring of 2012 with his customised solo show at Tate Modern.

Suspicion of wilful deceit – with accusations against artists such as Hirst and Emin of pulling off conscious confidence tricks and 'laughing all the way to the bank' – is too widespread to be ignored. Critics point to Hirst's Other Criteria promotions and Emin's sales company Tracey Emin International, with its shop in Spitalfields. Such views highlight a fundamental misunderstanding about how almost all full-time artists function. Of course, there will always be talented individuals who bastardise their skills with forgery, and other artists whose ambitions are wholly commercial, regardless of content, but those artists whose names we have come to know and whose work we regularly see in exhibitions are differently motivated, however disenchanted we may find ourselves with the results. The reason for making art is more vital than a penchant for deceit, much more of a necessity, close, after several years of constantly making stuff, to the core of the person. There is, in most cases, no choice: whether rich or poor, good or bad, happy or sad, making things is what has to be done. As Hirst put it, in conversation with Burn:

Damien Hirst is consistently drawn to work in series. His first widely exhibited work with fish appeared in the group show *Broken English*, at the Serpentine in 1991. In 2006 he made the related sculpture *School – The Excellence of Every Art Must Conquer in the Complete Accomplishment of its Purpose*, a detail of which is published by Other Criteria as a postcard.

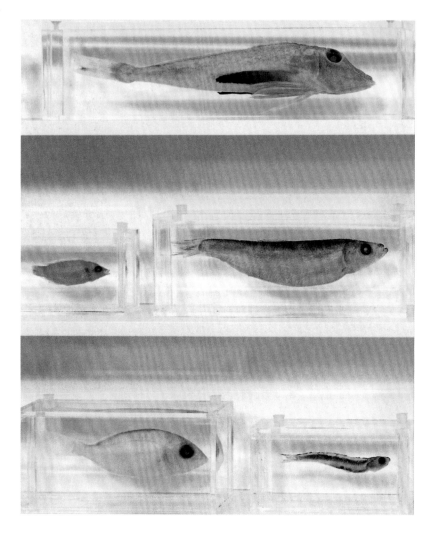

I'm nothing unless I make art. I'm a great geezer if I make art. I used to think if I put into life what I put into art, I'd have a much better life. But it's not true. There's no way out. You think you're an artist? Well, get on with it.

Hirst's ebullient ability to cause offence pre-date his artistic successes. The sculptor Frances Richardson, a Leeds schoolmate, remembers Hirst at twelve revelling in his naughty-boy reputation, to the delight of the rest of the class, who would await in anticipation his late arrival, tie fantastically askew and sweater worn both inside out and the wrong way round, their teacher failing to understand that her angry attempts to tidy him up fuelled the young Hirst's intent to entertain. There is a telling photograph of Hirst, taken by the painter Marcus Harvey when they were on Foundation at Leeds Art School, on an official outing to the hospital morgue to draw. Although cameras were banned, Hirst was photographed in uneasy, nervous laughter beside the severed head of an old man, on an escapade where he somehow ended up with a cadaver's

ear, which he sent through the post to Carl Freedman's elder brother. Richardson also remembers an earlier example of 'classic' Hirst, as a fifteen-year-old boy on the way home from school, baring his bum in gleeful defiance outside the Deer Park pub on Street Lane, a signature gesture of his a decade later, down in London. Hirst was – predictably – an irrepressible Bottom in the school production of *A Midsummer Night's Dream*, loving the attention of it all.

Hirst once took Harvey to see the packed rooms abandoned by Mr Barnes, a neighbour who had been rehoused by the Council. The old man had lived in this small terraced house in Leeds for sixty years, Hirst reckoned, and the place was stacked to the ceiling with kept and salvaged material. 'Crawl space,' Harvey called it. Hirst reported finding 'a bag with every toothpaste tube he'd ever used all folded up really neatly' during the weeks he spent there, sorting things to remove to make collages with, before the Council turned up one day, and in a few hours cleared the house to bare walls.

One of Damien Hirst's party tricks was to stick a cigarette in the end of his penis, as here seen in the Colony Room in Dean Street, Soho, in a photograph taken by Chris Draper, published in *The Idler* in 1997.

Hirst has a habit of repeating his favourite routines, in work and in life. A sporadic customer of the Colony Room in Soho, an artists' drinking haunt made famous by Francis Bacon, Hirst was seen on at least one occasion before its closure at Christmas 2008 wandering around the green-painted, art-stacked rooms with a great grin on his face, his cock hanging out of his trousers and a cigarette stuck in the end. An old friend grimaced in bored disapproval: 'Damien, how long have you been doing this trick?' 'For ever!' Hirst beamed. There was and is a desire to entertain more than to shock about Hirst's performances in public.

In the book *Damien Hirst: Pictures from the Saatchi Gallery*, published in 2001 by Booth-Clibborn Editions, designed by the Barnbrook studio, the American academic Richard Shone concluded his essay by saying of Hirst:

> His work has served as a yardstick by which to measure the ambitions of others in a generation of high-profile artists. This position has been attained through an exemplary belief in what he has been doing ... Though much of his work is shot through with the dystopian character of the times, it is also celebratory in its power to amaze.

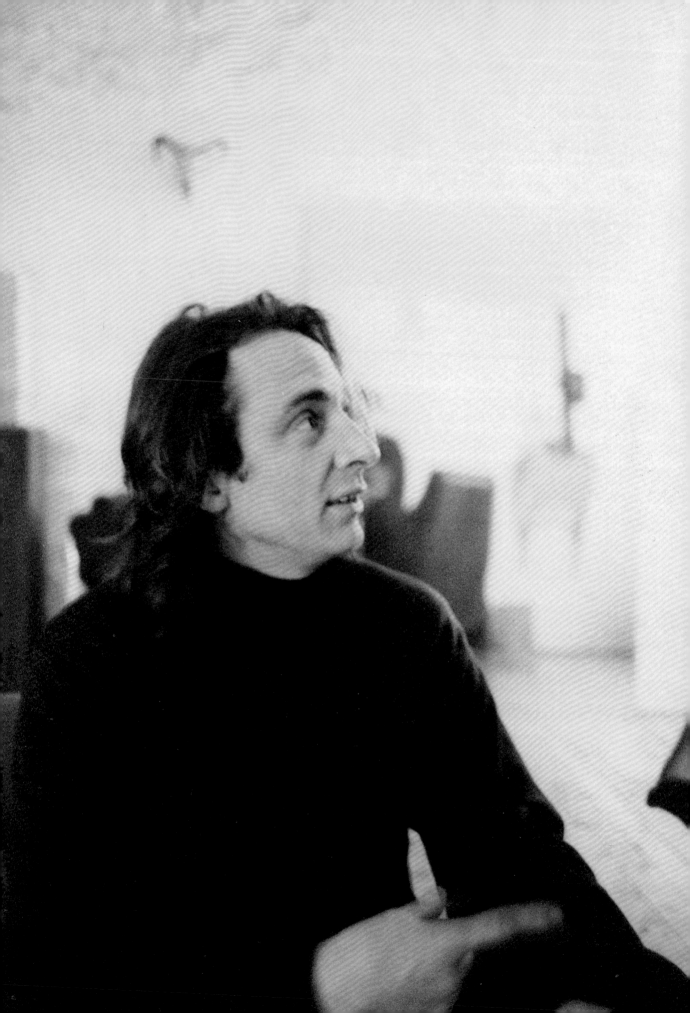

6 / GARY HUME

A couple of years ago Gary Hume said to a friend over a glass of wine: 'I'm running out of time. I'm 45 years old. I smoke. And I'm running out. My son's 20. I'm running out. And that's what keeps me going. Because I've only just sta-a-arted.' In written words on the page the sound of Hume's voice is lost, his particular lilt, the expressiveness of intonation missing. Hyphens approximate the sweep of his belief, curving up then down then up again.

The youngest son of a determined single mother, Hume left state school in Kent at 16 with only three 'O' levels, and was himself the father of a son as a 25 year-old student, in 1987. Despite these apparent disadvantages, he has consistently proved to be one of the most sought-after British artists of his generation, commercial success earning him the pleasure of ownership of a farm and studio in up-state New York and a five-floor 18th-century house off Gray's Inn Road in central London. None of this has happened by chance. One of the principal reasons for Hume's achievement is his disciplined consistency, pursing a steady line of artistic exploration since discovery of his basic technique with the gloss door pieces he produced for the exhibition *Freeze* in his last year at Goldsmiths. And despite the thousands of paintings and prints he has produced since then, he remains desperate for the time and skill and inspiration to do more, to get further down the road along which he relentlessly drives. In another recent conversation Hume indicated an essential characteristic that makes this journey possible: his self-centredness. 'Academics are always asking me what I think of Ellsworth Kelly, or Brice Marden's stripes, any of the minimalists,' he says. 'They're great artists. I love their work. But what people don't understand is that the only person I'm *really* interested in is me!' Kelly and Marden probably feel the same. Simon Bill, a contemporary British painter friend of Hume's, certainly agrees, to judge by his novel *Brains*, published by the Cabinet Gallery in 2011, in which the central character, an artist, notes: 'The only distinguishing characteristic I really care about is that of being me.'

Women have always mattered to Hume: his intimate relationships with them have had a noticeable effect on his work. First of all, there was the encouraging example of his unmarried mother, who embraced her five children as the happy result of the choices she made, the product of what she decided to do, not of what was done to her. Now in her early 80s, Jill Henshaw remains the loved centre of her closely knit family and

Gary Hume's only child, Joe, then aged four, standing in front of *Four Doors 1* (1989–90) in the studio prior to his father's exhibition at Karsten Schubert in Charlotte Street, in 1991.

a cared-for presence at her youngest son's exhibition openings around the world. Hume delights in his mother:

> **My Mum is a loving and very positive person. She has no trust in anything other than hope. 'If you're just going to whinge,' she used to say when I was young. 'If you're just going to be a moaning bored person, just go over there and do it. Life's too short.'**

The lack of a paternal presence – Hume only met his father once, on a dramatically curtailed family holiday in Cornwall when he was 12 – has not been without its effects. Unwanted repetition of separated fatherhood was one such consequence, when Hume found himself in 1987 the father of a child by Clare Franklin, a woman he had already left – for Sarah Lucas, as it happens. Goldsmiths had drawn him away from the world he had shared with the little boy's mother, who was then a community gardener in the park near the squat on the Lloyd Baker Estate, where he lived at the time, near King's Cross Station.

Lucas was a challenging influence. The quality that impressed Hume most was her energy, the yes-saying of her engagement with what

crossed her path and the iconoclastic freedom of her attitude to the making of art. They were very involved in each other's work, Hume taking several of Lucas's choreographed self-portrait photographs, which have become – to his lasting delight – iconic elements of her early work. In her Doc Marten boots and denim jeans, Lucas showcased her feminist credentials; she said about *Got a Salmon on (Prawn)* (1994) and *Get off your Horse and Drink your Milk* (1995), from two series of suggestive images of the naked torso of Hume, taken long before their publication: 'The work always has something added to it by the fact that a woman did it. I can't say why this crossover in sex roles should make it stronger, but it does.' In Lucas's *Soup* (1989) a blown-up photograph of the end of Hume's penis floats in a plate of vegetable soup. She encouraged Hume to make the set of four photographic prints of himself, titled *Ugly Self-Portraits* (1993), using a mask, wig and baby's teat. At this testing period in their lives, Lucas was as generous to Hume in support of his work as he was to her. In Hume's struggle to settle on new subjects after turning aside from the success of his door paintings, he found Lucas's example an emotional incentive. His memory of the 'private view' she gave on his 30th birthday, 9 March 1992, captures the mood of the times:

> **Taking the bad things and making them into positives. When I didn't have a dealer for a show, Sarah said 'Let's have it at my bed-sit!' And we put one painting on an easel, served gin and tonic and cucumber sandwiches. Ironic salon sort-of-stuff. A total success! It felt, fuck it, we've got the best bed-sit show in London this week! We're all seeing it! Everybody we know is coming! What more could you want?**

LEFT
Sarah Lucas and Gary Hume became close companions at Goldsmiths in 1987–8. They remain good friends, although the relationship ended a couple of years before Lucas published, in 1995, her photo of Hume in *Get off your Horse and Drink your Milk*, a 3-foot by 3-foot C-type print mounted on aluminium.

RIGHT
Ugly Self-Portraits (1993) one of four photographic images issued by Gary Hume in an edition of only three, one set of which is in the collection of City solicitors Simmons & Simmons.

The exhibited piece, titled *This is Not Possible*, was semi-figurative, the bright colours and part of the surface obscured by the sculptural insert of masking tape and a square of Perspex fitted with a nipple-like rubber teat from a baby's bottle.

Asked in 1996 by the curators of the *British Art Show 4* if he thought it wise for two artists to engage in a long-term relationship, Hume gave the enigmatic reply: 'Two barn owls hooting the break of day.' He had tried and tried to make the relationship with Lucas work, before finally accepting that their differences were too great. Difficult times followed the break-up with Lucas, during which Hume drank too much and lived in relative squalor in his studio–home (see p. 46), a 1950s' machine shop in Hoxton Square, without central heating or an adequate bathroom. 'Gary went through very hard times, living in a tent in his studio, and we all thought he was going to die!' Gallaccio remembers. 'But he's been fine, more than fine. Determined to do his work whatever the cost. It's a combination of pragmatism and idealism which we all have.' A vital element of Hume's recovery was the arrival in his life of another artist, Georgie Hopton, to whom he is now married. They spent their first Christmas together in the studio tent, with a mini-settee and an electric heater inside, and a glittery, fairy-lit Christmas tree just outside the entrance to the tent, casting reflections on his big gloss paintings leant in rows against the walls. In conversation with Iwona Blazwick before an evening audience at the Royal Academy in 2010, Hume expressed his gratitude for the fact that both the women he has lived closest to as an adult, first Lucas and now Hopton, consider art-making and life-making to be the same thing. He finds this encourages him to trust that this is indeed true, something which he is drawn in despair to doubt.

Like Gallaccio, Hume has always been concerned about issues of possession and identity. In the catalogue produced by White Cube for Hume's exhibition *American Tan* in 2007, the art historian David Anfam quotes at the head of his piece Hume's remark 'I paint to try and recognise myself.' Hume put the same thought in a different way to Catherine Lampert, Director of the Whitechapel at the time of his large exhibition there in 1999: 'The whole process of making something is finding something that is mine, that I recognise straight away. It's not like trying to construct a whole edifice of cultural thought, it's just saying: I know that that can be mine, and I will possess it.' To Blazwick, the present Whitechapel Director, Hume spoke in 2010 about the sense of potential ownership that an artist feels of everything seen, a characteristic which he illustrated by describing visits to museums: 'When I go around galleries I look at the work of 15th-century artists, say, and think: I'm them. And they, if they were living, would be me. The unity of art is fantastic. We sort-of possess each other!'

Like Hirst, Hume was relatively quickly recognised by leading art institutions. In 1996 it was announced that Janet Wolfson de Bot-

ton had authorised the gift to the Tate
of 60 major contemporary works of art
from her collection, by Carl Andre, Ju-
lian Schnabel, Andy Warhol, Cindy Sher-
man and others, including Hume's iconic
door painting *Incubus* (1991), in two tones
of pink gloss on board. He was the only
young British artist selected, and this
was the first of his works to enter the
Tate's collections. Although De Botton
was relatively independent in her taste,
she was nevertheless entrenched in the
art world's moneyed establishment, and
the purchase in 1976 of her first con-
temporary paintings was influenced by
private conversations with her friend
Charles Saatchi. Already at *Freeze* Saatchi
had successfully pursued the purchase of
work by Hume. Later, when the artist was
desperate for money, he did something
that was unusual for him: he telephoned
Saatchi to explain the situation about
moving on from door paintings, and to

say that he had a good new piece that he needed to sell. Hume stated
that this was one of the best pictures he had ever painted; Saatchi trusted
the artist's judgement and bought the piece sight-unseen for £2,500. The
picture was *Vicious* (1994), accepted by now as one of Hume's classic early
figurative works and valued at over £250,000. At the exhibition in 1997 at
the Saatchi Gallery in Boundary Road *Fiona Rae Gary Hume*, the painting
Vicious was prominently displayed.

Whilst his friend Hirst is often described as a clever promoter
of his own work, Hume is quietly also seen as an astute organiser of his
business arrangements. From early on, Hume has been represented by
the same dealers, Matthew Marks in New York, who took him on in 1992,
and, from two years later, Jay Jopling in London. Described in 2000 by
The Observer as 'the White Cube star artist', Hume feels fortunate to
have been involved with these two smart dealers of his own generation.
All three started their careers at the same time and together expanded in
stature; over the years he has grown relaxed in their company and they
have become friends, never declining to handle any of his work, always
positive and encouraging. At the same time, like many artists, Hume
likes to feel in control of important aspects of his artistic life, and he
has had the strength to avoid exclusive arrangements with either dealer,
persuading them instead to do two years on and two years off, each with
automatic first refusal on everything he makes during their turn, always

By 1994 Gary Hume had moved
securely into his still current phase of
work, in which elements from nature
and the human figure and face are
incorporated into his compositions,
fluid and colourful. *Vicious* (1994) was
one of his break-through paintings.

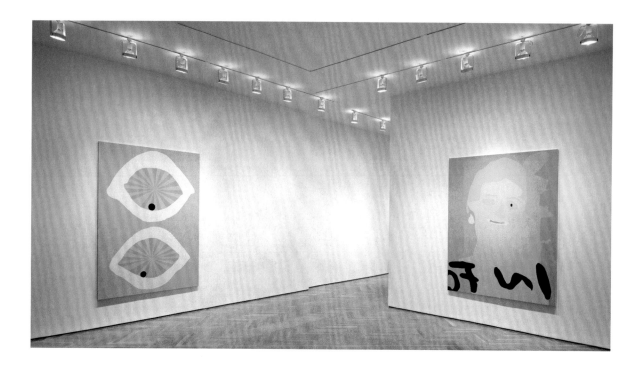

While working for Anthony d'Offay in London in 1991, Matthew Marks bought a set of Gary Hume doors, and he then represented the artist when he returned to New York to open his own gallery in 1992. Hume's solo exhibition with Marks in 1994 included the work *Poor Thing* (1994), shown here on the right, and *Iris* (1994), on the left.

OPPOSITE
Nicola (2002) is part of a substantial body of Gary Hume paintings and sculpture in the collection of the singer Elton John. The title refers to the artist's painter friend Nicola Tyson.

concluding with a solo gallery exhibition. When, in 2010, Hume decided to appoint Monika Sprüth of Sprüth Magers in Berlin and Cologne as his continental dealer, Marks and Jopling were obliged to agree with this too. He had also known her from the beginning, liking what he calls 'her craziness' and trusting the gallery.

Spending alternate double-years working for his American dealer, it made sense, when this became financially practicable, for Hume to set up a working studio in the States. Accustomed to visiting the English artist Nicola Tyson, whose features he has used in several paintings, a contemporary who established her home in up-state New York in the early 1990s, Hume and Hopton eventually found, an hour or so away, a relatively inexpensive farm to buy, with barns and woods and a small lake, where they now live for up to five months of the year. They have converted three of the outbuildings into large studios, planted an orchard, made a vegetable garden and cleaned the pond, where they swim on hot summer days.

This is, of course, a fierce contrast to the life of the average artist, marking the extraordinary financial rewards that have accrued to Hume, as to several other yBas. When he was younger, a deal of time passed on the booze, meeting people in the pub of an evening and drinking too much. And for many years every spare moment from the studio during the day he used to spend with his son Joe. Time ... time was scarce, leaving little room free for other interests. The big difference now with the farm in New York is spending hours on the land, simply lying in the fields in the sun, or planting trees and tending his vegetables and fruit, harvesting maple syrup, doing something productive with time outside work. He has taught himself to keep bees and collect their honey. Hume cherishes the fact that this is creative work in which he is not judged and where nothing ultimately is changed:

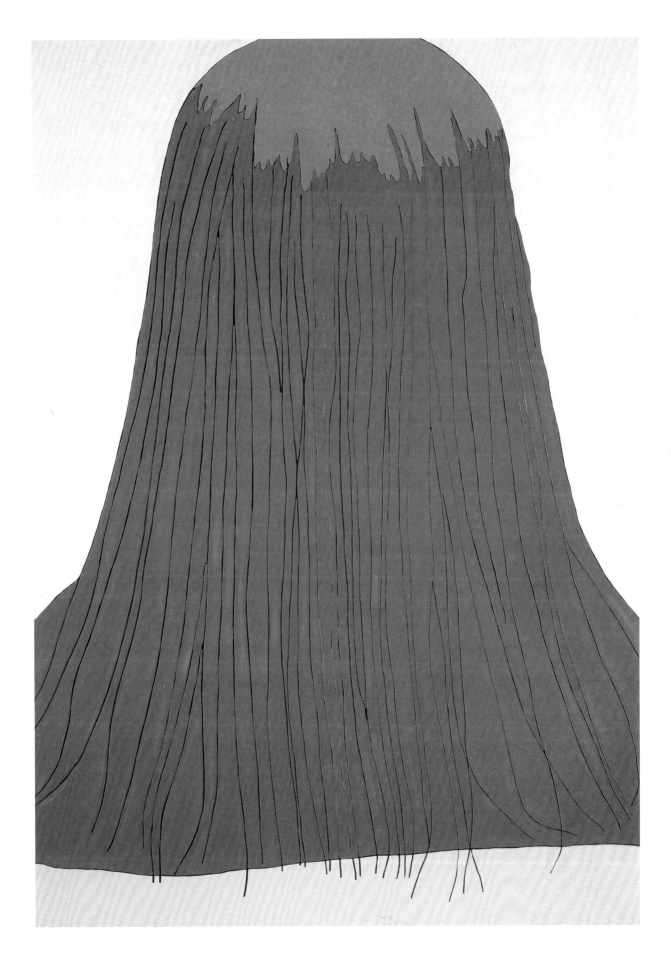

At the back of the largest of Gary Hume's studios on his farm in up-state New York in 2005 stand three of the small versions of his *Snowman* sculptures, in gloss paint on aluminium. The first large version was made in 1998.

As soon as I die, it'll start going back to its own state. Nature will take over, life will carry on. It'll just do it. There might be some echo of my presence, but basically it stays itself. I love that ... Because ... because ... I look for saplings and nurture them. I like the fact that almost everything I do won't look its best until after I'm dead. I enjoy that.

These rural pleasures have not slowed Hume's disciplined working schedule. His 2012 diary begins with the stage design for a short ballet at Sadler's Wells theatre in London. He then has solo shows planned at White Cube in London and at the Pinchuk Art Centre in Kiev in February, opening the same month in which the Arts Council's *Flashback* exhibition opens in Leeds, before touring to Wolverhampton and Aberdeen, and then finishing in Exeter in 2013. The first of a new series of exhibitions, *Flashback* focuses on the work of a single established artist, 'inviting him to revisit his earlier work in the Collection and reflect upon his subsequent practice'. Hume's exhibition at Tate Britain in 2013 offers an opportunity to assess his work in comparison with Patrick Caulfield, each with three large adjacent rooms.

The tendency of critics to compare artists is a problem for Hume – as is the habitual practice in England of standing successful artists on

pedestals and throwing at them first garlands and then rotten tomatoes. Motivated by the desire to be accepted as a normal human being, Hume hates this attitude to artists and is, in fact, more suspicious of praise than of vilification. He repeatedly insists that painting is nothing special, merely the thing he chooses to do, just as making bread is what a baker does. His feelings and theirs – about friendship and competition and recognition, all human emotions – are in essence the same, with only the usual differences around personality and experience. A baker needs to be valued in himself and for his work in the same way that an artist does. We all need genuine appreciation, from somebody, in some form. Lucas agrees: 'I don't think there's much difference between people in the creative sense, there's just a bit more of it if you're an artist. More focused. You can let it out. But on the whole I think it's sort of the same.' An artist is nobody special, Hume argues. *He* is not special: 'I'm just a bloke from Kent who loves his Mum!'

And yet, while Hume and Lucas dislike the idea of treating art, and therefore artists, as exceptional, it is difficult to avoid recognising the fact that the emotions involved in their work are not the same as for a baker. More of the individual person is invested in the making of a good picture than a beautiful loaf of bread, and it is also generally true that the artist is subject to greater levels of anxiety. In an interview with Hume published in *Tate* in 1999, Candida Clark asked: 'What do you worry about?' The painter replied:

> Only about how disappointingly bad I am at doing what I do ... It's like a total awfulness, hideous. You worry at it to maybe make it better, or shiny, like a worry bead. So I worry at it to get it right ... And I only exist in my work. I don't exist anywhere else. That's how I feel. I'm nothing apart from my paintings and that's it. So if I don't work, I'm nothing.

Hume returns to the contradictions within his perception of the function of an artist, aware that a particular dedication is required, whilst remaining wary of the danger of idolisation: 'You have to keep going, always further. But I'm reluctant to talk about it, because I'm reluctant to romanticise.'

In an article in the *Financial Times* in June 2008, 'Eloquent Silence', the journalist Emily Stokes suggested:

> Where the other yBas have made confrontation, identification and self-confession a part of their work, Hume has done quite the opposite, making images of silence and anonymity in his. In this way, his works both cover up and reflect the personality of their maker; they are like gestures of shyness asking to be drawn out.

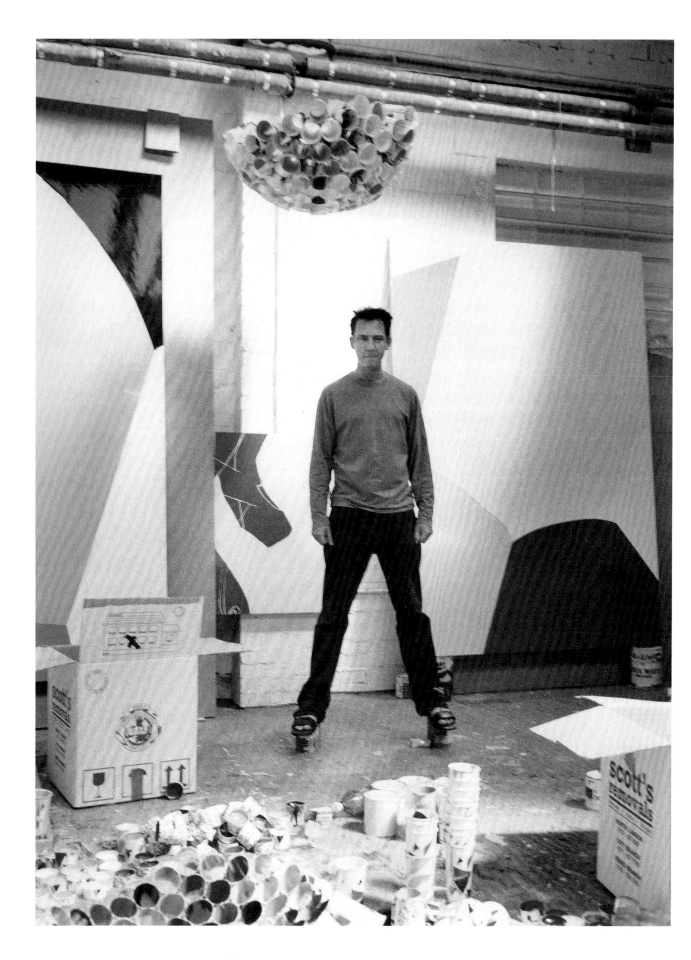

Interestingly, this is paralleled by a remark about Hume's teacher at Goldsmiths, the painter Michael Craig-Martin. In the catalogue to a solo show of 1980s' work at the Waddington Galleries, Richard Shone wrote: 'He has always been fuelled by doubt. This is not so much the doubt of an artist assured of his or her activity but an all-embracing scepticism turned on the very substance of the work itself.' Common ground with his ex-student was also revealed in a comment by Craig-Martin himself, in a BBC radio interview with John Tusa: 'I'm very driven and I'm happiest when I'm working.' He continued: 'I like making things and ... one of the things I think that drives me is I'm very intrigued to see the thing that I want to see, and the only way to see it is for me to do it, it has to be made so I can see it.' In June 2007 Hume expressed similar views about the job of a painter: 'I can think of lots of people who may have been quite good artists but never really got into doing the work. The work is what counts.'

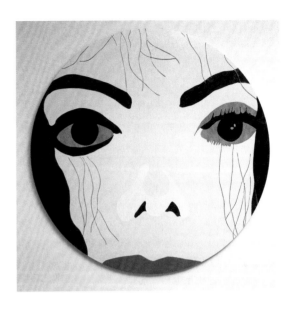

ABOVE
The trawling of magazines and catalogues for images to adapt for his own purposes has always been part of Gary Hume's practice. He regularly turns to iconic 'pop' characters: his *Michael* was painted in 2001 on a circle of aluminium. In 2002 he used the image to make a screenprint edition of 80, and in 2007 he used it on a car tax disc.

It is a mystery what, exactly, motivates an artist to keep going through the inevitable times of doubt and discouragement. For the *Minky Manky* catalogue of 1995, Carl Freedman asked Tracey Emin why she made art. With the directness for which she is now famous, Emin responded: 'I think I'd go insane if I didn't.' The personal need to make things, of various kinds and for various reasons, can be very strong indeed. And highly problematic too. The painter George Shaw, a successful contemporary from outside the Goldsmiths group, hates pretension, claims – like Hume – no moral distinction for what he chooses to do in making meticulous paintings and wonders, with a shake of the head, 'Why do I do this ridiculous activity, all day on my own, working until midnight?'

Hume elaborated on his personal experience of the artistic process in conversation with the curator Ulrich Loock, for the book *Gary Hume: Cat on a Lap*, published at the end of 2009 by Hirst's Other Criteria:

OPPOSITE
Gary Hume paints in gloss straight from commercial tins, using waxed paper cups to contain the amounts he needs at any one time. At one stage he tried to make sculptures out of the cups, but he later destroyed them all in Michael Landy's *Art Bin* at the South London Gallery in 2010, including the piece hanging from the pipes of his Hoxton Square studio. Here he stands on paint tins between two of his three *Close-up Paintings* of 1999, both of them upside down, unfinished.

> **When a painting is successful, it's self-satisfied. Even if it has failings, it's satisfied with its failings, that's when you know the painting is finished ... I'm trying to make something that can be in the world and have its own sense of self, not be an echo of my sense of self ... The paintings are a series of flawed individuals. They're like the real world. They're not perfect fictions. They really do exist.**

Looking back over more than 20 years of painting for all of most days, Hume is no less keen and inquisitive than he was at the start. Some of his happiest times are early evenings in the London studio, with the

For his exhibition at the Whitechapel Gallery in 1999, Gary Hume created a series of five large works which involved an overt use in paint of his skills as a draughtsman. Three of the *Water Paintings* (1999) hang on the right here, with another work suspended from the ceiling on the left.

busy-ness of the day done, the phone fallen silent, when he likes to sit in his paint-spattered clothes, smoke a fag and gaze at the half-finished works propped up for inspection on empty paint cans against the walls. Listening as much as looking, and relaxing, until the moment comes that he feels that he clearly hears what the pictures are telling him. To Hume there is, along with his technical expertise and ever-developing expressive agenda, a spiritual element to making things. He often speaks as if his pictures were alive, with a will of their own. Painting is a process difficult to put into words, one that Hume experiences in the final stages of completion as a conversation with the picture, where he proposes – in his head – a particular change of tone or hue for one small section and is politely turned down. 'I'm pleased you think that,' he reports of having heard a picture say. 'But *I* don't agree. My colours are fine. While I'm pleased you think I'm about bisexual atrophy and hope you're having a nice time with these thoughts, frankly I don't give a damn. Because I'm me!' As if the picture had developed an individual personality, polite but firm – much like Hume himself.

An essentially practical man, Hume is, of course, aware that the 'I' and the 'me' of the picture are indeed himself. And yet there is a discernible process by which something that one makes, whether a book or a sculpture or a song, feels at a certain point to be reaching for its independence and must then be allowed to exist in the world as itself. This is an integral part of the completion of a work of art. Hume accepts that the anthropomorphising of pictures is a result of the intensity of his involvement with them – he sees more because he looks more, looks at his pictures more than any other individual person ever will. It is not the grand things but the small details, such as the speed of the curves, which end up giving him an overwhelming amount of pleasure. Every time he sees that curve he breathes out a little, in relief, gratified that the painting has become itself.

Although Hume is not envious of other people's wealth, he likes having his own money and values the material benefits it has brought. He is also aware of his responsibilities to the people he employs, and to his wife and family. He is – quietly – very generous to friends as well as family, as reflected in Michael Landy's nickname for him: Gary Humane. At the same time Hume tries to be prepared at any time to lose his capacity to earn money, seeks the strength – despite nausea at the idea of being strapped again for cash – to enjoy the fact that art is a living thing, with the inevitable consequence of moving in and out of attention.

> So far financial success has been an enabler. Nothing more. Only positive ... I've always been determined. Always had to earn every penny of my own, never been given any money ... And never been directly motivated by it, because I've always thought that money would be the by-product of my activity. That I should concentrate on the activity and the money would come along on its own.

In practice, his response to exposure to other people's views and to the market-place remains fear-filled, raising doubts about the quality of his work. The only way that he has found of suppressing these fears is through a categorical decision to enjoy the occasion. This was particularly true of the Venice Biennale in 2000, when he was commissioned to fill the British Pavilion with his work and flew all his family out for their first visit to Venice. Their pleasure was so acute that he was taken up by the spirit of things and forgot about his antipathy to art-market jamborees. Whenever the jitters flared, he looked over at his mother's happiness and smiled, renewing his determination not to ruin things for her by being miserable.

Working with a friend from pre-art school days, Kim Meredew, who became a stonemason, Gary Hume regularly designs works to be made in stone, with the carefully selected marbles divided by lead – as in the stone paintings installed in 2011 in a private swimming-pool, a stylistic development from his *American Tan* exhibition of 2007.

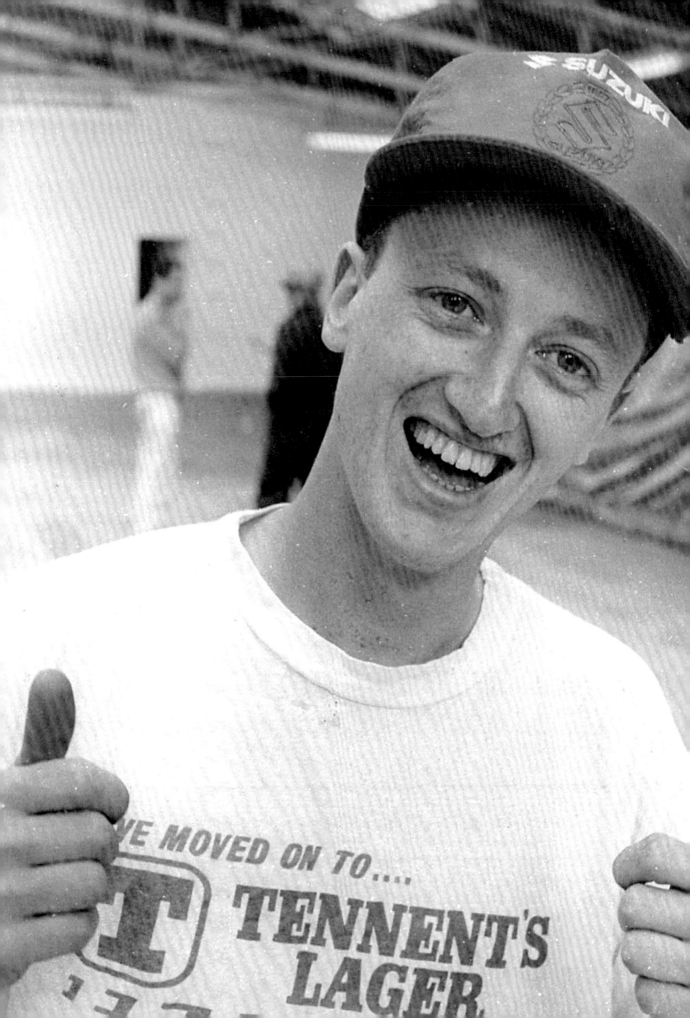

7 / MICHAEL LANDY

Making a different kind of work from Gary Hume's, in a relatively small number of composite projects, Michael Landy was equally admired within the art world in the early 1990s and yet took longer to establish a public reputation. His first substantial appearance in institutional exhibitions was with *Scrapheap Services*, a version of which was completed in time to join the show *'BRILLIANT!' New Art from London*, which opened in October 1995 at the Walker Art Center in Minneapolis.

Landy had started out on this project in 1991, undertaking focused work on it from 1993, doing detailed research and taking elaborate drawn notes during days in the studio. Spare evenings were spent raiding re-cycling centres and take-aways near his studio in Clapham, in south London, and for months and months stamping out from the gathered debris 5-inch-high schematic figures, each one handmade by him, thousands of which were scattered across the exhibition floor in Minneapolis. The room-size installation, which was bought for the Tate in 1997 by the Patrons of New Art, consisted of uniformed life-size mannequins, a large red steel refuse shredder, the sea of small cut-out men flowing across the floor, and various waste bins and other rubbish-management equipment. The show was accompanied by an 11-minute video with a voiceover spoken by Peter Chater, an assistant at Karsten Schubert: 'Welcome to Scrapheap Services. The cleaning company that cares because you don't ... Scrapheap Services consider it important that any people who are discarded are swiftly and efficiently cleared away and this is our duty of care ... Scrapheap Services: We leave the Scum with No Place to Hide.' In the spring of 1996, the installation was reassembled by the Henry Moore Foundation at the Electric Press Building, Leeds, and later the same year it was exhibited at Chisenhale in London. In 1996 Landy's research drawings for the project were also shown, at *The Making of Scrapheap Services* at Waddington, the West End dealers. In the catalogue, Alison Jacques – who founded her own gallery in 2004, off Oxford Street – wrote: 'The drawings are working diaries crammed with snippets of information which were important for the artist at particular stages of the venture ... They resemble a soap opera. Each episode reveals the absurd particulars and variety of characters drawn into Landy's world.'

Landy gave his drawings the kind of titles real cleaning companies might adopt to market their services. One of the last of this group of works, *Bin It for Britain* (1996), was as demonically detailed as all the others, and, at 100 x 70.2 cm, larger than most of them. The vulture, Landy's

fictional company symbol, appears several times in this ink drawing, together with details such as a mock share certificate, trial logos and insignia, and also technical specifications about the staff's protection helmets and gloves, their filter masks and much else besides. As is customary for Landy, the essence of his artistic explorations was consistent and long-term, and elements of these early ideas from the 1990s re-emerged in 2010 in *Art Bin*, his organisation of the massive disposal by hundreds of London artists of unwanted works at the South London Gallery, described by him as 'a monument to creative failure'. Visible to the gallery's visitors during the first week amongst the growing pile of smashed work were a Rorschach drawing by Cornelia Parker, a monumental white polystyrene full stop by Fiona Banner, into which a Gillian Wearing photograph had embedded itself, two Damien Hirst skulls and a 7-foot-square painting also by Hirst, Gavin Turk's *Robert Indiana painting*, Julian Opie steel and enamel signs and pictures, and an Ian Davenport drip painting on aluminium.

The gestation periods for Landy's projects are long; their themes link backwards and forwards with a commitment that affirms the artist's emotional attachment to the subjects from which he makes his art. While *Scrapheap Services* is seen to face forwards to *Art Bin* of 2010, it also connects directly back, to *Closing Down Sale* at Karsten Schubert's in 1992, where a similarly insistent audio presentation accompanied the viewing. Scripted by Landy, this audio text commented in market-ese headlines:

> **We're so cheap today, Ladies and Gentlemen. We're saving you cash, we're saving you money … Bear in mind you are under no obligation to buy, no obligation to spend money here today. Have a look round, please. Everything must go! … Bargains, Bargains, Bargains! If you're 5, 15, or 60–6, 16, or 66 we said we would treat you and treat you we jolly well will. Don't be shy 'cos I was shy when I was a little girl and look at me now …**

A key unifying factor in all these works is Landy's attitude to the ritual of labour, both to his own labour as an artist and to his father's devastation at being disabled from work, by which he had felt defined as a human being. Very little sold at *Closing Down Sale*, and much of the

ABOVE
Art Bin, at the South London Gallery early in 2010, became a popular public performance, with artists gathering from all over London to discard their unwanted art into a giant steel and reinforced-glass skip. All day every day Michael Landy sat at a trestle table by the steps to the discard tower, taking the names and details of artists participating. A postcard was sent around to tell artists of the opportunity to participate!

OPPOSITE
Scrapheap Services (detail), installed at the exhibition *'BRILLIANT!' New Art from London* in Minneapolis in 1995. Michael Landy had worked for four years on the project prior to this first showing.

With the support of Artangel, Michael Landy staged in an empty store in Oxford Street in 2001 his *Break Down*, with 36,000 people dropping in during the fortnight to see him and his team shred all his possessions.

material was still in Landy's studio nine years later, ready for *Break Down*, a major project which came to reductive life in 2001.

In *Break Down*, executed with Artangel's financial and organisational support, Landy systematically destroyed in public, at a vacant C & A store at the Marble Arch end of Oxford Street, every single thing he owned. Artangel have since published a ring-bound manual naming in numbered and categorised lists all 7,227 of Landy's former possessions, including all his artwork, his clothes and a much-loved second-hand Saab motor car, which he had bought with the proceeds of his first sale to the Tate, of *Scrapheap Services*. It took Landy and an assistant, off and on, over a year just to make the inventory. There is a contemporary parallel in the publication by Book Works in 1998 of Virgil Tracy's *Under Hempel's Sofa*, with its equally obsessive listing of the artist's possessions, divided into categories such as 'hand tools', 'socks and bedding', 'framed art works', '7-inch singles' etc. and, in Tracy's case, with comments on the objects' origins. In an interview with Julian Stallabrass in 2000, Landy said: 'The inventory is the material history of my life. All that's left at the end of the process will be my memory and the inventory.'

The humanity of Landy's enterprise is marked by a letter from his mother, transcribed in the manual: 'To: Dear Michael & Gillian. Hope everything turns out great. I hope everything is fine for you. I am so proud of you, as so is your dad. You must be so tired. Gillian said you were enjoying every minute of it. Anyway will see you soon. With love Mum X.' The simple conclusion to Landy's afterword has its own poignancy: 'I would like to thank Gillian Wearing for loving me and allowing me to use all her possessions.'

In *Michael Landy: Everything Must Go*, published by Ridinghouse in 2008, the artist demonstrated his awareness of the conflict between admiration and uncomfortableness within many who viewed *Break Down*:

> I thought about it being an examination of consumerism, about me being one of many millions of consumers and somehow at some point we begin to create our own biographies from the things we own or possess. And to realise the power of things and possessions. It was anti-consumerist but it was also as much to do with people's love of things, and of different values and value systems. Because I was dealing with love letters and personal material like that, and they were very important to almost everyone.

He was aware of the element of violence in *Break Down*, with the destruction not only of such love letters but also of art works given him by friends, especially the Hume painting *Clown*, a birthday present of the previous year. Hume had been upset on hearing about the planned obliteration of his work and insisted on taking it back home, before relenting and a couple of weeks later returning the painting to be 'deconstructed', a response described by the Artangel director James Lingwood as 'an incredibly generous gesture'. In an account of the event in *Off Limits: 40 Artangel Projects* (2002), Landy is quoted as saying: 'Talking about value: the only time I ever thought "Christ what am I doing?" was when I set about blow-torching the gloss paint from Gary Hume's painting in front of Canadian and German film crews.' Landy returned to the topic in *Everything Must Go* (2008):

> They were gifts and they were art works and in some ways art works are not in anyone's possession as such. They're just passing through people's hands. But what I think is you can't ever iron it all out, it's never going to be tidy. I couldn't keep the art works because it would have been a cop-out. I thought the art works should be treated just like everything else and not given any special kind of treatment.

Hume agreed so forcibly with these statements that he ended up giving Landy – close friends still today, after meeting at Goldsmiths in 1986 – the present of a replacement painting after the completion of *Break Down*.

The performance by the team of blue-boiler-suited helpers, with Landy stationed in command on the bridge of the conveyor belt, proved compelling, and over 30,000 people visited, some of them several times, to check on progress. Curious shoppers wandered in from Oxford Street, laden with bags of consumer purchases, and marvelled at the mad artist organising the destruction of everything he owned, including objects

Michael Landy's parents, John and Ethel, at Tate Britain in 2004, standing in front of *Semi-Detached*, their son's precise, 1:1 scale replica of their home in Essex.

more or less identical to stuff they had bought a few minutes earlier. Curators also admired this Landy project, and a page from his manual was exhibited in *Face Off* at Kettle's Yard, Cambridge, in 2002, beside contrasting forms of self-portraiture by Lucas, Shaw, Turk, Wearing and others.

Landy put off destruction of his record collection until near the end of his fortnight in Oxford Street, playing selections of the music throughout, the last song spun every night being Joy Division's 'Love Will Tear Us Apart'. Since losing this historical collection, he has ceased all purchase of records, and of any other non-essential items. Because of its emotional weight, the object kept till the very last to dis-assemble was listed in the inventory as 'C318 Bailys of Glastonbury Genuine Sheepskin brown coat 40" chest' – it was his father's most extravagant possession, never worn because, shortly after purchasing it in 1977, John Landy broke his spine in a work accident and the coat was too cumbersome ever to put on. His wife, Ethel, went on paying off the hire-purchase instalments for the unusable coat for a whole year. George Shaw, who was short-listed for the 2011 Turner Prize, also comes from a working-class background, the son of a car assembly-line worker in Coventry who was

made redundant and suffered a serious work-related heart attack in 1979, preventing him ever again getting a job. Shaw, a diligent archivist, keeps safe his own Dad's sheepskin and leather jacket, grateful for the weight of memory it carries. Before his father's death in 2006, Shaw had treated his parents to a special visit to London to see Landy's subsequent major work, *Semi-Detached* (2004), in the Duveen Gallery at the Tate, a full-size replica of the outside of the family's terraced house. George Shaw senior was deeply moved by the parallels.

The completion of *Break Down* left the artist in tatters. It took him a considerable time to recommence work again of any sort. Once he managed to, his self-protective response was quietly, privately, to concentrate on drawing – and on etching: the *Nourishment Portfolio* of 12 etchings of common weeds, published in an edition of 37 by the Paragon Press in 2002, and the *Nourishment* series, a set of 19 etchings of a different group of weeds, in a numbered edition of six, also with the Paragon Press. This delicate, naturalistic work perfectly expressed his mood, focusing on these unappreciated wild plants – in an interview for *The Guardian* in February 2002, Landy said that, having started drawing again, he couldn't stop: 'I've been doing drawings of street flowers. They don't need many nutrients. Can survive in very harsh conditions. I like that analogy of a plant that lives in little cracks in the street. I just pick them from around the estate where I live.' He also made at this time a group of graphite and colour-pencil studies of his father, regularly travelling to his childhood home in Essex to draw portraits of his father's face and sketch his ravaged feet and hands.

These visits played a part in the generation of Landy's next major project, which culminated in *Semi-Detached* at the Tate in 2004, a 1:1 scale replica of the back and front of his parents' house. John Landy's accident, and his uncompromising reaction to it, had affected every aspect of the family's life; indeed Michael Landy sees it as the formative influence on his work after taking up art. *Semi-Detached* is an examination of the personal restrictions suffered by his father, and to a degree by them all, as a result of the accident. On the neutral, gallery-like interior walls, Landy projected three different, fuzzily shot films, edited from 110 hours of video footage he took at his parents' home in 2003. One of the films, *Shelf Life*, focused on the necessities laid out on John Landy's bedroom shelf, listed by Judith Nesbitt in the Tate's booklet as: 'cable clips, Sellotape and electrical tape, a vice, batteries, at least six torches, welder glue, lighter fuel, car indicator lights, dice, Blu-Tack, Vaseline, fuses, utility-knife set, steel-wire brush set, bulldog clips, magnifying glass, heel grips, industrial ear plugs, chainsaw brushes (neatly bagged and labelled)'.

The film *Four Walls* displayed images taken from DIY manuals, as John Landy had decided, despite his injuries, to continue his habit of acquiring the latest power tools and repair equipment, which lay around the house without ever being used. The other film, *No. 62*, usually the

first seen by viewers, was the moving display of confused household details, cutting from the image of a dragonfly trapped in a Tupperware bowl to the broken earphones from Michael Landy's Walkman, abandoned when he was 18 and hoarded by his father through the intervening 20 years. Nesbitt accurately suggests that 'just as *Break Down* directly addressed the question of what composes life, this new work brings that question to bear on the linear, cumulative narrative of the life of a traditional working-class man, whose most vital location of identity has been abruptly removed'. The images projected inside the simulacrum of John Landy's house show him managing, with his damaged hands, to roll a cigarette and sit there smoking it in his claw-like grip. At home he is a slow, sombre demi-presence. In *Semi-Detached* his son made him vividly present to us all.

The hiatus in Landy's life that followed the making of *Semi-Detached* resulted from the diagnosis of testicular cancer, concluding with an operation to remove one of his balls. He marked this event in magnificent fashion, by making in coloured pencil a series of five close-up post-operative examinations of his scarred crotch, one of which is now in the permanent collection of the Wellcome Foundation, others in private international collections. There is a palpable sense of pain within the most detailed drawing, of Landy's mirror-reversed left hand cradling his genitalia in tender distress. He can joke about it now: 'I had to pay for the operation myself. So I did the drawings to get my money back!' He waited two years for the all-clear from cancer, with a resilience and sanguinity evident in the drawings themselves. Recovery has led him to see this potentially threatening experience as having turned out beneficially, since its many interesting sights and sounds have fed his imagination. These intimate self-portraits relate to another substantial group of drawings, mostly in coloured pencil, which Landy made of his father and of the objects at his bedside, such as a Barbie comb, Swan lighter, Extra Long Life battery and Lustral tablets. It was while doing a drawing of the livid scar on his father's leg, where a vein had been removed for a heart bypass, that Landy quietly told him that he had his own scar, the first mention to his parents of his cancer operation. These father drawings were exhibited in Landy's solo show *Welcome to My World (Built with You in Mind)*, which opened at Thomas Dane in Duke Street, St James's, on 1 December 2004.

The next large-scale investigation launched by Landy has yet to be completed. Drawings for the project were exhibited in 2007 by Alexander and Bonin in New York and Thomas Dane in London, with a detailed essay in the catalogue by Barry Schwabsky. The object of Landy's obsession was and is Jean Tinguely's machine *Homage to New York*, which destroyed itself in 27 minutes before an invited audience in the Museum of Modern Art garden in Manhattan on 17 March 1960. Anaïs Nin watched the machine's demise:

the entire structure went into a spasm which opened the boxes of chemicals, and they exploded into coloured smoke which filled the balloon with air, set the roll of pare unrolling and the brush painting erratically ... The piano started to burn slowly, and as it burned the notes played wistfully, out of tune, unreal, like a pianola.

The art critic David Sylvester had marched out of the invitation-only performance before the sculpture was ready to auto-destroy, muttering that he didn't like 'tuxedo Dada'.

Although the shape and formation of Tinguely's machine are thoroughly recorded in photos and words, the actual workings were improvised by the artist and it would be impossible, therefore, for Landy to produce a precise replica; choreography of the destructive event itself is also inevitably open to chance. It may never happen, as the project has encountered copyright problems. But Landy's powers of perseverance are proven, and one of these days we may yet see a rebuilt *Homage to New York* go up in flames again in the same privileged garden at MoMA – 'like a ghost', as Landy sees it.

In *Radical Orchidectomy for a Solid Mass in the upper pole of The Left Testicle* (2005), Michael Landy chose the medium of coloured pencil for one of a small group of self-portrait drawings, part of the process of coming to terms with the removal of a testicle in 2004, while he was being treated for cancer.

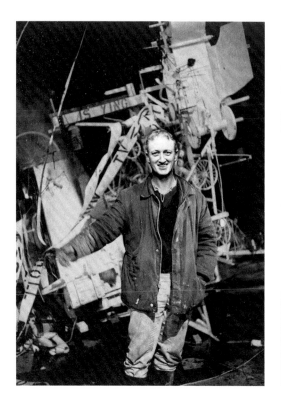

Landy's systematic concentration on the labour of making things was illustrated in his next project, an unbroken stretch of work in his studio over five and a half months in 2007, drawing 70 detailed, life-size portrait heads in two groups: the first is titled *Family* and the second *Friends*. The dealer Karsten Schubert, one of the portrait subjects, insisted on a mirror being rigged up so that he could see the drawing as it progressed, intermittently suggesting improvements. Norman Rosenthal – Sir Norman, now – talked a great deal about artists whom he and Landy knew, with a generosity that belied his acerbic reputation. At the crowded private view in London of the drawings, the sculptor Rebecca Warren expressed relief that her portrait was absent: it had been exhibited and sold in Amsterdam earlier in the year.

As with other members of the Goldsmiths group, Landy's work found its way early on in his career into national collections. The British Council's first Landy purchase was back in 1991 – *I'm Forever Blowing Bubbles (Small) No. 2*, whose bright red wheel came from an old market stall – and they have continued to acquire work connected to most of his major installations. The Council's purchase in 2002 of Landy's large bird's-eye-view drawing of the conveyor belt configuration at *Break Down* was made direct from the artist for £8,000. A drawing of his father's purple-veined lower leg and foot was bought by MoMA in New York, and a group of Landy's portrait drawings from his exhibition in 2008 with Thomas Dane has entered the National Portrait Gallery collection.

Following on from *Market* (see p. 29), Landy made a number of related pieces, including *I'm Forever Blowing Bubbles (Small) No. 2* (1991), which was bought by the British Council.

Artist inter-connectedness is no less evident with Landy than with the others. He had a close relationship during the early 1990s with his fellow *Freeze* exhibitor Abigail Lane, although he has since lived for nearly 20 years with Gillian Wearing, sharing the Spitalfields house they bought from Tracey Emin. Wearing herself was previously involved for several years with another Goldsmiths artist, Mark Wallinger. Financial freedom for Landy and Wearing enables them also to own their self-contained studio, occupying a floor each of the ex-industrial building in Vyner Street, running parallel to the canal at the northern end of Cambridge Heath Road, a brief cycle ride from home. Landy runs regularly in nearby Victoria Park, often with François Chantala, his dealer friend at Thomas Dane's, for company. Fiona Banner's studio is around the corner. Both of them exhibited large, unforgettable wall drawings at the artist-run space City Racing in 1993, and a decade later, Banner and Landy were still showing together, in the Arts Council's touring exhibition *Bad Behaviour* of 2004. Then, in 2009, many of the same artists were involved in the exhibition *Exquisite Trove* at the New Art Gallery, Walsall, mounted by Gavin Turk and Deborah Curtis for their performance creation *The House of Fairy Tales*.

A recent development for Landy is the direct involvement of the wider community in his work, both in subject matter and realisation. In earlier work, such as *Break Down* (2001), the presence of the public as observers was essential to the idea, although they took no part. Stepping towards fuller public participation, in *Art Bin* (2010) the contributors were

Another of Michael Landy's early shows was at the artist-run space City Racing in 1993, when he made the wall drawing *Run for Your Life*.

artists, many of them unknown to Landy. And in *Acts of Kindness*, commissioned by London Underground and running in changing forms continuously from October 2011 to 2013, the public is central to the creative act. Through various forms of promotion, users of the Underground are encouraged to record on a special website acts of kindness by themselves and fellow passengers. A select number of these are then incorporated in enamel signs and on posters placed in and around Central Line stations, and above the seats inside the trains, accompanied by Landy's graphic illustrations, using a version of the 'everyman' cut-out figure invented two decades earlier for *Scrapheap Services*. In describing his visual scheme Landy emphasises the fact that 'the stations are connected by the red line, and people are connected too, whether we like the idea or not'.

Landy developed the *Acts of Kindness* concept in a different form in the central business district of Sydney, based on rotary pen and watercolour pencil drawings he made of the area's map, which was made into a jigsaw and laid on the ground in an open square, to be walked across by the public. Individual jigsaw pieces were also mounted on lampposts throughout the district. The Sydney project opened at the end of September 2011 and ran for a month, followed by a similar project in Athens in 2012.

One night when I was 18 years old I was trying to find a restaurant some friends were meeting at in the city. It was pouring with rain and I was completely lost when this man went out of his way to show me directions and then gave me the huge rainbow umbrella he had with him – all without even a handshake or name exchange. It was so simple but it made my night. The rainbow umbrella still reminds me of its benevolent previous owner.

Also in the autumn of 2011, Landy rebuilt at the Frieze Art Fair his credit-card-eating machine, which also makes drawings, first seen at the Louis Vuitton store in Bond Street a year earlier. The unlikely sight of the left-wing Landy inhabiting a luxury shop of designer bags is explained by Vuitton's sponsorship of the contemporary arts, which includes their two-page advertisements in every issue of *Frieze* magazine. Vuitton, Landy points out, paid for *Art Bin* at the South London Art Gallery, on the condition that they premièred his machine. As the public operate the credit-card destruction themselves and make their own drawings, sometimes on Landy-signed paper, this too is part of his new participatory theme.

Landy's artist's residency at the National Gallery in London runs until 2013, and this also contains elements of participation, with members of the public visiting his studio there, and with imaginative forms of gallery discussion, culminating in an exhibition of his work in the gallery, some of it related to the collection. 'It does interest me, using the public somehow. Rather than being used! Sort of turn the tables,' Landy says, with a characteristic twist of irony, recalling the early years when his work was ignored by almost everybody outside his narrow band of supportive Goldsmiths friends.

Michael Landy's big public project in Sydney, unveiled in the last week of September 2011, with its jigsaw map in Martin Place and individual 'acts of kindness' signs in the streets, was instantly popular with the Australian public.

8 / SARAH LUCAS

Located at the centre of things in relation to the yBas, Sarah Lucas nevertheless leads a highly independent life, artistically and socially. Since the mid-2000s she has spent most of her time in the Suffolk countryside, in a secluded property close to the Norfolk border. Accustomed to making use of the material and circumstances at hand, Lucas has made much of her recent work in the house, at times in the kitchen, helped by her partner, the photographer and audio experimenter Julian Simmons. In the past she has been particularly close to – in chronological order – the Goldsmiths artists Grenville Davey, Gary Hume and Angus Fairhurst, the first of whom won the Turner Prize, for which Lucas herself has regularly declined to be short-listed. Her bold approach to the means of art-making was much admired by these early partners, and she remains an influential figure today, selected for the second time, in 2011, for the Hayward's five-year *British Art Show*, on the grounds that she was making 'the best work of her career', notably with *NUDS* (2009–10), a series of writhing sculptures formed from stuffed nylon tights. The curators wrote in the 2011 catalogue: 'Of all the British artists to emerge in the early 1990s, it is perhaps Sarah Lucas who deals most persuasively with the human body and how it is enmeshed in a sticky web of desire and disgust, oppression and resistance, and the tragicomedy of sex and death.'

Although Lucas retains solitary control of the creative decisions about her work, and indeed seldom requires help even with their physical execution, she is in a sense the most collaborative of these five Goldsmiths artists. Over the years she has shared studios with Hume, Fairhurst and others, largely for social reasons, relishing the exchange of ideas, whilst making most of the sculpture itself either at her house in Dalston or 'on the hop', as she calls it, on site at the various locations of her exhibitions. With the passage of time this practice has developed, so that her solo shows in Auckland, New Zealand, in 2011 and Mexico City in 2012 were largely executed in the studios loaned by the museums for her use on extended visits prior to the openings.

'I try to keep my plans to a minimum, for shows and things like that. To hold the freshness,' she explains. 'I don't like to fill up my daily life with a job of work, because I've never really known what the real work is with me. I mean, obviously there's a moment when I'm actually making things, but I'm a head person mostly, spend more time reading than making art!' Living these days in relative isolation in rural Suffolk, the objects she makes become, on exhibition, the place where her freshly

OPPOSITE
Sarah Lucas in 1992, standing in front of a wall of her solo exhibition at City Racing in Lambeth, pasted with her blown-up images from the *Sunday Sport*.

Continuing in her established preference for using accessible resources in the making of art, Sarah Lucas cast most of the sculptures for her show *Penetralia* in her own kitchen in Suffolk, including the piece *EROS*, presented at Sadie Coles HQ in 2008.

developed ideas meet the outside world. The work retains its youthfulness in part because art is to her a form of direct dialogue with wider concerns. With Lucas, the installations need to be accessible to everyone, not simply to the narrow art world. She carries an image of herself living as if hidden in a deep forest, gathering berries and nuts, and every couple of months taking her discoveries out into the local market square to show and share and sell. Lucas remembers with self-sympathy the idealistic fantasies about being an artist with which she went to art school in the mid-1980s, and then quite quickly beginning to wonder how you

LEFT
Made from stuffed nylon tights, *NUD 25* (2009) was first exhibited in Sarah Lucas's solo show at Sadie Coles HQ in London in 2009. The photograph here is by her partner, the sound artist and photographer Julian Simmons.

RIGHT
In advance of her shows Sarah Lucas likes to spend time in the places where she is exhibiting and executes much of the work on site. Clearly, the visit to New Zealand in 2011 for her exhibition *NUZ: Spirit of Ewe* provided direct inspiration. Opening in Auckland and then moving on to Dunedin, Lucas referred with gentleness rather than derision to the country's dependence on sheep farming.

knew when it was that you became one. Eventually, when she started to make things that she herself was surprised by, she thought that maybe this was what made the difference. The criteria have remained the same, proof that being an artist has for Lucas nothing to do with reputation, or sales, but is dependent on her own private sense of surprise in what she creates: 'I still have that romantic idea of making art being a kind of magical thing.'

This approach was illustrated at a show she devised to coincide with the five days of the Frieze Art Fair in October 2011, mounted in the bar of the St John Hotel, off Leicester Square, owned by the chef who began 15 years earlier with the restaurant in Smithfield that Lucas and her friends frequented. The artist was described as 'making new works and holding court in both her bedroom and the hotel bar'. Lucas had only thought of the idea ten days earlier, and based the work on a piece she had made for the Snape Maltings in the summer – she has never visited Frieze itself: 'Not a thing of principle,' she insists, 'I just know I don't want to go!'

Lucas does not spend much time in town these days, centring her life in East Anglia. Hidden down a single-track lane that winds behind a Methodist chapel, her house in Suffolk was chosen by Benjamin Britten and his partner, Peter Pears, as a retreat from their busy big house at Snape. The link to Britten was one of the main reasons Lucas bought the house in 2005, before moving there full-time in 2007, when she became based outside central London for the first time in her life. Britten built himself a working hut at the opposite end of the garden to where Lucas

Sarah Lucas in 2008, in the studio in her garden in Suffolk, with views through the glass doors out on to open farm fields. She contemplates a work in progress, with the title *NOBODADDY*, taken from a poem by William Blake about a patriarchal God. The name was also reused by Salman Rushdie in his book *Luka and the Fire of Life* (2010).

assisted in the physical making of her larger wood-and-glass studio. The entire property faces directly out over fields and trees, with no intervening fence or hedge, not another building in sight, the sky an inspiring presence at every moment of the day.

Although Lucas spends much of her time alone, reading and thinking, she also needs other creative people at hand to share thoughts and ideas. Several of her regular local contacts are ex-London connections, including her *Freeze* colleague Abigail Lane and the sculptor Don Brown, both of whom live full-time in Suffolk. Her dealer Sadie Coles, who initially shared the house with her, now keeps a weekend cottage on the coast not far away, with her partner the German photographer Juergen Teller, the father of her child. The photographer Johnnie Shand Kydd is a regular visitor to his mother in Suffolk, whose estate encompasses a cottage rented by Pauline Daley, Coles's colleague at the London gallery. One of Lucas's nearest neighbours, another friend from London, is the sound artist Russell Haswell, who was already exhibiting at the ICA in

the early 1990s and has worked with artists such as Cerith Wyn Evans on installations, using his own version of the UPIC system invented in the 1970s by Iannis Xenakis, a machine developed to turn graphic marks into sound, with the utopian aim of freeing composition from the limiting constraints of musical notation – 'multi-channel electro-acoustic diffusion', Haswell has called it. With Florian Hacker, Haswell performed a graphic musical piece for the Serpentine Gallery's crowded opening of their summer 2007 pavilion, designed by the fashionable British architect David Adjaye and the Norwegian artist Olafur Eliasson. Down in Suffolk, Haswell and Lucas, with her partner, Julian Simmons, mount exhibitions and attend concerts at Snape; the presence of György and Márta Kurtág has been a highlight of recent seasons. Without the interference of London demands, Lucas relishes the opportunity to develop her long-term interest in experimental music.

Through a chance meeting at the Aldeburgh Festival in 2008 with her old tutor Michael Craig-Martin, Lucas has been encouraged to reactivate the original Benjamin Britten plan of combining the visual and the musical arts. The first flowering of her ideas was in putting on the show *SNAP: Art* in Snape in June 2011, which brought together sculpture, photography, video and sound installation. The central trio of Lucas, Haswell and Simmons were joined by Lucas's friends Don Brown, Gary Hume, Johnnie Shand Kydd, Cerith Wyn Evans, Abigail Lane and Juergen Teller. This collaborative form of curating has always appealed to Lucas, and she intends to do more of it in the future. Her exhibition at the Kunsthalle in Krems in the autumn of 2011 illustrated another form of artistic co-operation that Lucas enjoys, in making things that worked effectively with the four-artist German group Gelatin and some 16th-century paintings by Hieronymus Bosch.

Bosch has long been a yBa favourite, particularly with Damien Hirst and Jake and Dinos Chapman. On occasion their work, and that of Gelatin, and indeed of Tracey Emin, with her infamous bed, has been judged by members of the public gratuitously offensive, whereas people usually respond to the work of Lucas, despite its overt sexuality and blatant disavowal of crafted technique, as a serious, personal expression. From her first solo show, *Penis Nailed to the Board* in 1992 at the artist-run space City Racing, to her contributions to the *British Art Show* in 2011, Lucas has consistently dealt with issues that she cares about, often to do with public attitudes to sexual difference. Part of the critical respect for Lucas arises from her being a difficult artist to categorise – in some senses a 'political artist', dealing with issues also tackled by the Feminist movement, Lucas creates work that is nevertheless strictly non-doctrinaire. In 1996 she had her first two European solo shows, one at the Museum Boijmans van Beuningen in Rotterdam and the other at the Portikus Gallery in Frankfurt (see p. 9), where, in conversation with Brigitte Kölle, Lucas claimed that 'what I am like is very much what I'm after in my work'. On

Both an exhibitor and a spectator at the nearby Aldeburgh Festival, Sarah Lucas co-curated the exhibition *SNAP: Art* at Snape Maltings in 2011, combining sound and vision. This section of the summer show was recognisably created by Lucas herself.

OPPOSITE
At Krems in 2011 Sarah Lucas took advantage of the space to make a great pink spiral staircase, with *NUD* sculptures on the steps and new chair pieces sharing the platform.

the other hand, she also stated that the art persona was fictional: 'The work isn't me ... it's more a question of "I see that in the world", and I think I have to face up to that somehow or another.' These outwardly contradictory remarks hint at the reason for the art world's continuing fascination with Sarah Lucas.

Although it took place at City Racing, an artists' squat in Lambeth, and was seen therefore almost exclusively by the young art crowd, Lucas's show *Penis Nailed to the Board* has had a lasting impact. The largest sculpture in the exhibition, *Last night I got loaded, on a bottle of whiskey, you know I feel alright* (1992), consisted of a bicycle balanced upside down on the gallery floor, its back wheel held in a wooden fork which was fixed to a long shelf supported at its other end on the front wheel of the bicycle. On the shelf stood 22 cardboard cut-outs mounted with photographs of the torso of a seated naked man holding a pealed banana in suggestive positions. In some of the photographs, which faced in both directions, the phallic banana was accompanied by a testicular apple. The man pictured, head and feet cropped, was Gary Hume.

In Lucas's photographic self-portraits *Eating a Banana* (1990) and *Divine* (1991), also in the City Racing show, the latter of the artist sitting spray-legged on a flight of steps, the situation was reversed and Hume was behind the camera, following his girlfriend's directions. This series of works was significant in establishing the Lucas image of an outwardly tough young woman, with short hair, no make-up and a fag hanging out

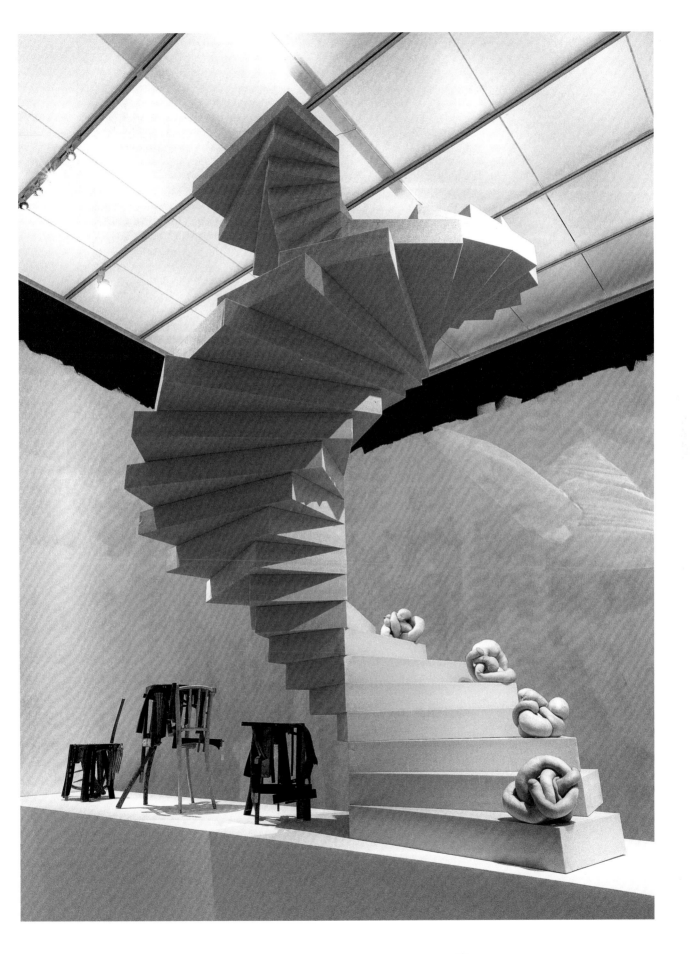

Unknown Soldier (2003), erected in the doorway of Sarah Lucas's house in Dalston. The placing of the concrete military boots is based on her early *Boots and Razor Blades* (1991), and the fluorescent light tube symbolises both gun and penis.

of her mouth. The exhibition included *Sod You Gits* (1990), *Fat Forty and Fabulous* (1990) and *Seven Up* (1991), comprising photographs cut from the *Sunday Sport*, blown-up and mounted on cardboard, highlighting the sexually compromising kind of articles that regularly appeared in the tabloid newspapers of the time – the three were bought, as it happens, by Charles Saatchi for £3,000. City Racing charged only 10 per cent commission, rather than the standard 50 per cent, fulfilling their principle of working for the artist rather than for profit. Images such as these were the standard daily fare of Lucas's girlhood on the Holloway Road, and her approach to this element of her work is typically untypical of the art school milieu, referring jointly to her enjoyment of the wild diatribes of American feminist Andrea Dworkin in her books *Pornography* and *Intercourse*, and at the same time emphasising a sense of fun with the subject. Lucas was interviewed for her Rotterdam catalogue in 1996 by Jan van

Adrichem, currently Head of Collections at the Stedelijk Museum, Amsterdam, to whom she said:

> One of the things that is fundamental to art – and especially to the art I do – it to keep it alive. There is a certain energy about it, which is important ... I can use my awareness of aspects of everyday life in making art ... My work is not laboured; it's like play. Things somehow have to flow quite naturally. It is like I have to be distracted.

The exhibition *In-A-Gadda-Da-Vida* at Tate Britain in the spring of 2004 brought together Lucas, Hirst and Fairhurst in a large and ambitious three-person show. Photographs published in the catalogue documented their long friendship: on the inside back cover was a black-and-white shot, taken in the mid-1990s by their mutual friend Johnnie Shand Kydd, in which the three of them sat in the summer heat in an old stone horse trough, Hirst with his head shaved and Lucas with her hair longer than customary, wearing a white dress and with an open smile. In the catalogue Lucas described this exhibition as 'a conversation I've been waiting to have for a long time', before proceeding to acknowledge how difficult she finds working relationships, particularly with two men so different from her, and from each other: 'Where Damien uses every trick in the book to satisfy demand, including packaging everything beautifully, Angus often seems to resist satisfying anybody.' The title of their show, proposed by Fairhurst, was taken from a 1968 recording by the

A number of Sarah Lucas's works in *Penis Nailed to the Board* at City Racing in 1992 used photographs of Gary Hume, her partner at the time. *Last night I got loaded, on a bottle of whiskey, you know I feel alright* (1992) incorporated a row of naked, headless photographs of Hume.

In the 1970s the Arsenal footballer Charlie George was a local hero in Holloway, where his family lived a few doors from Lucas's parents. For her show *Charlie George* at Contemporary Fine Arts in Berlin in 2002, Sarah Lucas issued an invitation in the shape of a pizza box with, on one side, the exhibition's details and, on the other, a collage, related to leaflets that she called *The Charlie Red Series* (2002).

psychedelic rock band Iron Butterfly, in which the keyboard player, Doug Ingle, mangled the title of their new track 'In the Garden of Eden'.

At times Lucas has objected to the exaggerated exploitation of the yBa phenomenon. In 1999 she spoke to Richard Cork about her unease with the media coverage of group shows such as *Sensation*: the hype made it difficult for her work to be seen for what it is, and the social issues that concern her tended to be ignored. On the other hand, the power of such exhibitions to generate subsequent solo shows is welcomed, and she does not wish to lose this access: 'It does worry me that the scene here might run out of steam. The idea of artists slaving away in isolation has never appealed to me. I'm very keen on maintaining my potential as long as possible. Other people use face cream – I want potential.' It is instructive that over a decade ago Lucas already felt the art bubble must at some time burst, whilst remaining positive about such a prospect. She recently reiterated her trust that, whatever happens, she will respond resourcefully.

Although, years ago, Lucas decided never to have children, she is gregarious and fun, and a loving companion. Hume describes their time together in the years either side of 1990:

> We had people round a lot. Sarah, she's a good cook. I cook. And there'd always be an overwhelming amount of booze drunk. People dancing on tables ... Living in a squat somewhere, you had space and noise and chaos. ... And you'd always have something to look at, a piece of new art ... 'What do you think of that?' I'd ask ... Years ago, having dinner at Don [Brown]'s flat in Hox-

ton Square, a couple of doors from my studio, I'd be dragging my paintings round. Out into the street. Up the stairs. Asking everyone what they thought ... Now I'm too shy. In the studio people are looking at my work and I wish they weren't ... I'm too anxious about it ... In the old days we really were an empowering gang.

Where Hume began commercial exhibiting in London in 1988 with Karsten Schubert, before settling down in 1994 with Jay Jopling at White Cube, Lucas took longer to find her dealer home. Courted by several leading London galleries, she was given solo shows in 1994 by both Anthony d'Offay and Jay Jopling, and in New York the following year by Barbara Gladstone, with *Supersensible*. During this time Lucas was waiting until her friend Sadie Coles was able to open her own gallery, her period as principal assistant to Anthony d'Offay having been followed by a year in New York working for the artist Jeff Koons. In 1997, the first year of operation of Sadie Coles HQ, Lucas's patience was rewarded with two solo shows: *Bunny Gets Snookered*, in Heddon Street, and *The Law*, an off-site installation at St John's Lofts in Clerkenwell. Since then, the public profiles of Coles and Lucas have grown in tandem. The gallery rapidly expanded to include regular off-site exhibitions by people such as Matthew Barney, and in 2007 Coles opened a second gallery, in South Audley Street in Mayfair, with the addition of an intriguing muse-entrance display area. In the winter of 2010, a year after closing the Heddon Street premises, Coles opened a large new space in Nigel Greenwood's old premises in New Burlington Place, back in the West End centre of things for contemporary art. In February 2012 Sadie Coles opened a section of these premises for the exhibition of work made and curated by Sarah Lucas. With *Situation* as its working title, the new gallery planned to show four new Lucas installations every year, alongside a programme of events directed by the artist.

Although Coles's involvement with the well-known American artists John Currin and Richard Prince, both of whom she represents, is commercially significant, these and all her gallery connections are, from Coles's point of view, personal and individual: 'The artists and their ideas – I think that a million times a day ... And talking about art to facilitate the commerce that repays the artists and supports them in what they want to achieve.' On another occasion, Coles told the socialite collector Adam Lindemann that taking on 'a new artist is going to require spending a lot of time together, with a lot of ideas and trust and effort ... [and] as you tend to have close, long-term relationships with the artists you represent, so you need to choose carefully'. Benefits flow in multiple directions: Coles was able to persuade Prince to paint his largest mural to date on commission from her gallery's major backer, Oliver Peyton, at his Knightsbridge restaurant Isola. From its inception, Sadie Coles HQ has

When Sadie Coles opened her own business in 1997, she immediately gave her friend Sarah Lucas two shows, one of which, titled *The Law*, was an off-site installation at St John's Lofts in Clerkenwell.

handled the work of a select group of British artists, including – in addition to Lucas – Angus Fairhurst, Don Brown, Simon Periton and Nicola Tyson. Appearances deceive. South Audley Street is an old-fashioned Mayfair street, with a gunsmith down the road and Thomas Goode, the Queen's ceramicists, opposite. Luxury and privilege and convention flourish. But the slickness and sophistication of the Coles premises conceal relationships that go back a long way, committed to mutual trust: the dealer's trust in the artist to make good work, and the artist's trust in the dealer to sell it.

Significant shifts in the habits and location of a maker's life can occur without any shattering break in the nature of the work. When Lucas presented her new pieces in Audley Street in the autumn of 2008, in *Penetralia*, this was her first London exhibition for six years. While the gentler materials of a rural landscape have replaced the detritus of a big city, Lucas has retained her old principles of improvising uses for things around her, such as chunks of timber and slabs of slate encountered on country walks. In this instance, Lucas worked on the show with her partner, Julian Simmons, who took a series of black-and-white images (see p. 116) for a limited-edition volume, printed and bound locally. Admiring this whole project, Anya Gallaccio reckons Lucas gains enormously from always being herself: 'Sarah doesn't give a shit about money. She produces as much work as she wants to. Lives down in Suffolk. Does it for herself.'

At the time of the *Penetralia* exhibition, Lucas was still struggling to come to terms with the suicide earlier the same year of her previous boyfriend Angus Fairhurst. The journalist Deborah Orr suggested in *The Guardian* on 8 October 2008 that the loss of Fairhurst had 'made her even more wary about those parts of the art world that are not entirely focused on art'. The sense of loss does not get any easier with the passage of time, and whenever Lucas is preparing for an exhibition and the time of tension and doubt arrives, these days she always thinks of Fairhurst, and feels such sadness for the difficulties he always had with his shows.

Lucas believes in openness, in sharing actual feelings and thoughts, right or wrong. As she said to Orr in 2008:

> I have more money now than I ever did before, but in many ways my life is the same. I don't want loads of people in my life to look after things. I don't want making art to be a business. I don't want to employ people. I've never wanted that. That's never what it has been about for me ... What appeals to me is that life

is a mystery – that there's a world and it's an adventure. I think I always wanted to go on the adventure, and take the leaps that you can in the potential world.

She also listed some of the disadvantages of acclaim: 'One is that you don't have time hardly to even think of what you're doing; the second awful thing is, nobody gives you any sympathy because they think you are doing so well!'

In some ways the woman-oriented strength of Lucas's work, whilst drawing attention to female artists, also blurs the concentrated focus required to register the softer approach of many amongst the next generation of women artists. The artist and critic Matthew Higgs pointed this out as a judge of *British Art Show 5* in 2000: 'I think it's harder for younger female artists to find a place for themselves in relation to works as strong as, say, Sarah Lucas's representations of herself, or Tracey Emin's quite phenomenal ability to make her own history public.' Lucas was accompanied in the 2000 British Council touring exhibition by 50 other artists, including her *Freeze* colleague Michael Landy, her Goldsmiths contemporary Liam Gillick, her friend Tracey Emin and Paul Noble, one of the co-founders of City Racing. The art-company of like-minded friends matters to her, helps her keep the work fresh. The fact that Lucas has managed to maintain into 2012, her 50th year, both public and private faith in her capacity to surprise and challenge is a considerable achievement.

In another of *The Law* exhibits in 1997, Sarah Lucas adapted one of her iconic black-and-white photographic smoking self-portraits, made in 1996. Twenty images were applied with different inks and coloured acrylic to make a large frieze, titled *Fighting Fire with Fire (20 Pack)* (1997).

9 / LOSS

The future matters to artists because they give the major part of their lives to creating things, with the hope that their work will make a difference. Artists have to believe that there is, at least in the long run, a wider meaning to what they do, need to sustain faith in the essential quality and worth of their work.

If not ... what?

Difficult.

It feels impossible to accept defeat and do something else. After 20 years of being full-time makers, what else *could* they do? Art school graduates, with no other qualifications and negligible aptitude or desire for anything else. Haunted by a threat of failure and the anticipated shame of giving up the struggle. Fear of being unable to make sense of things, of one's life becoming a nonsense.

Hard.

Too hard for some. At least three of the yBas have died young, either in neglect, through foolishness or by desperate intention. Angus Fairhurst's suicide early in 2008, out in remote woods near Bridge of Orchy, in the Highlands of Scotland, was publicly the most prominent of these deaths, with a memorial evening held at Tate Britain in his honour later in the year.

The guests invited to the Tate were greeted in the entrance hall by the sound of a looped tape, originally compiled in the early 1990s by Fairhurst for his air band Low Expectations. Further inside, a bronze cast of his life-size armless gorilla stood at the centre of the Duveen Gallery, where friends gathered to celebrate his life. Speeches were made, the principal responsibility for this taken by his Goldsmiths colleague Anya Gallaccio. She began hesitantly, affected by the occasion, telling the crowd of when Fairhurst and she first set eyes on each other, over 20 years earlier, at the start of their undergraduate study at Goldsmiths. It was in the college canteen, she remembered, and he was looking at her breasts: 'I didn't object. Liked the way he stared, actually!' she said. Gallaccio emphasised the warmth of Fairhurst's attention to his friends, from beginning to end, and praised his active belief in the artistic community. Like many of this reputedly decadent group of artists, Fairhurst was a perfectionist, whether making a drawing, chopping vegetables for a meal or synchronising his band. Kindness, imagination and a sense of humour, Gallaccio suggested, were inseparable from his self-doubt. Fairhurst's sensitivity made him a particular support when Gallaccio went

OPPOSITE

In Abigail Lane's *Misfit* (1994) the model for the wax figure was Angus Fairhurst. It was part of Lane's solo show *Skin of the Teeth* at the ICA in 1995, and the piece was purchased by the Saatchi Gallery.

Join us to celebrate the life and work of

Angus Fairhurst
(1966 – 2008)

Friday 25 July 2008
19.00 – 21.00
Speeches at 19.45

Tate Britain
Please arrive via
the Millbank Entrance

RSVP:
Brad Macdonald
External Relations

telephone: +44 20 7887 8748
email: brad.macdonald@tate.org.uk

Angus Fairhurst *Untitled* 1994 ink on paper 21 x 30 cm
Courtesy The Estate of Angus Fairhurst

BRITAIN
TATE

Angus Fairhurst's untitled drawing of a gorilla from 1994, used by Tate Britain on their
invitation to attend a private celebration of the life and work of the artist, held in the
Duveen Gallery on 25 July 2008.

through her own period of darkness, in 1989, after her artist brother hanged himself. Fairhurst never deserted her, a reliable presence even when there was nothing practical to be done to stem her sorrow.

Mat Collishaw, Gary Hume and Cerith Wyn Evans, all air players in Fairhurst's band, were there at the Tate; only Damien Hirst was missing from the old line-up. Don Brown, his wife Yoko Yamado and their baby Eriko – the family with whom Fairhurst had stayed over the weekend before he died – were there too. The two artists had shared a studio in Kilburn for a couple of years, until Brown moved to the country. Beside a column stood Sarah Lucas, Brown's near neighbour in Suffolk, pallor resonating her sadness at the loss. A headless life-size concrete cast of the naked Fairhurst had featured in Lucas's sculpture *Cnut* (2004), exhibited at Tate Britain in their joint show with Hirst, *In-A-Gadda-Da-Vida*. Ten years earlier Fairhurst had agreed to be the model for another *Freeze* friend, Abigail Lane, in her piece *Misfit* (1994). The mood at the Tate was of gentle sorrow, of love and affection for the first key member of their group to die, at the age of 41. The progressive novelist B. S. Johnson was a year younger when he killed himself in 1973. He had stated in his book *Aren't You Rather Young to be Writing Your Autobiography?* (1967): 'There are not many who are writing as though it mattered, as though they meant it, as though they meant it to matter.' Fairhurst was this kind of artist. Writing in the catalogue of the group show *Apocalypse* at the Royal Academy in the autumn of 2000, Norman Rosenthal suggested that Fairhurst 'acted as a kind of moral preceptor to a whole group of artists'.

Doubt about his art was at the centre of Fairhurst's pain. By general standards he was a successful artist, admired by colleagues he trusted and praised by critics whom he did not, with several solo museum shows and numerous prestigious group exhibitions to stamp his public worth. All the same, Fairhurst had made his self-disdain increasingly clear. Gallaccio observes that 'Angus was a bit like a middle child, always feeling in the shadow of us ... first of Damien, then of Sarah ... He wasn't, but I think he felt he was.' Sadie Coles, his dealer, wrote in *The Guardian* in December 2008: 'He was unafraid and generous enough to show how difficult the creative process could and should be. His readiness to reveal self-doubt was risky, but ultimately sincere and brave. How much of his work was informed by melancholy is now open to examination.' The day of his death, Saturday 29 March 2008, was the final day of his third solo show at Sadie Coles HQ, in her South Audley Street gallery, where he had an appointment to meet Coles and Lucas for lunch and a last look at the work before it was packed away. Instead, after months, even years, of loss of faith in himself, utterly bereft of ideas for future work, Fairhurst was unable to face his friends. His body was discovered the following day.

Fairhurst had come to question the whole yBa project. He was conscious of the compromises that he and the Goldsmiths group had made with established institutional habits and with the cult of celebrity.

Angus Fairhurst liked to work with found postcards, from which he usually removed sections with a scalpel, but in this early example, from 1989, he blocked out a tourist view of the Matterhorn with a felt-tip pen, in an act of determined obliteration. Tacita Dean made significant use of a Matterhorn postcard from her collection for *FILM*, mounted in the Turbine Hall at Tate Modern in the winter of 2011–12.

The suggestion that their early energy and adventurousness were compromised by capitulation to the very orthodoxies they had set out to demolish was a personal sadness to him. There are parallels between Fairhurst and the mail-art pioneer Ray Johnson, who in January 1993 jumped from a low bridge in Sag Harbour, Long Island, and swam out to his death at sea. In Alex Sainsbury's view: 'There are myriad Ray Johnsons: fêted pioneer, obscure outsider, critic or craver of celebrity. He possessed seemingly contradictory impulses, to be private and public, to guard the exhibition of his work, and to lose it in mass circulation.'

Philippe Bradshaw, whose body was recovered from the River Seine in August 2005, had also been at Goldsmiths in the mid-1980s, and later became the regular drummer for the band Low Expectations. He was 39 when he died, and an obituary in *The Independent* wrote of the 'genuinely dangerous pitch to his recklessness'. Not that these known traits had halted increasing public attention to his work, with solo shows at Independent Art Space in London, Jeffrey Deitch Projects in New York, Galerie Thaddaeus Ropac in Paris and the solo exhibition *A Fly in the House* at the Museum der Moderne in Salzburg in 2004. At the largest of the shows, in Salzburg, Bradshaw made impressive use of the technique he had developed of stringing classic pictorial images together with personal, patterned and graphic inventions on long, ceiling-hung curtains of aluminium chains. Alongside the Old Master images he projected videos onto the curtains, one of himself becoming progressively more drunk while lying naked on the floor watching the Olympic Games on television, pissing on flowers growing on a couch standing next to him.

In conversation with Carl Freedman for the catalogue to the exhibition *Andrea & Philippe Present: Philippe Bradshaw*, at The Showroom in 1999, Bradshaw stated certain self-perceptions:

An installation view of Fairhurst's last solo live show, at Sadie Coles HQ in Mayfair. He killed himself on 29 March 2008, the final day of his exhibition, at the age of only 41.

Discarding rules, recognising my own rules, and being aware of when and why and how I'm breaking them. Recognising my contrariness and directing this into my work and not so much into the world. Perhaps it's having this constant urge to satisfy something and not know what that something is. A perverse kind of curiosity.

Philippe Bradshaw, who drowned in Paris in August 2005, here seen in 2001 standing beside one of his trademark coloured curtains.

In a joint venture with his partner, Andrea Mason, the mother of his two sons, Bradshaw made the *Vending Machine*, designed to join Sarah Staton's *SupaStore* in its perambulations around the country between 1993 and 1995, selling pillbox franchises, with every buyer receiving the prize of a small box containing original works of art, made not only by Mason and Bradshaw but also by Deller, Turk, Fairhurst and Emin. A related idea involved the design and making of a painted galvanised-iron kiosk which they transported to prominent sites in London for the day, and from which they sold pillbox lighters, key fobs and walking-stick badges, to promote *Landfill*, the name of their fictitious estate agency.

Joshua Compston, a fellow-traveller of Bradshaw and Mason's, had assisted them with the *Landfill* project, taking trips into the countryside with them to document concrete pillboxes on the banks of canals, part of the Second World War

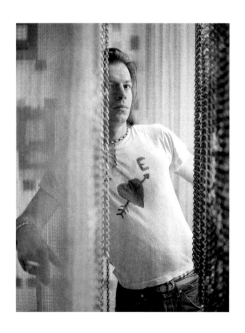

defence system against putative invasion by the Germans. Both Compston and Bradshaw were celebrated by their peers. The pall-bearers at Compston's funeral in 1996 included the artists Turk, Hume and Fairhurst, and two of Europe's leading dealers, Jay Jopling and Aurel Scheibler, whilst the donors of work to an auction in 2007 on behalf of Bradshaw and Mason's young sons included Collishaw, Landy, Hume, Noble and Webster, Wearing, Turk, Deller and Lucas, who together raised over £90,000. It is unlikely that either Bradshaw or Compston intended to be dead, on the threshold of serious public attention. Both of them had frequently diced with death, taking so many chances with drink and drugs and sheer bravado that an air of semi-invincibility, tinged with delusion, had been allowed to incubate. They were caught by their own hubris: one tumbled into the clutches of a big-city river and was found four days later in the weir by Notre-Dame; the other fell asleep in a stupor beside an open bottle of liquid ether, where his body lay undiscovered for three nights.

Marc Quinn, Hume's studio neighbour in Clerkenwell, also risked death, in his case by descending at a young age into alcoholism. He has recovered through total abstinence, and made a piece called *Self-Conscious* (2000) that reflected directly on the science of this fact. Quinn wrote about the work for the catalogue of his large Groningen exhibition in 2006:

> **Self-Conscious is a strand of my DNA containing many complete copies of my genome preserved in a test-tube in 99% proof alcohol – which is ironic, since, being an alcoholic, I can no longer drink alcohol. The destroyer of one part of me becomes the preserver of another. There is probably a gene in my DNA which contains the possibility of alcoholism.**

Quinn was at school with Jopling at Eton, and became his friend's first artist client in the late 1980s, despite not having gone to art college. It was Quinn's relative wealth which enabled him to drink to excess while still so young, whereas with Hume, Hirst, Emin and other top drinkers amongst Jopling's artists, when a weekend's supplies ran out, work had to be done and money earned.

The painter Simon Bill participated in all the Factual Nonsense street events in the early 1990s, notably with his stall at the *Fête Worse Than Death* in 1994, *Cabinet Gallery's Mutilate the Melon Man*, at which fairgoers were invited to stab knives into the juicy red flesh of a scarecrow made of water melons. Seventeen years later the Cabinet Gallery were to publish Bill's first novel, an indication of the longevity of some art-world relationships, which offer a bulwark of protection against the inevitable onslaughts of fragility. Bill's narrator in *Brains* (2011), a fictional artist, expresses recognisable truths:

Landfill, a long-term project by Andrea Mason and Philippe Bradshaw, was exhibited at IAS in Chelsea in 1997. Prior to his death the previous year, Joshua Compston had helped with the identification of Second World War pillboxes for inclusion in their realist-seeming property prospectuses.

APPLEDORE, KENT

Idyllic canal-side setting. A hexagonal, concrete pillbox
with protected entrance, on the edge of the Romney Marsh.
This well preserved pillbox has a good view of the lock and
the picturesque village in the background.

PROPOSAL To glaze in 6mm toughened glass

DIMENSIONS Currently unavailable.

PRICE On application

 Ref 032

I had become subject to a kind of depression or weariness – a sense of defeat that afflicts me sometimes when I look at great art of the last century. This is to do with perennial insecurity about my work, when it's brought home to me that I have added nothing to the achievements of the past. I'm not really saying anything new.

If makers are to experience their work as meaningful, they must at the least survive. The late 1980s and early 1990s were a period when almost all young artists drank much too much. Many of today's art students still do. With Hirst and Hume, however, the habit of excessive drinking lasted beyond student time and became dangerous, a threat to their ability to work and, potentially, to their survival. Hirst explained

The painter and novelist Simon Bill in Hoxton Square, with his stand *Cabinet Gallery's Mutilate the Melon Man* at the *Fête Worse Than Death* in 1994.

in an interview on *Front Row* on BBC Radio 4 in September 2008 that he felt for 20 years that drink was an essential part of his life, which made it hard for him to see it as a problem. Looking back, he admitted that for several years his intake of alcohol was out of control, making him irritating company. In a conversation with Gordon Burn on the train from Stroud to Paddington in 2000, the writer noted that Hirst had stopped drinking. The artist explained that he'd begun to get black-outs: 'I used never to get black-outs ... I don't know if it's something mental. But I just think it's safer to lay off it for a bit, and calm down.'

At around the same time, Hume registered danger in his bouts of paralytic drunkenness. Warned by an intrinsic sense of self-protection, and wishing above all else to be fit and focused enough to paint and paint and paint, he has taken up regular Pilates and swims as often as he can. Friends recall the too many times, for too many years, when the normally articulate Hume was impossible to understand at public gatherings, un-sensed by alcohol. He tended to become either sexually aggressive or physically inept when drunk, behaviour he would never have tolerated sober. Finally acknowledging the complaints of his family, he cut down radically. Pride came into it too: a wish to avoid the embarrassment of acting like an offensive idiot. In conversation in 2008, Hume spoke warmly of his companions at the time:

> We're still friends but life has changed. We're middle-aged. We've got our own lives. People have children. Live somewhere else ... I don't see people regularly like I used to. Can't do the drink any more, makes me ill. Not a kid any more. I play football for 20 minutes with my son and I can't walk for two days! ... So you do things differently. It'd be boring if it was all the same. You're always the same on booze or drugs. Seems fascinating, exciting at the time. In fact you're a bore ... In the end I was ashamed of myself ... Occasionally I slip back into it. More by accident than design.

Tracey Emin also suffered from excessive drinking, which became a cause of concern to her father, who wrote her a letter about it that became part of her sculptural installation *Knowing My Enemy* (2002), placed inside a beach hut balancing at the end of a rickety raised boardwalk.

The commercial successes of the yBas and the media attention this generated were a delight to the artists – although they were not without problems too. Expectation for the future, especially of self for self, can be very damaging indeed. At Fairhurst's show at St Gallen in 1999, Michael Archer suggested that his own 'disappointment, in the sense that things anticipated are inevitably frustrated, sits at the heart of his

Drink has always been part of art-world life. Gilbert & George made a number of works on the subject of drink in the 1970s, and at their exhibition in Beijing in 1993 they labelled their own wine. The drink manufacturers Beck's Beer and Bombay Sapphire Gin sponsored numerous shows by the yBas in the 1990s. Beck's produced special artist labels of the beer supplied to private views, with two different spot images for Hirst, as well as others by Emin, Taylor-Wood, Noble and Webster, Gilbert & George, Koons, Whiteread, Long etc.

work, and to an extent fuels it'. The expectations of the outside world, though less burdensome, may also cause anxiety and distress. Richard Shone wrote in the catalogue introduction to Fiona Rae's solo show in the autumn of 1995 at Waddington's:

> **Will she sustain this level of achievement? The risks are tremendous. The tightrope is long and high, the safety net seemingly miles below ... Rae has confidently side-stepped the trap, not so much of easy success but that of continuing to please without raising our expectations. This is rare in British art where painters of obvious gifts and youthful achievements seem to roll over into the mud of imitations or self-indulgent picture-making.**

The yBas' early reviews tended to be encouraging, and only later turned sour. The other dedicated painter in Rae's *Freeze* year was Gary

For their invitation to the private view of Gary Hume's *American Tan* at Mason's
Yard in September 2007, White Cube used a photograph of the artist's Clerkenwell
studio, with work for the exhibition propped on the tins of household gloss with
which they are painted.

Hume, whose large exhibition *American Tan* at White Cube in Mason's Yard was reviewed in *The Guardian* of 19 September 2007 by Jonathan Jones:

> This is actually his worst show yet; the end, in fact, of whatever eminence he once had, precisely because he is so obviously straining to reignite a jaded style ... But, even at his very best, he was never first-rate. Look closely into his shiny surfaces, and you will see a tiny artist trapped in the empty wastes of his own style.

The semi-abusive nature of much public response to art is one of the reasons why Rachel Whiteread avoids the very social occasions that appear to be the source of endless enjoyment to her contemporaries Emin and Hirst. Whiteread is the one British artist of this generation already to have built an even more solid international reputation than Hirst, and she is thus unable completely to escape public attention. She finds the inevitable intrusions acutely unsettling, mitigated in part by adoption in 2002 of two small boys, whose presence in the daily life of her and her long-term partner, Marcus Taylor, who is also an artist, are an antidote to art-market mania. Interviewed on behalf of the Tate by Hirst's novelist friend Gordon Burn in 2005, Whiteread said:

> I think the difference between me and some of the other yBas was that I was ambitious for the work, and not ambitious for myself. You know, personally. And I think that's quite a big difference. Of course, it was interesting watching people like Damien really playing the media; just working out how to do it, and doing it. And he did it very well, actually. I just wasn't so interested in all of that.

In taking on challenging commissions Whiteread has regularly stretched herself to the emotional limits, one of the most arduous commissions being for the *Holocaust Memorial* in Vienna, which was awarded to her in 1996, although the memorial did not open until October 2000.

A cautionary scepticism about public response to art is illustrated by the fact that, late in 1990, Whiteread ceased giving titles to her work, as she dislikes the connotations that develop in the minds of viewers. Twenty years later, most of Whiteread's sculpture is still titled *Untitled* – as she explained to John Tusa:

> To give it a name, it made the reading of it very specific, which is why I stopped titling things and now everything, which makes life very complicated, is untitled and then would be maybe 'Grey Bed' in brackets or something, you know so it's very, it's much more specific rather than having a kind of poetry to the reading of it.

With the development in 2007 of groups of small-scale work, Whiteread revived the occasional naming of her pieces – such as *Line Up* (2007–8), formed of modest painted plaster objects on a wooden shelf.

The other major loss around the yBa movement, apart from casualties amongst the individuals themselves, is the apparent disappearance from public attention of many British artists from the previous generation. On examination, although there undoubtedly are a number of good artists born in the mid-1950s who have been denied the careers that might have been theirs were it not for market madness around the yBas, there are others who have managed to follow their own very creative paths. In terms of the market, the obvious example is the painter Peter Doig, who was born in Scotland in 1959 and then went to Wimbledon College of Art, St Martin's and Chelsea College of Art, and whose painting *White Canoe* (1990–91) sold at auction in 2007 for $11,300,000. Julian Opie, who was born in Oxford in 1958, a graduate of Goldsmiths ahead of Hirst and his colleagues, never seems to have come up against resistance to his adventurous work. Even a publicly less familiar figure such as the English artist Hannah Collins (born in 1956), a graduate from the Slade and a maker of complex films, has been able to sustain substantial studios in both London and Barcelona and already in 1988, the year of *Freeze*, received a solo show at Matt's Gallery and the ICA, titled *Legends*, with a large, progressively designed catalogue. For some artists of the pre-yBa generation, Collins amongst them, it could be considered an advantage to have avoided the steamrolling razzmatazz of popular publicity. Different situations, of course, suit different people, and there will be some graduates of this previous decade who would clearly have enjoyed joining the yBa scene, just as there are many from the post-yBa generation who feel that the art world is a poorer place to inhabit, philosophically, as a result of the excesses of media attention to Damien Hirst, Tracey Emin, Jake and Dinos Chapman, Tim Noble and Sue Webster and other ambitious London artist stars of the 1990s and 2000s.

Writers, whose medium is words rather than images, tend to get closer than artists to the descriptive truth of what it means to be a person who makes things. The novelist W. G. Sebald, known to his friends as Max, was killed in a car accident near his home in Norfolk in December 2001. His daughter, who was with him, survived. In 1995 Sebald had published, in German, *The Rings of Saturn*, which was subsequently issued in an English edition by Harvill. In it Sebald wrote:

> **For days and weeks on end one racks one's brains to no avail, and, if asked, one could not say whether one goes on writing purely out of habit, or a craving for admiration, or because one knows not how to do anything other, or out of sheer wonderment, despair or outrage, any more than one could say whether writing renders one more perceptive or more insane. Perhaps**

Rachel Whiteread has developed techniques for making beautifully restrained maquettes for large-scale projects in her Shoreditch studio. Shown here are a proposal from 1995 for the *Holocaust Memorial* in the Judenplatz, Vienna, and a study from 1998 for the fourth plinth in Trafalgar Square, London.

we all lose our sense of reality to the precise degree to which we are engrossed in our own work, and perhaps that is why we see in the increasing complexity of our mental constructs a means of far greater understanding, even while intuitively we know that we shall never be able to fathom the imponderables that govern our course through life.

Painters as well as writers tend to spend long hours alone at their work, enclosed in the private worlds within studio and study. At least, they do if they are people of the character of Sebald. Graham Greene, on the other hand, pronounced himself more than happy with 500 good words a day, and if these happened to be achieved by 11 in the morning he liked to spend the rest of the day with a lover! Marcel Duchamp gave up making things altogether in 1925 to play professional chess, and maintained the withdrawal until his death in 1968, despite keeping in close contact with his artist friends. Sad though it is to think of all the works of art Duchamp might have made during these years, he was, however, very much alive. When, in 1960, Richard Hamilton asked Duchamp for a signature to add to his typographic translation of the *Green Box*, Duchamp replied by signing the blank page of a 'DON'T FORGET' memo pad! In 1979 Hamilton made this into a postcard. Duchamp had switched happily from the art of art to the art of chess, whereas Fairhurst found himself unable to keep going in any form.

10 / FUTURE

The curator Hans Ulrich Obrist presented his first public exhibition at the age of only 23, in his kitchen at home in St Gallen, Switzerland, with work made especially for the show by internationally celebrated artists such as Christian Boltanski, Hans-Peter Feldmann, and Fischli and Weiss. Obrist's next exhibition, *Hotel Carlton Palace Chambre 763*, was organised two years later, in 1993, in a single room at the Carlton Palace hotel in Paris. The catalogue consisted of postcards by the more than 60 artists shown, packaged in the sliding drawer of a neat yellow box. Included in the exhibition was work by Richard Wentworth, Anya Gallaccio's principal tutor at Goldsmiths, and by the young British artist Steven Pippin, prior to his selection by Carl Freedman for *Minky Manky* in 1995 and to his short-listing for the Turner Prize in 1999. Pippin produced for Obrist a postcard with photographic images on both sides: the front a closed wardrobe and the back the same wardrobe with the door open to a shadowy presence. The image related to Pippin's pin-hole camera experiments, during which he took photographs from the inside of baths, wardrobes and working washing-machines, some of which Freedman exhibited in *Minky Manky*. Obrist followed the Carlton Palace show with dozens of adventurous curatorial projects, including hundreds of interviews with artists, architects, scientists and historians, leading to an ongoing series titled *Marathon Interviews*. His weekdays are currently based in London, where he is Co-Director of the Serpentine Gallery, and his weekends at home in Berlin.

Obrist has forged a dynamic presence in the art world. Identified by art watchers as a 'truffle pig', someone who discovers trends before others come across them, he is regularly asked to predict the artistic future. Irritated by this, he decided to question the artists themselves. Damien Hirst replied that 'the future is without you', while Peter Doig wrote 'suture that future', Douglas Gordon 'the future will be bouclette' and Liam Gillick 'the future will be layered and inconsistent' – collectively proving that prediction in the arts is ridiculous!

The one thing that does seem certain about the art market's immediate future is its ineluctable alignment with the structures of moneyed investment. This is true, of course, only of certain sections of the contemporary art world, in particular those parts of it connected to the yBa phenomenon. Whilst plenty of interesting work continues to be made outside the hothouse, all sorts of public institutions, private corporations, individual collectors and dealers have trapped themselves within

In 1988, after leaving his family home in Northumberland to go to art school in London, Paul Noble and four art student friends set up City Racing, in an unoccupied building in Lambeth. There Lucas, Landy, Wearing and other now leading British artists put on their early significant shows. Noble is himself now an internationally established artist, best known for his large, detailed pencil drawings, seen in this 2007 view of his studio in Bow, east London.

the over-heated market system. In a recorded conversation with Noah Horowitz in 2006, published in 2011, Obrist said: 'Something I've repeatedly stressed is my motivation to enhance the pathways or circuits within which art circulates ... [I am] not offering another art economy.' Although Obrist happens not to have worked extensively with any of the Goldsmiths five, he has much in common in particular with Landy and Gallaccio, and also with Douglas Gordon, one of the contemporary Scottish artists with whom he does work regularly. These artists and their curator are united by the ability to organise the practicalities and finance of adventurous projects while nevertheless declining to be motivated by commercial considerations.

Obrist is an encouraging figure to see in a powerful curatorial position in the art world, because he invariably aims to do things differently, always looking towards the future whilst at the same time appreciating those artists of an earlier generation who made and in some cases – Christian Boltanski, Maurizio Nannucci, Daniel Buren – continue to make radical interventions. Obrist sleeps little, travels extensively, drinks dozens of strong coffees every day, interviews incessantly and knows 'everybody', and his presence in the art world promises attention to those forms of artwork unavailable for purchase. He affirms his repeated commitment to promote the idea of art as 'elite for the masses', and has avoided involvement with acquisitions for public or private institutions, instead emphasising the value of detailed archival retention, often the only form in which the work he promotes exists.

Reversal of the finance-oriented themes of the art market of the 1990s and 2000s could indicate a viable way forward for the 2010s. Matthew Higgs, artist and curator, who was closely involved in the 1990s with the artist-run spaces Cubitt, Cabinet and City Racing, expressed in conversation with Paul O'Neill for North Drive Press in 2006 his sadness

at the loss of influence of such outfits, with their emphasis on the artist's creative freedom:

> I certainly think in London one of the most disappointing things that happened was the way that the artist-led, and artist-run culture – for the most part – capitulated to the market. Where you might have had a number of independently minded organizations or idiosyncratic initiatives, you have instead a plethora of new spaces employing exactly the same mannerisms and methodologies of commercial galleries – where the only tangible ambition appears to be a desire to be accepted into the fold of certain international art fairs.

There is one place in London where the original ideals have been maintained: the exceptional Matt's Gallery, founded in 1979 by the artist Robin Klassnik as a conscious creative act, which continues to present half a dozen stimulating solo exhibitions every year at its Mile End premises. Klassnik has succeeded in creating and running an organisation that is crucially different from other galleries, both commercial and institutional. He has done this through a central concern for the relationship between the viewer and the work, as seen in a Serpentine exhibition organised by Alister Warman in 1984. 'It was the last moment of what seems now quite another era, innocent of marketing and the half-truths of PR,' Warman commented in 2011, by which time he was about to retire as Principal of the Byam Shaw School of Art. Jean Fisher wrote in the Serpentine's 1984 catalogue:

In founding Matt's Gallery in 1979, the artist Robin Klassnik was making a creative protest against the conventional art world and also expressing dissatisfaction with his own work. This had included an impressive group of mail art postcard collages, here hanging on the wall behind him during a talk given at an exhibition in Portugal in 1974. Matt's Gallery remains a stimulus to the showing of progressive art in Britain.

> Matt's Gallery orchestrates this sensitive space between viewer and work with a singular control and understanding of art's function ... Its shows are more than displays of works of art, they are its experience; its mailing cards and publications, whose production values often outclass those of the major institutions, are more than publicity or information, they are visual and temporal extensions of the work itself.

Almost all the exhibitions are created for the specific space, giving the artist potential control over how their work is perceived and adding focus and intensity to the viewer's experience. In 2008, in 'Present Tense', his essay on Matt's Gallery, the historian Richard Grayson expressed the same feelings Fisher had noted 20 years earlier: 'In many ways it operates as a conscience in a field that is losing function and compass ... Its approaches are particular, the artists unexpected, and it remains in vigorous discourse with the arguments and approaches of contemporary culture and the new establishment.'

Klassnik readily admits that the selling of work is not his strength – as he told *Art & Design* for their publication *British Art: Defining the '90s* (1995):

> I've always said that everything is for sale, but I've never gone out to try and sell work. I don't know how to do it and I don't feel comfortable with it. Look, I didn't really envisage any of this when I started. I never really thought about how I was going to approach it, how long it was going to last, but I was serious from the word 'go'.

Both during his time at the Royal College of Art and afterwards, Paul Westcombe had to work long hours as a car park attendant to earn his way. Primarily a draughtsman, he developed the habit of making things from the material available, especially the throwaway paper coffee and espresso cups that he rescued from the bin at the kiosk he went to every day on the way to work. He titled and dated the bottoms of these cups: *I'll folow you through the peephole* and *My breth with drew, my head rolled for a moment*. Both were drawn in 2009, with the black coffee stains showing through, and the spelling mistakes unintended.

This kind of moral support places at the gallery's forefront the ambition to help artists realise their creative wishes in a respected public space in the East End of London, from which collectors and commissions follow. Although it is years since Klassnik made any specific artwork of his own, the operation of Matt's Gallery is itself a work of art, run with rigour and integrity and ambition. There is always room for other artists today to develop individual ways of presenting their work, as Paul Noble and Keith Coventry did from 1988 to 1998 at City Racing and as Damien Hirst did at *Freeze* and Building One from 1988 to 1990. The amazing thing about Klassnik is that he started his gallery a decade earlier than them, and is still doing it, with energy and ability.

Klassnik is an individual, not a paradigm – no one else can do quite what he does and, to make an impact, newcomers must instead express their own ideas, not his. Quite a few younger artists turn away from making things already as students, and choose instead to follow the Klassnik path of becoming curators. Both Susie Clark and Marie-Anne McQuay initially took BAs in practical art before joining the MA course in curating at Goldsmiths from 2005 to 2006, headed at that time by Andrew Renton. By 2011 Clark was gallery manager at the London contemporary art dealers Kate MacGarry, attending art fairs and visiting studios all over world, and McQuay was a curator at the adventurous art space and studio complex Spike Island in Bristol. Under the direction of the imaginative Helen Legg since 2010, Spike Island encourages the work of a younger generation of artists who, in their early 30s, seek a form of expression that avoids the high-cost art works of their seniors. Sean Edwards, for example, makes compelling work from found cardboard boxes and scraps of discarded wood; the identical twins Simon and Tim Bloor, who have also had a show at Spike Island, draw on fluorescent paper, and construct tables of commercial brick and sculptures of gilded cardboard.

And the young Scottish artist Paul West-combe makes regular use of discarded paper coffee cups, his dense style of drawing influenced by Michael Landy's studies for *Scrapheap Services*. This attention to objects of everyday use, if it takes hold, will bypass the vast, luxurious London premises of dealers like Jay Jopling, Larry Gagosian and Hauser and Wirth, where art and wealth are ostentatiously aligned. Typical in its ambition is Gagosian's giant premises in King's Cross, operated at elegant expense and yet declining ever to label works on display, and often neglecting to keep available a supply of caption sheets.

Jake and Dinos Chapman are represented by Jopling, who opened in the autumn of 2011 a third London space, in Bermondsey, at 58,000 square feet the largest commercial gallery in the whole of Europe. Tim Noble and Sue Webster are Gagosian artists, and Martin Creed is with Hauser and Wirth, all mounting expensive installations. In contrast to these established yBa habits, the most adventurous work of the future is likely to come from the next generation, and although there is no single dominant theme in the work of British artists still in their 30s, it does seem that their most interesting work turns resolutely away from easy acquisition or definition.

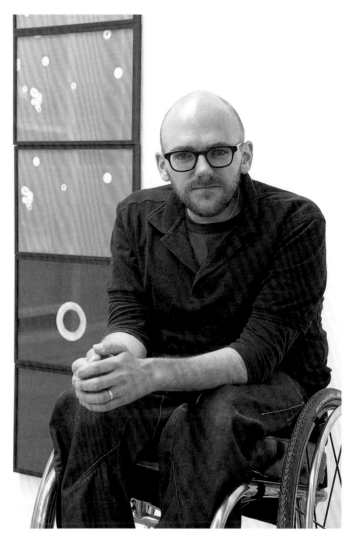

Although Jamie Shovlin (see p. 143) typifies the independence of these younger artists, they were – as always in the unfolding of artistic expression – influenced by their predecessors: for example, the talented young draughtsman Kate Atkin is a firm admirer of Gary Hume's painting techniques, while her sister Meri Atkin is a studio assistant to Gavin Turk. The nature of this movement was exemplified by Ryan Gander in the perplexing *Locked Room Scenario*, shown by Artangel in the Londonewcastle Depot in Wenlock Road, alongside the City Basin, from 30 August to 23 October 2011. On arrival at the empty depot it felt as if the show was over, the corners of the remnants semi-visible through broken blinds on the windows of locked internal doors. Lying in a passage corner was the crumpled and re-crumpled handwritten seating plan for supper after the private view. A slide-show was being projected at floor level through a glass panel onto the next-door wall, the carousel filled

Like a number of British artists in their 30s, Ryan Gander has turned against the costly installations of the yBas, as shown in his *Locked Room Scenario* (2011), in an abandoned depot off City Road, London. This photograph of the artist, who is a wheelchair user, was taken inside the section of the installation called *Field of Meaning*, which is largely hidden from the visitor's view.

Some of the challenge of Gary Hume's early years is illustrated in the White Cube private view invitation to his solo exhibition in the spring of 1995. Wearing a long-eared winter woolly hat, the artist is reflected in the gloss enamel of his own picture *Baby* (1994–5).

with copies of the same slide, endlessly repeating itself. On a wall in the yard the grafittied name Mary Aurory.

The audience, who were admitted singly, by appointment, also left alone, in a certain amount of bewilderment – especially when each in turn was informed a good way down the street, by an apparently deaf-and-dumb passer-by, that they had dropped a piece of paper on the pavement. Although you knew that the double-folded sheet was not yours, you picked it up and saw that it had been torn from a second-hand book, with 'Mostly English; not too English' printed across the top and the phrase 'Aston's yellow mackintosh' circled in black biro in the text. Down the page a paragraph began in capital letters 'MARIE AURORE SORRY', and over the page the characters Vivi and Abbé were mentioned. On the Artangel website a circled entry about Gander's installation read, 'MARY AURORY SORRY Vivi is dead …'; and one of the postcards in a wire stand in an abandoned office room in the exhibition was ascribed to Abbé Faria and titled *Barragan's Device* (1988). Although the different spellings remained a mystery, slowly the rest began to connect, and it transpired that everything – the artists, the postcards, the narrative – was the invention of Gander, who directed the actions of actors, the building of the internal walls and passages, the painting of graffiti and the making of the half-hidden art.

The art historian and long-serving art critic of the *Daily Telegraph* Richard Dorment began his review of the exhibition on 30 August 2011:

'If you haven't heard of Ryan Gander, believe me you will. In his ambitious new installation/performance piece, *Locked Room Scenario*, this extraordinary artist draws on the conventions of detective fiction to set up a conundrum that would have baffled Sherlock Holmes.'

The relationship between artists and the art market, including reviewers as well as financiers, is difficult to categorise – even Gander chose to turn for finance of *Locked Room Scenario* to the establishment outfit Artangel, who gained public recognition as long ago as 1993 through funding Rachel Whiteread's *House*. Many of these older artists are as irritated as Gander by standard art-market practices; they participate in order to earn a living but keep as much out of sight and sound as they can, trusting that the work will be strong enough to speak on their behalf. Whiteread's preference in this direction is well known, Hume's less so. In his Clerkenwell studio in December 2007, he revealed some of his feelings on the subject, describing the changes that had taken place in his working life since the early 1990s:

> My only place now is just making the things. Unlike in the independent early days, I've by now passed the power of choice to other people. To museums, dealers, collectors. I've become an insider myself. So I have to go to the only thing I can truly control, and that is the painting. The only fear is that this internal circle can become too small. Though at the moment it seems so rich that everything else feels like a distraction ... When you're young you feel like you're creating the culture, whereas on the way to 50 I simply hope I'm contributing to it.

Privately, Hume has always been a loving companion, and this gentleness more often appears these days also in his work, a reflection of the emotional security of his marriage to the artist Georgie Hopton. A disciplined maker, Hume's large two-floor studio in Clerkenwell has a permanent air of ordered activity. Most of his paintings are initially composed lying flat on tables, but in the later stages he sometimes lays out squares of cardboard on the floor below the hung panels, catching the

Until recently, Gary Hume declined to sell or exhibit any of his drawings, despite their beauty. One of the works he has decided to show is this charcoal torso, drawn in 2009.

All artists tend to retain bodies of work that they choose, for one reason or another, usually private and personal, not to exhibit. Gary Hume is thinking of changing his mind and finally showing some of the spattered cardboard pieces from below his paintings that he has been selectively keeping for years, with marks of paint cans and of the soles of his work boots.

drips. He has kept the best of these multi-spattered cardboard pieces and is thinking of exhibiting of them – another indication that Hume's long haul to a personal sense of artistic security is getting there.

A different sort of artist, Martin Creed, the Turner Prize winner of 2001, made the first of his published statements about art to accompany exhibits in a group show at The Black Bull in 1989, when he was still at the Slade School of Art. The art school earnestness of these remarks was soon replaced by the Scottish-born Creed's attractively unspectacular and yet distinctly unapologetic way of communicating today. By now he gives the impression of non-laboured creation, with his folded then unfolded sheets of paper, buttons of Blu-Tack and balls of paper. He is, however, constantly making things, their production sometimes convoluted and time-consuming, at others economical and direct. In *Work No. 470: If you're lonely ...* (1995), which exists simply as a piece of typed text, he writes:

> Work ... this is work. This is hard work. Talking about work is work. Thinking is work. Words are work. Words are things, shapes. It's hard to compose them, to put them in any kind of or-

der. Words don't add up. Numbers add up! ... I want something
to ease the pain. I want to get out of my head ... Work is eve-
rything, I think. Everything is work. Everything that involves
energy, mental or physical. So ... everything, apart from being
dead. Living ...

In public discussion of the meaning of art, Creed's overall conclu-
sion is that it exists primarily in the eye of the beholder. In an interview
with Mark Lawson on Radio 4's *Front Row*, first broadcast on 30 June
2008, he said: 'People make art. Artists don't. Artists make funny things
which people look at.' The critic David Sylvester, in an essay collected in
his *About Modern Art*, published in 1996, five years before his death, also
placed the viewer at the centre of the process of bringing art to life: 'The
modern artist creates ... images in which the observer participates, im-
ages whose space makes sense only in relation to the position in it occu-
pied by the observer.' This is certainly true of Creed, in whose work the
spectator is often a semi-participator. Even for a painter like Hume, the
viewer's sight of the changing light and of self-reflections in the liquid-
like surfaces of his gloss paint is integral to the work's meaning. Liam
Gillick wrote in the catalogue for his solo show at the Arnolfini in Bristol
in 2000: 'My work is like the light in the fridge; it only works when there
are people there to open the fridge door. Without people, it's not art –
it's something else – stuff in a room.'

This point of view was also expressed by Rein Wolfs, artistic di-
rector of the Kunsthalle Fridericianum in Kassel, in the catalogue for

The Scottish artist Martin Creed
anticipated today's move towards less
materialistic attitudes to art with the
exhibition at the Cabinet Gallery in
London in 1994 of *Work no. 88: A sheet
of A4 paper crumpled into a ball*, placed
on the floor of the gallery.

Douglas Gordon's solo show *Close Your Eyes, Open Your Mouth* in Zurich in 1996: 'His work asks for active involvement. It does not first beg to be understood, but pleads to be experienced, to be imbued with life by the vital presence of the viewer.' The artist and critic Adrian Searle, who taught at Goldsmiths from 1994 to 1996, understands this approach – as expressed in his Introduction to *Talking Art 1* (1993), which he edited for the ICA: 'There is a way in which the artist is an onlooker, a beholder of his or her work, and suffers, no less than any other member of the audience, from the problem of defining just what it is that had been thought, made and achieved.'

Judged by these criteria, art-historical patterns within Western society are made by the public as much as by the artists, for, as individuals, the latter are both the product of and a response to the social circumstances of the day. It could be argued, on the other hand, that the most significant work from each generation exists despite the structures of the period, indeed often emerges in conscious opposition to presiding patterns of creativity. By this analysis, the narrative of art – past and future – lies in the independent work of a few exceptional artists. During their lifetimes it is impossible accurately to foretell who these individuals might be.

Mat Collishaw has thoughtful views on this subject. Interviewed at the British Film Institute in April 2010 in connection with his part-film installation *Retrospectre* (2010), he revealed his awareness of how attitudes had changed since the early days, emanating – with him – in less belligerence, the taking and giving of less offence. He remains, however, intensely committed to creative enterprise, passionately critical of any artist's lack of dedication or the aping of others, and wordlessly disdainful of crass, ill-informed opinions about his work. Listening to the public conversation in Cinema 3, the fullness of Collishaw's individual involvement in his work could not have been clearer, incorporating family experiences and ideas and feelings, the gamut of an individual's life.

Commissioned as a response to the films of Armenian director Sergei Parajanov, Collishaw commented: 'The title *Retrospectre* influences the way people come to the work. And I struggled with it, as usual. Titles are hard.' Making art, he revealed, was difficult enough for him anyway, as he is seriously colour-blind, leading to substantial misreading of the entire spectrum. This has the effect, Collishaw finds, of forcing

Douglas Gordon, the Scottish film-maker and, like Martin Creed, a Turner Prize winner, made the catalogue of his show at the Deutsche Guggenheim in 2005 as a box of postcards, designed by Stefan Sagmeister. For one of his own postcards Gordon took a Polaroid of the photograph from 1996 of himself in a blonde wig, titled *Self-Portrait as Kurt Cobain, as Andy Warhol, as Myra Hindley, as Marilyn Monroe.*

The connectedness between these artists appears in a variety of forms. For the invitation to his private view of *duty free spirits*, at the Lisson Gallery in October 1997, Mat Collishaw used the detail of a print he had made, for which Gavin Turk's two eldest children posed: Frankie on the right and Curtis in the centre.

him to look more intently, to think more questioningly about how he sees things and what he wishes to show. 'Colour-blindness is a bit of a disadvantage for an artist,' he says, with a grin. 'And bad for clothes. It's why I always wear black or dark blue!' Contrary to the atmosphere of much of his work, he can be light and funny in conversation. In response to a question, he admitted to having started to paint again, for the first time since art school, refusing to give any details other than to say his current pictures are 'conservative still-lifes with a bit of a twist in them'. Lest it be thought he may have gone soft, he added that the literature that most inspired his work was by writers like Huysmans, Genet and Baudelaire, although the main decisions were made through constant thumbing of art books and surfing on Facebook, eBay and YouTube.

And tomorrow? We'll see, we'll see.

One of Collishaw's teachers at Goldsmiths, the sculptor Richard Wentworth, has said: 'I think it's back to this thing that people who function well as artists probably function out of desire. They don't really function out of talent.' Nicholas Serota, who is the same age as Wentworth (both were in their mid-60s in the early 2010s), already had doubts in the year 2000 about the future for young artists: 'I don't feel very optimistic ... a huge part of the public remains sceptical about modern art ... And the press play up the sensational aspects all the time, reiterating clichés like the old accusation "that a child could do it".' It was Serota who negotiated the deal in 1991 with Channel 4 to run the annual Turner Prize ceremony live on television – a key element, as it turned out, in widening public attention to contemporary art. Cynics argue that the yBas, who dominated the Turner short-lists for more than a decade, made work in order to secure 'sensational' coverage on TV and in the press. Although a palpable symbiosis existed between some of the yBas and the media in general, the relationship between cause and effect is difficult to

In the summer of 2008 Anya Gallaccio installed at Camden Arts Centre *that open space within*, which involved cutting down and reassembling a fully grown horse chestnut tree, with the branches rejoined by steel pins into a form to match the gallery space.

disentangle: it's impossible to decide who may have taken advantage of whom.

Whatever the rational fears of those intimately involved with contemporary art, renewal is always taking place, somewhere or other, in some form, beyond the murky horizons of the TV-friendly commercial art market. Anya Gallaccio is far from a 'neglected' artist. Indeed by now she is an 'established' figure on the art scene: Professor of Visual Arts at the University of California, represented by an influential dealer in London's West End and Turner Prize short-listed in 2003. And yet she perseveres with work that simply cannot be sold in its exhibited form, pushing her creative ideas to their limits, and on occasion beyond, regularly reaching out to grasp the distant trailing ends of a newly adventurous project. Gallaccio's work has often been on a large scale: her largest project, *beat*, at Tate Britain in the summer of 2002, involved the installation in the Duveen Gallery of 1.5 tonnes of sugar and glucose, seven giant trunks of felled oak and the root ball of one of these trees. To complicate matters, the artist needed there to be a constant pool of water in the bowl of the root, which required the installation of a dialysis pump, the execution of which Gallaccio commissioned from the Mike Smith Studio. The tree was so big and the wood so tough that it took over a month to hollow out the stump to fit the pump (see p. 65) – which didn't, in fact, work very well in the show. Undeterred, Gallaccio created another massive tree piece in 2008, *that open space within*, which took up the whole of the major exhibition space at Camden Arts Centre, its articulated branches spreading throughout the gallery, like an untouchable adventure playground.

Later in the same year as the Camden show, Gallaccio went to live in San Diego, since when a substantial shift of emphasis has taken place in her work. How significant this turns out to be in the longer run re-

Anya Gallaccio's composite piece *Where is Where it's at*, folding around the whole space of the Thomas Dane Gallery in Duke Street, St James's, in the spring of 2011.

mains to be seen, but in the solo exhibition *Where is Where it's at*, in the Thomas Dane Gallery in 2011, the signs for the future were positive. Unlike most of her previous work, the installation was abstract, engaging with American traditions of hard-edge painting and of geometric land art. In her initial travels in the 'new' country, Gallaccio had gathered sands and sediment from Nevada, Utah and Arizona, which she chromatically enhanced and brought back across the Atlantic to lay across the floors and walls of the gallery. The form of the work was fluid, painterly and fragile, and at the same time geometric and firm, with the addition of narrow strips of glass on the floor displacing and echoing the bars of coloured sand, and with overlapping sheets of glass leaning against the wall. A work of delicate beauty, so easily by accident disturbed that Dane was unable to host his customary private view in the gallery. He was able to sell it only to a collector content to attend, with meticulous regularity, to the preservation of such a fragile purchase.

In the book of interviews published in 2011, *Everything You Always Wanted to Know about Curating (But Were Afraid to Ask)*, Hans Ulrich Obrist told Brendan McGetrick that in the art market of the second decade of the 21st century it will 'definitely [be] the new centres in China, India, and the Middle East that are so powerful'. Tino Sehgal, in his Foreword, suggested that 'Obrist is drawn to the field of art and especially artists for their absolutely serious speculation about the future and its postures, attitudes and modalities.' With Obrist himself, possibilities for the future know no bounds: he imagines himself one day 'building a new city as a curatorial project'. This is a daydream, not speculation. Artists also dream, and the good ones consistently realise their visions. With the best artists, these dreams-made-real resonate with us, the viewers. By our reactions, the future of art is ours to make as much as theirs.

I NEED
ART
LIKE I NEED
GOD

TRACEY EMIN

1997

CONCLUSION /
BEING AN ARTIST

The challenge of being an artist is similar, in essence, to finding satisfaction in any other form of work. Few of us are especially good at one thing rather than another, but we get through as best we can, relying for a sense of well-being maybe on the responsibilities of parenthood or the business of keeping fit, watching football, perhaps visiting country houses or going to art galleries. Whatever anybody does, they do so with the resources available to them, by personal nature and through the experiences of life. With the result that, like some estate agents, some artists are flash and unconvincing, some as hypocritical as abusive priests, and some lazy, like TV hogs and piglets, or incompetent like … well, like we all are at times. It is not easy to commit to making work the value of which cannot be judged definitively during our lifetime. In most other walks of life there are standards and rules, calibrated categories of achievement against which both participators and observers can measure themselves. Artists must instead rely on their own faith, and on the supportive presence of like-minded friends. With the added complexity that many artist friends perceive each other as rivals!

Whilst dreaming of endless uninterrupted days at work in the studio, Gary Hume is typical of his generation in being intensely competitive, his concentration hijacked by dwelling on comparative shifts in the public reputation of contemporaries, unable to ignore the art world's machinations. Failure to win the Turner Prize in 1996 continues to grate; and whatever the logic of his exclusion from a prestigious group exhibition might be, the felt insult always rankles. Martin Creed acknowledged equally competitive feelings when he talked to the critic Louisa Buck for her book in 2007 on the Turner Prize: 'The difficulty of being involved in it for me was realising that I desperately wanted to win it. That made me feel quite vulnerable … It was just the fear of not winning – of losing – that was the only problem.' Anya Gallaccio is quoted as saying, 'I wouldn't deny that I am ambitious, but I rarely put myself knowingly into situations where the objective is to "compete". Art is a subjective endeavour both in its practice and in its appreciation.'

One way or another, it is essential for artists to establish effective means of avoiding the self-hate of jealousy. Competitiveness can be a positive stimulus, especially if it is with oneself, but it can also paralyse. Iannis Xenakis, the architect from Le Corbusier's office who was in charge of their revolutionary Philips Pavilion for the 1956 Brussels World Fair and later became a composer of radical distinction, said in a pub-

OPPOSITE
In an interview with Bill Furlong for *Audio Arts*, before her solo show of 1997 at the South London Gallery, *I Need Art Like I Need God*, Emin said that the title was a declaration to herself, the most truthful thing she had ever written – emblazoned across the invitation card for the private view.

Whatever the world may say about his work, Gary Hume holds within himself the touch of an artist. *Untitled (0011)* is one of three drawings that he made of his own hand in 2000. All followed the same method: being left-handed, he placed his right hand on the table in front of him, fist softly closed in the comfort position of his boyhood with the thumb poking between the fingers, and then drew what he saw without looking at the paper.

lished conversation with Bálint Varga: 'Many artists fight each other, for power, money, recognition – but in the final analysis this is what it comes down to: you throw a bottle in the water and somebody picks it up.' Philosophical understanding did not stop Xenakis driving himself exceptionally hard in his work. Susan Hiller, the American artist who has lived and worked in London since the early 1970s, is quoted in the catalogue *State of the Art: Ideas and Images in the 1980s*, the ICA's exhibition in 1987, as seeing the artist as having 'a particular kind of job ... Art functions as a kind of mirror to show people, including the artist, what they don't know that they know. Now that's an actual job of work.'

Creed spoke of his personal ambitions in the catalogue for the touring exhibition *Intelligence: New British Art 2000*:

> I want to make things. I want to try to make things. I'm not sure why I want to make things, but I think it's got something to do with other people. I think I want to try to communicate with other people, because I want to say 'hello', because I want to express myself, and because I want to be loved. I know I want to make things, but other than that I don't know. I mean I don't know what to make, how to make it, or what to make it from. I find it difficult to say something is more important than anything else. I find it difficult to choose, or to judge, or to decide. I'm scared.

Creed's work seeks to combat the visual overload of the world in which we live, and is often made of the simplest materials: *Work no. 74* (1994) is a 2.5cm high stack of masking tape. His openness to the given situation of a particular event or commission or exhibition allows him to turn to almost any means and medium of expression. He is often surprising.

Gavin Turk has made his public reputation by looking at situations in unexpected ways. In conversation in his Bow studio in April 2011, he pointed out the changes that public attention has wrought – because when, in the early days, his name was mentioned anywhere in the press, a friend would excitedly contact him, whereas now nobody notices, and references pass unmentioned, missed by him too. 'And I still want to know, I always want to know,' Turk says, with a smile. 'I'm still amazed to be getting attention!' An artist's internal sense of his or her identity is seldom fixed. Even Turk, a sparkling, optimistic artist, from time to time faces challenges to his confidence. For years he happily inhabited two different individuals: 'Gavin Turk' the artist and Gavin Turk the person, in conversation using his index fingers to indicate the inverted commas around the former, inventing different signatures for each, and generally enjoying the dichotomy. Eventually he became noticeably muddled, unable to differentiate between public and private, uncertain which of the two personalities he was meant to be on any particular occasion. The problem has been resolved by more or less combining the two: both are now 'Gav', and Turk's work has recovered its thrust and bite.

There seems to be an almost universal need amongst these artists to establish what they themselves recognise as their personal manner of expression, thus to form a secure place in the world, where they sense there is a chance of saying something new. Perseverance. Near repetition. Slow development. Constant work. All part of being an artist. Writers call it finding a voice. Makers of things also need to define their individual voices: Whiteread in casting the void, Long in a lifetime of walks, Quinn in his medical explorations, Hume and Davenport in their different obsessions with household paint, Gilbert & George in photographs of themselves, Gordon in the imaginative reuse of archive film, Warren in her febrile sculptural forms, Hirst in the establishing of his brand and

In his large, wall-mounted piece *one thousand, two hundred and thirty four eggs* (1997), Gavin Turk signed his name, by hand, with a scalpel knife, in a bed of white eggs glued to a canvas. Eggs continue to interest him: in *Egg Space* (2009) he defined its form by absence from the paper of graphite marks.

Banner in the painting of words. The intensely obsessive older British painter Frank Auerbach said, again to John Tusa:

> **There must be some experience that is your own – try and record it in an idiom that is your own, and not give a damn what anybody else says to you. I think that is important and I think that the key word there is 'subject'. Find out what matters to you and pursue it.**

The novelist Nicole Krauss, who has written movingly about the American painter Elizabeth Peyton, said in her novel *Great House*, which was short-listed for the Orange Prize for Fiction of 2011: 'The power of literature, I've always thought, lies in how wilful the act of making it is.' This is equally true of visual artists.

As well as the lasting drive to make things for themselves, through the years this group of British artists has also sustained regard and concern for one another, expressed by continued involvement in each other's projects. In the early days, before she was publicly known, the only way Tracey Emin could afford to make her book *Exploration of the Soul* was by pre-selling to her friends, for £50, part of the limited edition of 200, each copy due to contain its own unique monoprint and tipped-in photographs of Emin and her twin brother, Paul, at the age of six. The books, when finally printed in 1994, were given to her subscriber friends in cotton bags with Emin's hand-stitched appliqué initials in different colours on the front, sewn by a team of helpful friends. Two years later Emin was still fabricating things with the help of others, including a small edition for sale in 1996 at the ICA in the Mall, composed of photographs of herself and Paul beside a childhood Christmas tree, stuck onto cardboard, attached by masking tape to loops of wire, and each with Emin's handwritten note of reminiscence on the reverse.

After their commercial success, the yBas have continued to work for free with people in whom they believe. One such project was set up by the founder of the removal and storage firm Momart, Jim Moyes, a Slade sculpture graduate of the late 1960s. Working on the principle that satisfaction comes from a balance of giving and getting, Moyes endowed a £6,000 annual fellowship at Tate Liverpool from the institute's foundation in 1988. Good relationships with practising artists were of crucial importance to Moyes, and Momart began in 1984 to send to its clients at Christmas the gift of a limited-edition 'card' commissioned from a well-known artist of his acquaintance, starting with Moyes's fellow Slade student Bruce McLean. The artists gave their creative work free, and Momart made the piece, adding to the order however many the artist might need. Those who have designed the Momart Christmas card include: Damien Hirst, with a spot-decorated paperweight in 1997; Tracey Emin, with an embroidered cotton handkerchief in 1999, 16 x 16 inches square, inscribed *Be Faithful to your Dreams*; Gary Hume, with his fuzzy felt snowman in 2000; Mark Wallinger, who in 2001 created an empty crepe paper Christmas cracker, *It's the thought that counts*; and Sarah Lucas, who in 2007 produced a mobile related to her life-size horse-and-cart piece *Perceval*.

Matthew Higgs, currently the director of the White Columns gallery in New York, was a selector for the exhibition *British Art Now 5* (2000). In his essay for the show's catalogue he wrote:

> Clearly the financial success and critical acclaim accorded by some could not be afforded to all. One result of this process has been the emergence of an elite group of some half-a-dozen or so artists – including Damien Hirst, Rachel Whiteread, Sarah Lucas, Douglas Gordon and Gary Hume – far removed from the apparently egalitarian nature of the nascent scene with which they have traditionally been associated ... In their shadow lie many artists, too numerous to list here, who must now confront the – very personal – reality of being consigned to second, or worse, third division status as the international opportunities to exhibit and, more significantly, to be collected, dry up.

In a note Higgs added: 'Others such as Peter Doig and Jenny Saville have largely avoided being associated with the yBa phenomenon.'

As well as painting live word-portraits of people and transcriptions from memory of films, Fiona Banner likes to draw the titles and covers of books. *Life Drawing by George B. Bridgman* (2011) is a flat drawing, although in 2007 she had made a shelf of solid books, all from instructional volumes on drawing, in a composite piece called *Life Drawing Drawings*. Banner also prints books at her own studio-run the Vanity Press.

Tracey Emin's *Exploration of the Soul* was designed and printed in Shoreditch by Tom Shaw in 1994, in a limited edition of 200. At the back Emin thanks: 'Everyone who helped sew the bags – And of course all those who bought the book in advance – before I'd even written it – Thank you for your faith.'

Higgs wrote from direct experience: he was actually at the *Freeze* opening in 1988; he lived with the inventive artist Ceal Floyer, first in Holloway and then, from 1996, in Hackney; and as founder of Imprint 93 he worked creatively with many young artists, mounting such events as *Weekender 3* in September 1994 with Creed (*Work no. 97: A Metronome Working at Moderate Speed*) and in 1996 a joint project with Doig (*There is a Painting on the Wall*, at Wilkinson's in Great Ormond Street). His remarks highlight the unhelpful looseness of the acronym 'yBa', too often used by others in thoughtless blanketing. Few of the artists are keen on the term – neither Whiteread nor Gordon exhibited at *Freeze*, and they do not think of themselves as yBas, even though, as Whiteread pointed out to Andrea Rose in 1997: 'Many of the so-called yBas are good friends, and many are very good artists.' As for Doig, he has lived in Trinidad for a number of years and is, anyway, from the previous art school generation. Though it may once have been convenient to label Whiteread a yBa, to do so now is inappropriate, which is why attention has here centred on these five Goldsmiths graduates, all of whom exhibited at *Freeze*. From them, the view is then widened to take in the comparable activities of their contemporaries, including significant contemporaries such as Whiteread and Gordon.

To the surprise of many, the art market bucked Higgs's millennial prophesy of collapse and continues – at the time of writing – to defy the varied financial catastrophes of recent years. Quite where the money comes from to buy Doig and Hirst, or the recently deceased Freud, for millions of pounds apiece is a mystery – given how relatively inexpensive plenty of excellent art always is, it is even more puzzling. Does it matter what happens at the upper end of the international art market? Not really, for it involves an infinitesimally small proportion of those of us who like to look at significant contemporary art. Best to ignore price jamborees. Values and reputations will go up and go down, as they have done since the late 18th century, when London auction houses and dealers first opened their seductive doors. In New York in 1998 the painter Robert Ryman, by now in his 80s, said to Maria Eichhorn, according to her book *The Artist's Contract*:

A painting only matters when it goes out into the world and it can live its own life and people can experience it and receive pleasure from it ... And, of course, (as the artist) you're kind of like a parent. You hope for the best. You hope that someone will take care of it and see that it's not damaged and that it's treated properly ... But it's free. It's a free thing. And there's no price on it. There's never any price because it's always priceless.

One way forward lies in accepting, at least as a possibility, that the Goldsmiths five – Gallaccio, Hirst, Hume, Landy and Lucas – may be capable of making things that turn out to be especially good, in the same sort of way that certain individuals are more successful than others at making cricket bats, say, or ballgowns. The possibility remains, of course,

In 1996 Tracey Emin supplied to the ICA, for sale at £25, photographs, already mounted and wired ready to hang, of herself and her twin brother, Paul. On the back she hand-wrote a story of the two of them rolling tiny balls of mercury down the stairs at home in Margate as children. 'Looking back,' she concludes, 'I think we've been lucky, very lucky.'

that posterity will judge their art works to be bad. Historically, even when admired in their 30s and 40s, numerous British artists have faded from view during their 50s and 60s, few of them reassessed after their deaths. Michael Landy was aware already as a student of this predicted trajectory. He sees the danger as the responsibility of the individual artist to deal with rather than for the wider culture to rectify, and continues to do what he can to avoid such a fate for himself: 'When artists reach a certain age, it's a repetition thing or one loses a handle on what one does ... you kind of work out, somewhere along the line, that something's missing!' While it is as yet too early to know which of the yBas will withstand the longer-term test of time, it is already possible to begin to assess how radical a contribution they have made to contemporary art.

The answer that emerges?

Some more so than others. Making it clear that these artists need to be treated individually, not as a group.

There are precedents. For a while, Robert Morris, Bruce Nauman and other Americans of their generation used to be seen as a group, whereas by now they are rightly judged as individuals. What's more, in the case of these two artists, the principle of radicalism has been maintained throughout their working lives, with the early creations still seen today to be striking and original. Speaking of the late 1960s and the videos of himself doing repetitive acts which he made soon after leaving art school, Nauman was quoted by Coosje van Bruggen as saying that these gestures of reduction came about because of his belief that 'art is what an artist does, just sitting around the studio'. In opposition, the powerful critic Hilton Kramer had been dismissive, writing in an article in the *New York Times* in March 1973, titled 'In the Footsteps of Duchamp': 'Mr Nauman's exhibition is no easier to describe than it is to experience ... [he creates] images that somehow manage to be both boring and repugnant.'

The early work of Damien Hirst was criticised in much the same language. In retrospect, though, there appears little that is essentially radical about his body of work, nothing that will inspire the art-making of later generations – as the work of Nauman undoubtedly does. Another criticism made of the *Sensation* artists is of their self-obsession, accompanied by failure to develop wider areas of thought and understanding about the making of art. Again there is a contrast with Nauman, whose print *Pay Attention Motherfuckers* (1973) provides physical evidence of the artist's early understanding that, in truth, an attentive audience is required to bring the work of art into existence. The making of art often takes place in extended isolation, but transformation of this into a 'work of art' is effected by the public. The Goldsmiths group started out with the kind of private courage that might have led to an aesthetic revolution, but this quality descended – some say – into indulgence and solipsism, acceptance of conventional market judgement and lack of the questioning rigour that leads to radical change.

Jim Moyes, founder of the art removal and storage specialists Momart, began in 1984 to commission from artists whom he knew a Christmas card to send to clients. The scheme expanded to incorporate small object-editions by leading younger artists: Sarah Lucas' mobile in 2007; Damien Hirst's spot paperweight in 1997; Tracey Emin's hanky in 1999; Gary Hume's fuzzy snowman in 2000; and Mark Wallinger's cracker in 2001.

There's a painting on the wall.

In the spring of 1996 Peter Doig and Matthew Higgs, the current Director of White Columns in New York, put on an Imprint 93 event at the Anthony Wilkinson Gallery, as announced on this special postcard. In the mid-1990s Doig hosted several other Weekender events for Higgs's Imprint 93 at his King's Cross studio.

Some of these ex-Goldsmiths students – Michael Landy, Mark Wallinger and Anya Gallaccio, for example – have already convinced socialist-leaning sections of the public of the worth of their work; their task is to sustain through the 2010s faith in the breadth, relevance and seriousness of their concerns. All five members of this group have projects coming up around the world during the next several years, and we will see what transpires. Their teacher at Goldsmiths, Michael Craig-Martin, continues to have faith in them all. Invited in 2010 by Galerie Haas & Fuchs to select from his ex-pupils for a substantial show in Berlin, his choice of 25 was dominated by the yBas, including Hume, Hirst, Landy, Fairhurst, Lane, both Patterson brothers, Bulloch, Lucas and Collishaw. 'They all make work of the highest order,' Craig-Martin wrote in the catalogue. 'I think of them all as friends.' Since ceasing to teach, he has found that he misses 'their effortless instinct for the present, which increasingly escapes one as one gets older.' As this group of no longer young artists reaches 50, they too may face this same fate. Although with Sarah Lucas, in particular, there is at present little sign of it happening.

It may be that, as an artist, Hirst's most significant contribution will turn out to have been in the independent conduct of his art practice and in finding, at the height of his commercial success, the energy and self-belief to manage his own affairs, removing himself from established relationships with his powerful dealer and his main collector to run his own shows, publish his own books, manufacture and sell his own art editions and fund his own massive museum. Many artists before Hirst have set out to shock, but no other British artist has ever placed himself in the position to spend millions on a museum of his own work to celebrate becoming 50!

In a free promotional postcard issued in 2011 by Tate Britain and their sponsors BP, Sarah Lucas (*Self-Portrait with Fried Eggs*, 1996) is paired with Sir Peter Lely (*Portrait of an Unknown Woman*, c. 1670–75).

In all of this, Hirst has consistently been himself and followed his personal interests and aptitudes, declining to be dictated to by the art establishment. The purchase of his work for hundreds of thousands of pounds by collectors and institutions around the world is not Hirst's doing. Justifiable criticism of the art market itself is wrongly placed at the studio door of any individual artist. Those who look at and buy art have equal freedom and self-responsibility. It is the high-rolling dealers, collectors and institutions that chose to make Hirst's disciplined work into works of art.

In conclusion to his 'A Postscript and More' in the Hayward Annual catalogue of 1985, *A Journey through Contemporary Art*, Nigel Greenwood, the most adventurous London gallery owner of his generation, wrote: 'We wait for history to pass judgement. Meanwhile I am much too impatient, I will make my own way through the woods.'

Greatest thanks to Anya Gallaccio, Gary Hume, Michael Landy and Sarah Lucas – the idea of this book has become a practical reality only by their support, in the time for conversation and in the loan of loads of images, many of which have never before been commercially published. A number of other artists, photographers and dealers have also been generous with information and images, including: Sadie Coles, Tracey Emin, Ryan Gander, Kate Blake, Mick Kerr, Helen Knight, Abigail Lane, Guy Moberly, Maureen Paley, Anthony Reynolds, Julian Simmons, Sarah Staton, Gavin Turk, Justin Westover and Rachel Whiteread. Owing to other commitments, Damien Hirst was unavailable for interview, although his office kindly supplied some images of his work.

Within the text, instructive comments are gratefully quoted from other sources, as indicated. The majority of undesignated quotations are from the author's conversations over the years with the artists.

This is MyFRiend Geremy TRAcyEmin 1997.

Tracey Emin's monoprint portrait drawing of Jeremy Cooper was executed on the spur of the moment in 1997, on one of his visits to the artist's studio-cum-museum, five minutes' walk from Waterloo Station. On this particular afternoon Emin was working in the front half of her High Street premises, a gauze curtain pulled across the plate glass window, in an ex-shop which she called the Tracey Emin Museum, with a neatly stored archive of memorabilia in shelved cardboard boxes and work in progress scattered about the place. The monoprint drawing was quickly done in her usual feathery blue line, the reverse-written dedication containing a characteristic spelling error, which may or may not have been deliberate. It was an instantaneous and typically generous gift. In 2012 Emin took up her appointment as Professor of Drawing at the Royal Academy, at the same time as which Fiona Rae became Professor of Painting. Emin and Rae are the first female professors at the RA in its entire 250-year history.

FRONTISPIECE:

Damien Hirst in *I Should Coco the Clown*, making his first spin paintings at the *Fête Worse Than Death* in Hoxton in 1993, with the art dealer Carl Freedman and the painter Zoe Benbow looking on.

Prestel, a member of Verlagsgruppe Random House GmbH

Prestel Verlag
Neumarkter Str. 28
81673 Munich
Tel. +49 (0)89 4136-0
Fax +49 (0)89 4136-2335
www.prestel.de

Prestel Publishing Ltd.
4 Bloomsbury Place
London WC1A 2QA
Tel. +44 (0)20 7323-5004
Fax +44 (0)20 7636-8004
www.prestel.com

Prestel Publishing
900 Broadway, Suite 603
New York, NY 10003
Tel. +1 (212) 995-2720
Fax +1 (212) 995-2733
www.prestel.com

Library of Congress Control Number: 2011944325
British Library Cataloguing-in-Publication Data
A catalogue record for this book is available from the British Library.

The Deutsche Bibliothek holds a record of this publication in the Deutsche Nationalbibliografie; detailed bibliographical data can be found under: http://dnb.d-nb.de

Prestel books are available worldwide. Please contact your nearest bookseller or one of the above addresses for information concerning your local distributor.

Editorial direction: Ali Gitlow
Editorial assistance: Supriya Malik
Copyedited by: Matthew Taylor
Production: Friederike Schirge
Design and layout: Benjamin Wolbergs

Origination: Repro Ludwig, Zell am See
Printing and binding: APPL aprinta druck GmbH & Co. KG, Wemding
Printed in Germany

Verlagsgruppe Random House FSC-DEU-0100
The FSC® -certified paper LuxoArtSamt has been supplied
by Sappi, Biberist, Switzerland

ISBN 978-3-7913-4702-8